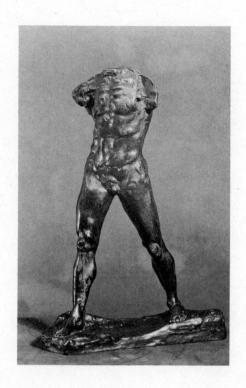

Origins of modern sculpture:
pioneers and premises

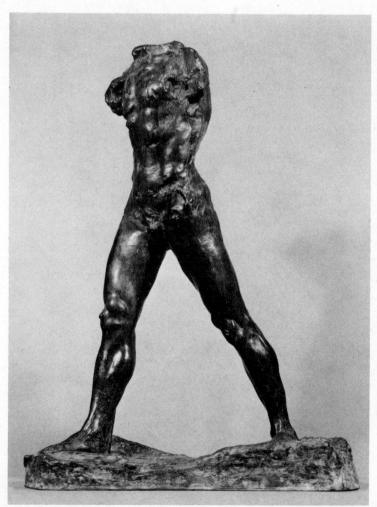

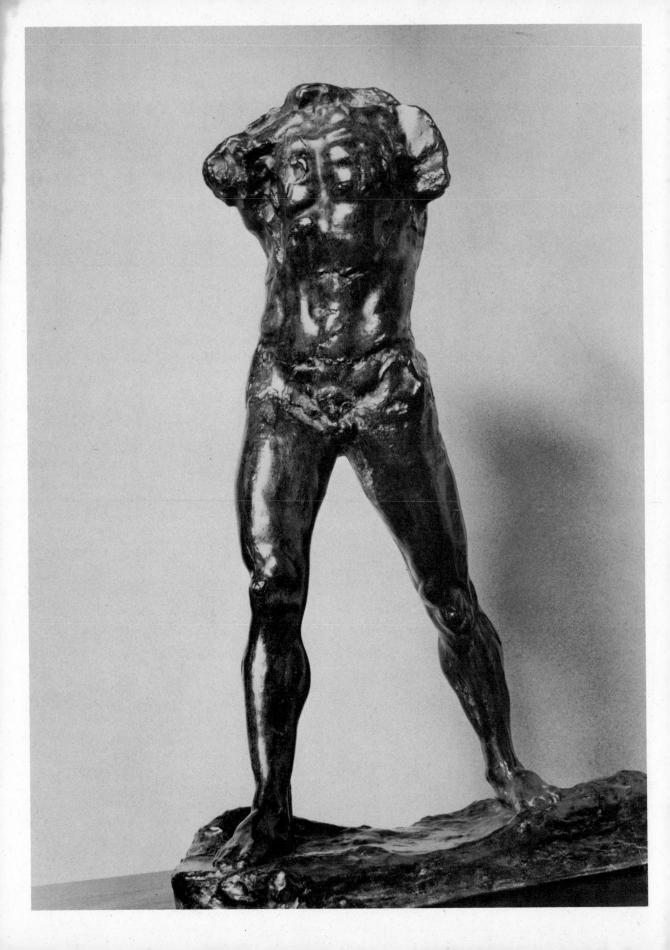

Origins
of modern
sculpture:
pioneers
and premises

Albert E.
Elsen

George Braziller

New York

In Memory of Robert Goldwater

The original version of the text here enlarged and altered was written at the invitation of the Arts Council of Great Britain and formed the introduction to the Arts Council's exhibition catalogue *Pioneers of Modern Sculpture* (Hayward Gallery, London, 20 July–23 September 1973).

Acknowledgments

My greatest debt in the writing of this book is to Norbert Lynton and the Arts Council of Great Britain who published its first version in England in conjunction with the exhibition *Pioneers of Modern Sculpture*, during the summer of 1973. They gave me the opportunity to pull together researches originally sponsored by a Guggenheim Foundation Fellowship, and to view the period in a more unorthodox way than its previous treatment. I am especially grateful to them for accepting the suggestion of introducing the exhibition as well as the book by means of a miniaturized turn of the century sculpture salon so that the public could recognize what the revolution was against as well as for.

Indispensable to the writing of this book and preparation of the exhibition was Daniel Rosenfeld, who for two years shared my office, concerns and hopes for both projects, and who worked so hard and well for their success. It is graduate students such as Dan who have encouraged the graduate art history department at Stanford University to develop this type of professional apprenticeship that will send strong scholars into museum work as well as teaching. We would both thank Mr. B. G. Cantor for the grant to Stanford University from his foundation that supported Dan's work in Europe, especially in the basements of museums. Dr. Jacques de Caso was a considerable help in this respect as well. Two colleagues who were always generous in sharing ideas and criticisms are Dr. Athena Spear and Sidney Geist. They were particularly helpful with their detailed criticism of the manuscript, as was my former chairman, Dr. Henry R. Hope, who championed modern sculpture when I was still in high school. For their assistance in the original and revised versions of this book I would like to thank Mrs. Frances Archipenko Gray, Dr. Kirk Varnedoe, Lincoln Kirstein, Jan Nadelman, Miss Betsy Jones, Mrs. Katherine Michaelson, Dr. Werner Hoffmann, Robert Kashey, and my colleague at Stanford, Miss Jean Finch. The scholar to whom I owe the incentive to cut across national and "group" boundaries in writing on this subject is the late Robert Goldwater, to whose memory I dedicate this book, and in gratitude for what he did for me personally and modern art in general.

Preface

It was the idea of Norbert Lynton, Director of Exhibitions for the Arts Council of Great Britain, to call our 1973 exhibition for which this essay was first written, "Pioneers of Modern Sculpture." We both recognized that the term "pioneer" had been overworked, but I respected Norbert's view of its aptness and have retained it in this revised edition of my original essay. A few words of justification for the selection of artists in this book are here called for. It is my view that modern sculpture did not begin with Michelangelo, Horatio Greenough, or Daumier, but with Rodin and his contemporaries. I have tried to demonstrate here and in previous writings that between roughly 1890 and 1918 new premises for sculpture were established by this great artist and younger venturesome sculptors which radically changed the look and focus of sculpture, thereby starting its continuous process of redefinition.

The basic criterion of who was a pioneer is whether or not the artist put sculpture into an area where it had not been before. That an artist was predominantly a painter and a part time sculptor, as in the cases of Picasso, Modigliani, and Matisse, is not worth quibbling over. Art historians should learn from artists in this period and stop nit-picking over categories. The fact is that the sculpture of these men did change thinking about sculpture as well as its appearance. There are some premises of modern sculpture that do derive from painting, as with Cubism, but it is no less to the credit of young artists at the time, such as Lipchitz and Laurens, that they recognized its implications for working in three dimensions. Artists of short-lived daring, such as Otto Gutfreund, are included because they were breaking a barrier that had taken three thousand years to erect and which was defended by a living army of artists and the most powerful institutions that could influence a sculptor's livelihood. We forget how tough it was to make a living as a sculptor in this period. Rare were supportive critics, dealers, and patrons. Unlike hundreds of sculptors today, the pioneers could not fall back on teaching jobs with universities providing facilities and materials for making sculptures. Brancusi never had tenure.

There were many sides to the early revolution. Maillol, Renoir, and Nadelman were bent upon retaining museum quality and viable aspects of tradition. Preserved were the primacy of the nude and the use of certain poses, but all were to be submitted to the personal experience, emotion, and thought of the sculptor rather than conform to conventions that lacked conviction. The work of Maillol and Renoir shades over into some aspects of the art of the Salons and reminds us that there is a conservative area in modern art at one end of a spectrum that terminates in radical invention on the other and where sculpture's very identity is problematical.

The sculptors in this essay have not been singled out because of influence, productivity, or durability measured by quality sustained after the period. Do we neglect Degas and Matisse because they had no followers into the new territory they opened up? Do we ignore Boccioni because he made so few sculptures? Is Archipenko to be snubbed because he was less audacious after 1918? Is Gaudier-Brzeska to be forgotten because he did not produce a masterpiece before he was killed in battle? Are we to be silent about Fortunato Depero because his few innovative works, probably made with Balla, have been lost? We cannot deny that although Marcel Duchamp was not even a part-time sculptor, his Readymades were more influential on later sculpture than, say, the art of his brother, Duchamp-Villon. Admittedly, the pioneers were unequal in the depth and scope of their daring. Rare would be the historian who would go to the stake to defend the quality of such sculptors as Gutfreund and Filla. It is obvious that men like Brancusi, Picasso, Boccioni, and Tatlin made more and drastically different contributions than did other pioneers like Maillol and Barlach. But they were equals in that they experienced hostility and lack of comprehension while working amidst at least ten thousand exhibiting sculptors, many of whom had more reputation with the art world and public than did they.

Least of all can one select pioneers on the basis of their present reputation. Nadelman and Lehmbruck are not admired in England. Some English critics see Epstein as greater than Brancusi. Gaudier-Brzeska is hardly known in the United States. The late Lipchitz sculptures have dismayed many critics. Renoir is no longer mentioned anywhere. Barlach is bought in this country primarily by immigrants who fondly remember his work from their youth in Germany. Nadelman's art is only now receiving sympathetic attention from more than a handful of dedicated admirers in America. It is in the last few years that Picasso and Matisse have been widely recognized as major sculptors.

Further argument over the question of who was and was not selected, and why, I leave to graduate seminars and critics. This is not intended to be condescending, as my own views have broadened in the direction of tolerance with regard to pioneering eligibility since the first version of this book a year ago.

The historian's problems

Our understanding of the beginnings of modern sculpture will always be imperfect. It is difficult to reconstruct how artists and the public within the period 1890–1918 knew the sculptures themselves. Many old plasters that won medals in the Salon are today rotting in storage outside of Paris, and it is not even possible to

photograph them. One has to tour basements not only in Paris and London, but in provincial museums in order to see the old bronzes and marbles commissioned from Salon showings. There are several such pieces almost under Manhattan's Fifth Avenue in the reserves of the Metropolitan Museum of Art. One can see in museums all over the world casts of the work of sculptors such as Archipenko that before 1918 existed only in plaster, terra cotta or wood, often in a smaller scale and available only in the studio. Only after his death were almost all of Degas' sculptures cast in bronze and publicly exhibited in the early 1920s. Many small- and medium-sized works by Rodin were not bronze cast in his lifetime and remained in his studio, invisible to most of the young sculptors. Marbles that Rodin *rejected* and which were badly soiled through rough handling have been indiscriminately displayed for years in the Paris Musée Rodin. Although of generally good quality, many Maillol casts are posthumous. The Lehmbruck family has recast in bronze some of the artist's early terra-cotta and cast stone sculptures on the grounds that he could not afford this casting during his lifetime and that metal was scarce during World War I. Some of Van Tongerloo's early works have recently appeared in new editions, and the original plaster form of *Construction In a Sphere* of 1917 was cut in marble in 1965, shortly before the artist's death. Max Weber's few small plasters had a limited audience for most of his lifetime, and his *Spiral Rhythm* was enlarged and cast in bronze before his death.

The most disturbing change occurred with Duchamp-Villon's great 1914 sculpture *The Horse*, in its original version roughly sixteen inches high. It was left in plaster and possibly unfinished at the artist's death during the war. Subsequently it was cast in bronze and twice enlarged by his brothers. The huge bronze we see today in several museums was enlarged without the artist's decisions about proportional changes or approval of the removal of all irregularities of surface. The result does not truly honor the artist, and the use of a motorized base, due to Marcel Duchamp, is a distortion of his brother's achievement. We must look at Walter Pach's 1924 book to see the photographs of the original sculpture.

Naum Gabo has himself remade in more permanent materials and enlarged some pre-1918 works, reminding us of the more monumental intentions of the young pioneers who lacked money and sponsors to realize the implications of their projects. Jacques Lipchitz cast and recast several of his early Cubist pieces before his death. But against the personal intervention of the sculptor himself, we have the case of Gaudier-Brzeska, many of whose stone pieces were posthumously cast into bronze, thereby violating the integrity of a style adapted to carving. Similarly unfortunate, if not unethical, are posthumous bronze versions of Gauguin's carvings, as well as those of Barlach, made for commercial purposes. The posthumous casting of Brancusi's work by his estate while legal raises questions about quality.

Archipenko was himself responsible for recasting, changing the finish, and enlarging and redating many of his own early works before his death. Often he had to reconstitute a lost work from either memory or a photograph. In a conversation we had in about 1964, he told me that during World War I, because of his absence from Paris, his studio was confiscated for the use of a shoemaker. After the war it was Léger, still in his army

uniform, who only by lifting the shoemaker off his feet, was able to obtain the information that Archipenko's sculptures had been stored across the street. The leaky shed had caused the destruction of most of his work.

It was Boccioni's fate to have several plasters destroyed. None of his works were bronze cast before his death. Only photography allows us to know what we have lost in terms of important sculpture from Boccioni and from Medardo Rosso (*Figures at Night on a Boulevard* and *Figures on an Omnibus*), as well as from Brancusi, Nadelman, Derain, Lehmbruck, and others. Understandably, but unfortunately for historians, most sculptors destroyed their early works, so that it is hard to show their possible connections with academic art or Salon sculpture at the turn of the century. The fragility of their materials, such as paper and wood, account for the loss of Braque's 1912 constructions, as well as the exciting construction of Balla and Fortunato Depero. Balla's fragile sculptures have recently been bronze cast and reconstituted. Lipchitz's wooden Cubist sculpture of rearrangeable parts, made around 1915, perished during his lifetime of painful uprootings. Certainly artists were to blame at times for the destruction of their works, as when Baranoff-Rossiné threw one of his 1913 sculptures in the Seine, but Epstein's Strand statues were mutilated by those who wanted them removed from the building they were designed for. It is not clear how nine of Alberto Magnelli's eleven sculptures were lost. The case of the Russian Constructivists is colored by politics, and how many works by Tatlin, Rodchenko, Bruni, Puni, Meduniezky, and others still exist in the basements of Russian museums is not yet known. (Some of Tatlin's reliefs have been reconstructed from old photographs.)

It has been the fate of early modern sculpture to receive the attention of relatively few serious writers like Herbert Read and George H. Hamilton. Some pretty bad books have almost succeeded in subtracting from what little knowledge we have. Early modern sculpture's history lacks the detailed chronicling of painting during the same period. Only in the last few years have an increasing number of serious monographs on individual sculptors brought scholarly attention to the pioneers of modern sculpture, whereas in painting even the farmers have been accorded one man exhibitions and dissertations. In textbooks that include painting, it is sculpture's fate to get shortest shrift, or a few signatures at the end because a publisher hopes to sell a few more copies. Often even museum curators begrudge space to sculpture and shove it up against a wall or into a corner or niche.

Some years ago the editor of a national art magazine given to announcing the latest "masterpiece" or historically "unprecedented" work by Anthony Caro, who is indeed a fine sculptor, asked me why the early Constructivists didn't produce masterpieces. I reassured him that they did but lacked the public relations services of his magazine. Perhaps if my editor friend could have seen the original, rough, even "hairy" look of early modern sculptures, adjusted his vision to their often surprisingly modest scale, and made comparisons with Salon art, he might have recognized what truly constitutes a sculptural revolution and that often masterpieces are not perfect.

Albert E. Elsen
Stanford, Cal. 1974

Contents

I

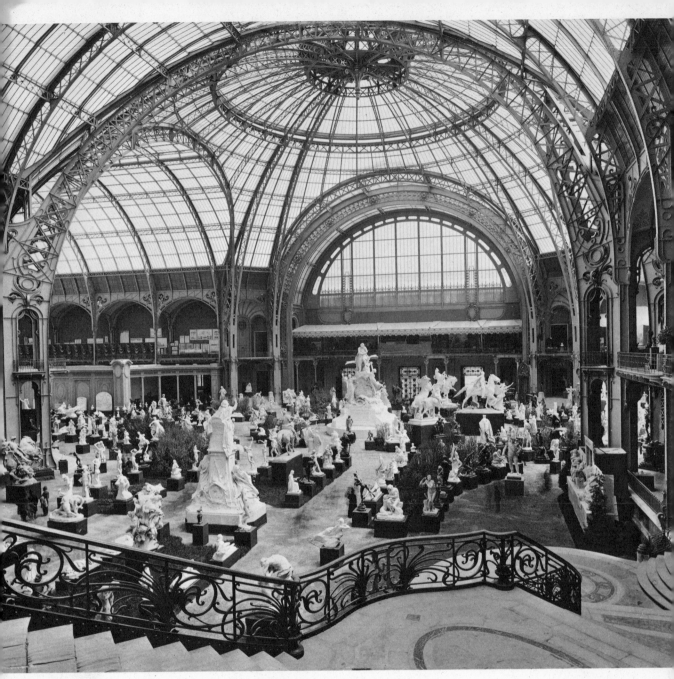

1. A turn of the century sculpture Salon in the new Grand Palais.

I

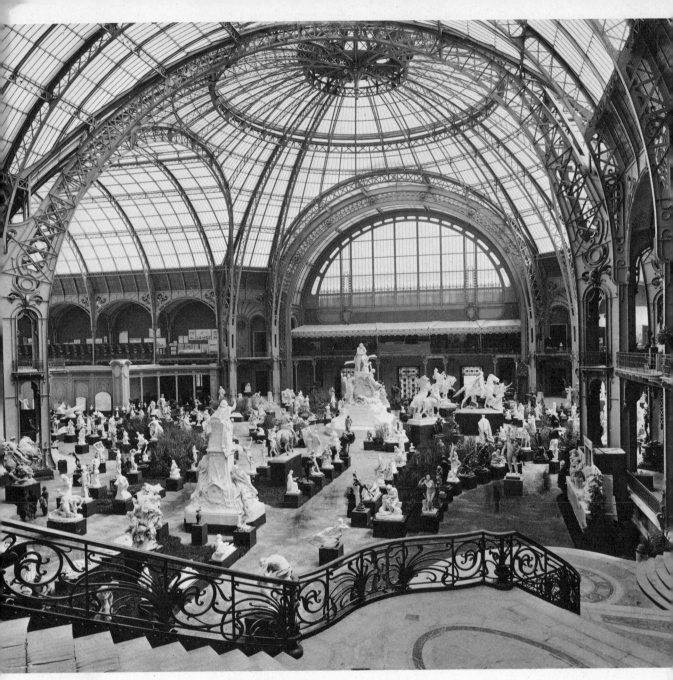

1. A turn of the century sculpture Salon in the new Grand Palais.

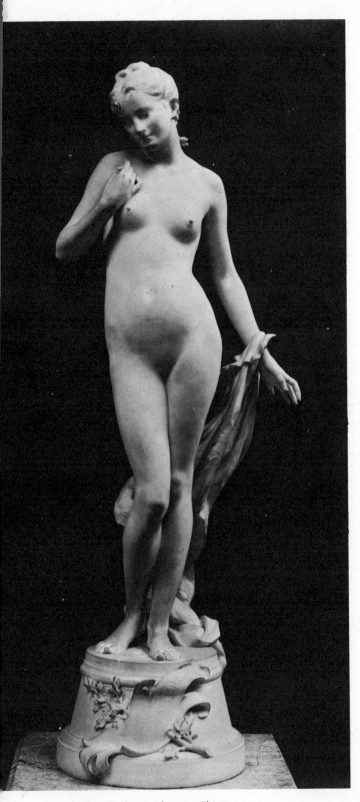

3. Charles Roufosse, *The First Shiver*.

monuments disproportionate in number and size to the merit of their subjects. Scarcely a public square was spared a monument in the statue-mania that (before and after 1900) was described as the *mal-de-siècle*. Every public and private garden was a potential Roman Forum or Parnassus. The number of fountain projects, if realized, would have endangered the Paris water supply. The success of the *École des Beaux-Arts* in turning out sculptors was partly its own undoing. Sculpture was running out of public space, and even before 1914 there were concerns voiced about where to put the enormous production annually disgorged from thousands of ateliers.[3] Contemporary architecture, traditionally the home of most public sculpture, was seen to have betrayed the sculptor by being either old-fashioned, (Louis XVI in style) and hence conspiring to glorify discredited political systems, or else sterile and uninspiring.

The battle cry that rallied the independents was *"Il faut être moderne,"* but every sculptor at the beginning of this century responded to the unvoiced imperative, *"Il faut vivre."* Salon sculptors so varied their styles and subjects to win public or private sponsorship that critics despaired over the loss of true personality. In the late nineties and after 1900, sculptors turned not only to portraiture but to small sculpture for private purchase. Apartment or cabinet or vitrine sculpture, as it was called, miniaturized portraits, mythological and historical subjects, nudes, genre and animal motifs did broaden the sculptor's market (Fig. 6). Small scale did not preclude bombast, superficiality, and preciousness. For many critics small polychromed and chryselephantine pieces of dazzling virtuosity closed the gap between serious sculpture and the

ranks of those dedicated to the pursuit of Platonic beauty in favor of what was considered genre subjects, did not diminish the Republican government's sponsorship of sculpture, because this art form was achieving a more broadly based public appeal at a time when France was experiencing a period of patriotic reunification.

In hindsight we see that only a few critics such as Guillaume Apollinaire and André Salmon were aware that the most serious challenges to traditional sculpture were not always visible in the official salons, but were being manifested in the new *Salon d'Automne* and *Salon des Indépendents*, in private galleries like those of Ambroise Vollard, Drouet, and Henri Kahnweiler, and in sculptors' studios, not just in France, but in Italy, England, Germany, and Russia. What is gained from reviewing Salon art today is an awareness of modern sculpture's continuity with as well as break from its past and an understanding that in some cases revolt was a matter of degrees rather than absolutes.

The crisis of sculpture before World War I

In the period from the 1890s to the First World War the body of French sculpture that was shown to the public in the great Salons seemed born of a distinguished lineage. It was robust and trained and disciplined to serve the nation and every person of taste. But this body was mortally afflicted by consumption, excesses born of successes, and incredibility. Sympathetic critics who saw sculpture as the last bastion of order and good taste after the fall of painting to "anarchy" give us an accurate diagnosis of the disease

for which early modern sculpture sought to provide a cure. Conscientious critics who tried to take in the more than one thousand sculptures of the annual salons were exposed to a mind-numbing confrontation with a "chimerical milieu, a carnival-like farandole," as Léonce Benedite described it, "a white plaster and marble world populated by operatic figures."[2] Perhaps reflecting a republican spirit, French Salon organizers ranked side by side Olympian divinities and Louis XIII musketeers, ballerinas and Venetian gondoliers, Cesar and Cléo de Mérode, farmers and miners, and such ironic personifications as "The Force of Hypocrisy Oppressing Truth." Inveterate Salon visitors could count upon an "eternal population of women," sleeping, waking, performing their toilette, bathing, reclining, being taken by surprise, experiencing their first romantic shiver, and grieving at the tomb, all in the service of the renewal of beauty and sexual education of the young (Fig. 3).

By 1907 historical subjects were declining in number, perhaps because too many patrons were dissatisfied with "incredible histories." We are told by commentators of the time that sculptors were aware of being superfluous, and that there was a growing public resentment of glorifying the *ancien régime*. The public was indifferent to being taught history by sculptors. The audience was more sophisticated, and the artists waged an unsuccessful competition with life. Allegory, by which serious subject matter was to be conveyed, had dissipated its force except in the area of funerary art where themes of friendship, mourning, and resurrection continued to receive somber approval. One could be anticlerical in politics but not in death (Figs. 4, 5). Sculpture suffered from

Sculpture as it was

As the twentieth century began, sculpture seemed secure in purpose, place, and practice. It had not experienced the many revolutions that successfully challenged traditional painting. The most famous sculptor in the world, Auguste Rodin, was dedicated to reforming but not destroying the system. His own one-man show of 1900 in Paris, held physically apart from the huge salon of almost ten thousand sculptures, was a source of pride to the nation and the critics, and respected by such fellow artists as Dalou, Barrias, Frémiet and Falguière, who themselves seemed to insure France's continued world leadership in sculpture.

In purpose, thousands of sculptors still followed the academic ideal of the distinterested pursuit and renewal of beauty as sculpture's highest calling. In practice, almost all sculptors were dedicated, by personal conviction and the exigencies of making a living, to the celebration of the nation's heroes, institutions, and middle class values. To educate, elevate, and delight—and in that order—were the purposes that guided the making and judgment of sculpture since the Middle Ages. Privately, sculptors and critics may have cherished the ideal of sculpture's freedom from service to others, and looked upon its destiny as the remaking of the human body by hand, but every *École des Beaux-Arts* sculptor had been trained and was expected to be able to personify abstract ideas— from saving one's country to saving one's money.[1] He knew he would be criticized as a dramatist or poet. Every carver and modeler had the mission of embodying in his work both nationalistic traits and "universal life." Good citizenship and the making of sculpture were not only compatible but desirable. Since the disaster of 1871, sculpture in France carried the burden of rousing flagging patriotism. Above all sculpture was a souvenir art, memorializing those who had nobly served art, country, science, and thought; candidly, if morbidly, men and women of distinction were shown as they died; and as further *memento Mori*, sculptors dramatized life around the tomb and life menaced by death (Fig. 1).

The rewards to the best sculptors

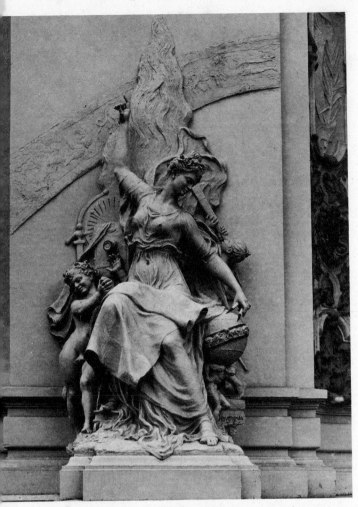

2. Charles-Jean-Cléophas Desvergnes, *Statue of the Arts and Photography*, made for the section on the Chemical Arts of the 1900 Paris Exposition.

thought to give the man on the street, preoccupied with petty affairs, the shock of great ideas, usually by showing the men and women who had thought of them. It not only provided models of ethical conduct, but good physical posture. To secure the proper continuation of these functions and of quality, a steadfastness of purpose and allegiance to government, there were (all over Europe) federally sponsored art schools. They inculcated the time-tested maxims that answered basic questions about the purpose and appearance of sculpture. Students could thus concentrate upon developing skills and on individuality rather than originality with the aim of escalating through a prize-oriented system.

Within the annual government sponsored salons at the *Grand Palais* in Paris, where hundreds of sculptors, foreign as well as French could exhibit their work, one could see and sense after 1900 that there were ideological differences between those that admired the past, with its ideals of truth and beauty vested in the nude human form, and those with "modern" aspirations who appealed to the patriotism and sentimentality of the masses (Fig. 2). To the critics in conservative publications, if there was a crisis in ideology it was not necessarily a disaster or threat, for both sides, in their own way, were interpreting the soul of France (or Germany or England) and its rapport with universal humanity. The basic premise of sculpture's purpose remained intact. Sculpture was viewed by writers and sculptors as a strict, narrowly defined art, less flexible and susceptible to change than painting, which seemed in total disarray with respect to goals and styles. The defection of *Prix de Rome* sculptors such as Henri Bouchard, trained in the *Villa Medici* in Rome, from the

(best in terms of ability or political connections), were visible all over Europe in the form of statuary in public squares and cemeteries, on and within institutional buildings such as schools and museums of art and of natural history. Sculpture was a status symbol in aristocratic and middle class homes and gardens. Viewed as a branch of philosophy, sculpture's place was in a nation's educational system as well as its most honored physical settings. Public sculpture, for example, was

4. Leonetto Cappiello, *Yvette Guilbert*, 1899.

lesser, purely decorative *objet d'art* identified with commercially oriented craftsmen. Vitrine art confirmed for some critics and most of modern sculpture's pioneers a pernicious disease of sculpture. Many critics saw the Salons as providing "rainfalls of talent," and "execrable facility of the fingers," in all a surfeit of adroit "workers."[4] What was needed were true "statue makers," greatness coupled with enthusiasm, art capable of imparting the "great shiver." Missing were monuments in which the masses could recognize their hopes and terrors. Sculpture suffered from observance of the letter and not the spirit of life. Its vigorous gestures imitated the rhetoric of the theater and not existence. So many honorable works,

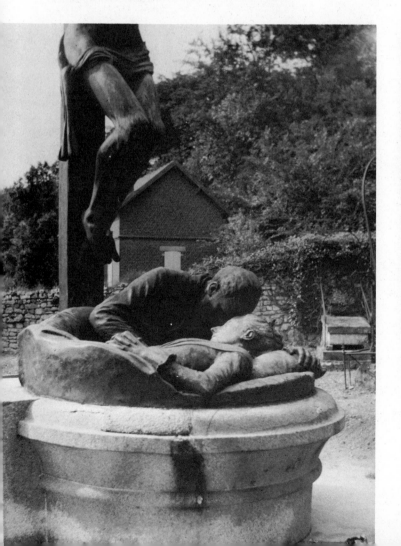

5. Albert Bartholomé, *Tomb of Mme. Bartholomé*, Bouillaut (Oise).

6. Emmanuel Frémiet, *"I'm Forever Blowing Bubbles,"* 1899, Tiffany glass light fixture.

"coldly conceived," produced sculptural consumption. Where was the evidence of sincere, "strong and healthy emotions?" Rodin remained a "*phare*," or beacon until his death, but those championed as his successors, Bourdelle, Schnegg, Landowski, Despiau, were not the ones to bring new light to sculpture.

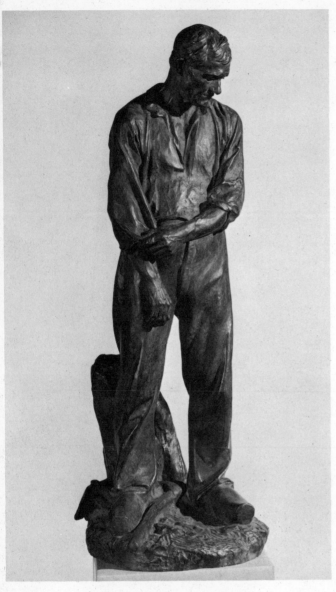

7. Constantin Meunier, *The Reaper*.

8. Léon J. Deschamps, *Harvest Time*, n.d.

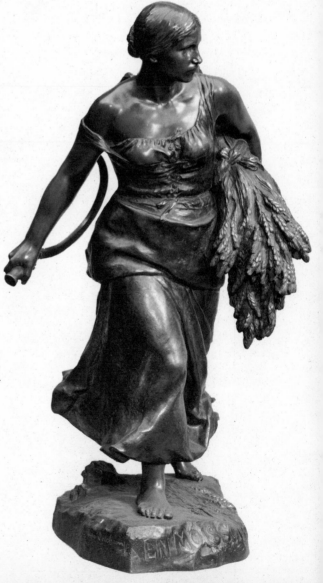

The subject of modernity

In the Salons before 1914, the subject matter that caught popular and critical attention as being truly "contemporary sculpture," came to be called, "*La Vie Moderne.*" This meant the glorification of all forms of labor, *le plèbe et la glèbe*, which was inspired by the sympathetic treatment of workers and peasants in the art of Constantin Meunier and Jules Dalou, art in turn indebted to Jean-François Millet (Figs. 7, 8). Academically this subject matter was classifiable as genre. It pleased the French public's vague notions of social or popular idealism and treated in strenuous and often sentimental fashion the hardships and virtues of the poor: tragedy among mine workers, the joys of the rural family, tender love and social misery, revenge and revolt. The *École* taught that men should be made into gods. Many sculptors were content to dramatize, not apotheosize, "*les classes populaires.*" Contemporary costume had begun to appear in the Salons in the late 1870s and 1880s. Before 1914, some critics realized that the nude and classical drapery no longer held the allegiance of the most talented sculptors (Fig. 9). Conditioned by Salon art, the public mind perceived modernity as the absence of allegory, the actual rather than the dream, the triumphs of tailors and modistes over the gymnasium and nature. The academic theoretician, Charles Blanc, reckoned that the use of rifles instead of spears caused the decline of physical fitness.[5] Men in trousers were definitely more democratic. The ideal was losing ground to reality and the "melancholies" of life. That Roger-Bloche did not win a medal for his Salon entry titled *Cold*, because the poor, shivering man had his hands in his pockets, did not

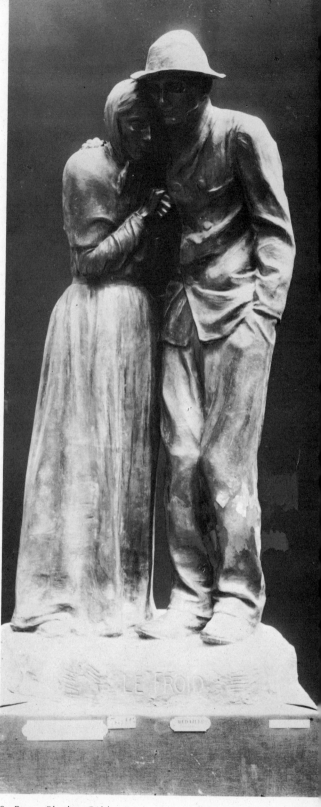

9. Roger Bloche, *Cold.*

9

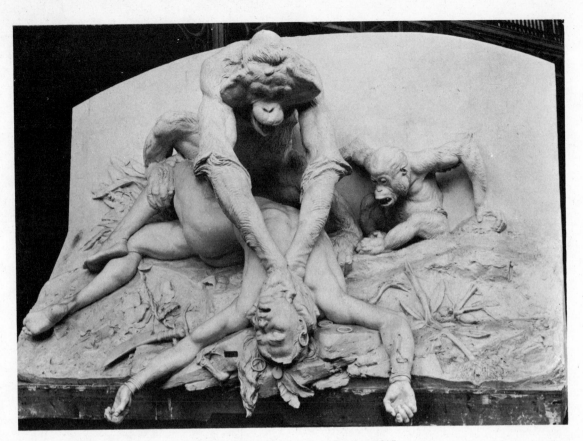

10. Emmanuel Frémiet, *Orang-outang Strangling a Savage from Borneo*, 1895.

deter his colleagues from portraying royal clients in yachting attire, surgeons in aprons, and muses in the latest *haute couture*. This was true of Paris, but in 1917, Elie Nadelman had to defend his clothed figures against the ridicule of a New York audience that vested seriousness and propriety in the nude.

Several years before 1914 there was a marked decline of Salon projects for monumental sculptures, historical subjects, and literary themes. Thematically, Parnassus had been replaced by Paris. There was a perceptible restraint of movement and gesture. A tranquilizing, sentimental mood was settling over the Salons before the war, despite France's eagerness to square accounts with the Boche. In the nineties the public took vicarious pleasure in the aggressive projects of Barrias and Frémiet for the new Paris Museum of Natural History that showed natives fighting for their lives against crocodiles and an orangutan savaging a hunter and abducting a girl (Fig. 10). Before 1914 the taste was for Bigonet's children taking their first steps to their mother or the quiet grief of a nude collapsed on a tomb as conceived by Bartholomé. Monuments to the heroism of the Franco-Prussian war were supplanted by *gisant* sculptures of fallen aviators and balloonists who had run out of gas (Fig. 11). *Animaliers* who were licensed by academic dogma to depict violence (the bestial side of existence), were noticeably domesticating their wild life. Bugatti's panthers

10

are tame compared to the deadly panthers Gardet had earlier shown in mortal combat.

With a few important exceptions, the themes of those we look upon as the pioneers of modern sculpture paralleled and were influenced by those of the Salons. What happened in sculpture was comparable to what had happened in painting after 1880, when the Neo-Impressionists reworked Impressionist themes imparting new meaning by means of new styles. A superficial understanding of style makes this sound as if the change was merely cosmetic. Brancusi, however, gave a freshness and profundity to such Salon-worn motifs as a mourning woman, infants crying, women's portraits, birds and lovers that depended upon a new and deeply personal vision of art and life. His sculptures of birds evolve from evocations of a mythological subject to the essence of flight and a private sexual metaphor. Gaudier's *Stags*

11. Henri L. Bouchard, Monument to the *Aeronaut Victims of the Dirigible "Republique,"* 1911.

(Fig. 12) with their crystalline structure would not have satisfied a contemporary director of a museum of natural history.

To the question of why this thematic conservatism, it seems appropriate to say, why not? What was left to show

12. Henri Gaudier-Brzeska, *Stags*, 1914.

of life that had not been treated by the encyclopedic sweep of Salon artists and Rodin, and which still conformed to ideals of decorum or proper conduct of the subjects? For the most part the moderns championed a new artistic ethic, not a revolution in social morality. If there is an underlying imperative to the choice of subjects at the beginning of modern sculpture, it is one shared with if not inherited from advanced painting from the time of the Realists and Impressionists; one must work from personal experience of life and art. To most sculptors this precluded working from the word, hence history, literary illustration, religious subjects, mythologies, and extravagant allegory. But old habits, the force of tradition brought home annually by the Salons did influence Maillol, Brancusi, Epstein, and Nadelman to name, if not conceive, their works with reference to such titles as "Night," "Sleeping Muse," and "Venus." Maillol's titles remind us that his art comes out of late nineteenth century symbolism. Not only in titles but also in form did the work of these and the other pioneering sculptors become more literal. Consider such nominations as "Woman Combing Her Hair," "Reclining Nude," "Walking Man," "Rising Youth," "Fallen Man," "Red Stone Dancer," "Rock-Drill," "Sailor with Guitar," etc. Except for some by Barlach and Boccioni, and a few works by Archipenko and Duchamp-Villon, strenuous action was avoided. Drama and psychological interchange between two figures, or the subject and the viewer, were largely absent. One did not illustrate the feelings of others. Formal, not thematic, violence was in favor. A new concept of expression and the expressive had entered sculpture; it shifted focus from the actions and feelings of the subject to those of the sculptor.

Rodin's dramatic art, his "histrionics" and "melodrama," are usually cited as what young sculptors rejected. Historically, it is more probable that the most venturesome young sculptors reacted against the surfeit of false and extravagant emotion in the Salons. The lack of sincerity or conviction about the subject was undoubtedly a potent force in stilling their figures and turning them inward or in treating their subjects as material rather than conscious bodies. Maillol was the first to bring a new psychological and emotional calm to sculpture. The women in Degas's sculpture were depersonalized by professional training and hygienic ritual and conducted themselves without feeling. Nadelman's beautiful sculptures are of types, either two-dimensional as people or ultra-sophisticated in disguising emotion. Archipenko's graceful performers are mindless. Matisse's women have character but display no passion. The feminine figures in the Cubism of Lipchitz and Laurens have been crystalized into fragments of gestures and postures, left with dignity if not identity. Duchamp-Villon's lovers display passionless movement. After 1900, Rodin himself did not exhibit a new life-size figure intact, but sometimes deprived his women of heads and arms, or legs, and their movement is restricted to the breath of life. Brancusi's women were absorbed in revery, daughters of Rodin's passive, tactful "soul portraits" that Victorian society so admired. It was as if these artists were saying that sculpture had suffered from too much psychology, and passion was passé. To engage in a display of feeling, as Rodin's figures had done before 1900, was to risk criticism of being too "literary," meaning illustrating the experience of others. Not competitive for public commissions with their work destined for studio or apartment,

12

sculptors such as Matisse, Maillol, and Brancusi may have felt the need for work that induced quiet and prolonged contemplation. An apartment was not the setting for the shock of great historical or scientific ideas. Matisse and Duchamp-Villon felt their art of small scale was for intimate pleasure and communion, relief from the strains and esthetic of the world of business.

The nude

One of the many ironies of the history of modern art is that it was the pioneers of modern sculpture who prolonged and revitalized the tradition of the nude when it was declining in favor. In the Salons the nude was suffering not only from being considered old fashioned by comparison with more socially relevant clothed miners and dandies, but it had fallen victim to overkill by skill. In the hands of a Gérôme, a Boucher, or a Marqueste, centuries of developing the culture and refinement of the nude had ended in clichés or demonstrations of mastery rather than discovery. Joseph Bernard, however, stands out among the persistent and admired Salon artists for his solidly fashioned, unpretentious women. The lucidity of their construction and proportion was achieved with no attempt at finesse (Figs. 13, 14).

It was Rodin, despite the reactions he inspired among the avant garde who did much to convince the best young sculptors of the still unexplored possibilities of the nude. By working from life in movement, he had broadened and naturalized the stylized repertoire of the nude. He had canceled the old credentials of period styles by insisting upon an unselfconscious style or no style at all. This paved the way

13. Jules-Aimé Dalou, *Nude Woman*, 1899.

14. Jean Léon Gérôme, *Corinthe*. Exhibited in the Salon de Mai, 1904.

15. Auguste Rodin, *Prayer*. Exhibited in the 1910 Salon, Musée Rodin, Paris.

16. Aristide Maillol, *Mediterranée*, 1905.

for artists to find their own styles and subjects. After 1900, notably in his partial figures, Rodin's nudes represent only themselves, the human, just being. What joined Rodin, the conservatives and progressives was a faith in the old academic idea that the nude was perenially modern (Fig. 15).

As Kenneth Clark aptly wrote about the early twentieth century, "When art was once more concerned with concepts rather than sensations, the nude was the first concept that came to mind."[6] This is especially true of Maillol, who contrasted his way of work and that of Rodin by insisting that for him the idea of the whole had to come first and then the modeling (Fig. 16). "I search for beauty and not character," was the way he distinguished portraiture and statuary, and this explains his opposition to Rodin's analytic approach.[7] His own "synthetic" method involved forgetting the model, reducing the figure to a few profiles, and simplifying the surfaces. In the

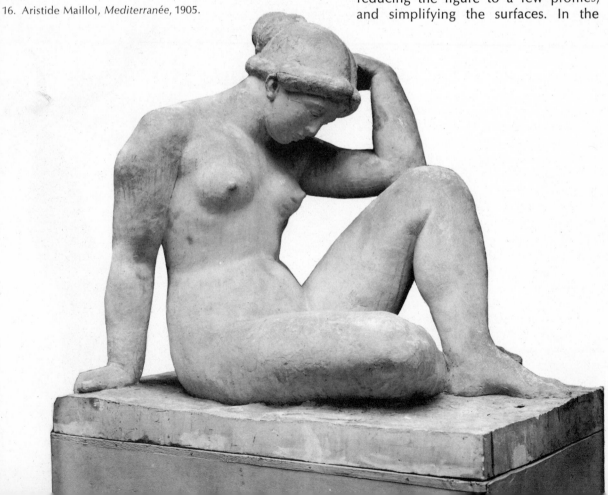

process Maillol stripped the nude of almost all physical movement, of coquetery, guile, anxiety, or grief. The svelte was exchanged for the ripe. In the Salons Maillol's women stood out by their solid bodies and stolid nature. Attempts to compare them with aristocratic Greek goddesses faltered because of Maillol's fidelity to his Banyuls peasant type. *"Il faut être moderne"* was his credo, and he shaped an art for this century and for France. Similarly Renoir sought in the nude a sense of its belonging to the France of his day, but his challenge to younger contemporaries was, "I love the old." Freed of academic canonical training, he had discovered Greek statuary in the Louvre on his own. As he had earlier in painting, in sculpture he revivified old postures, such as those of Venus, while working from his own norms of fulsome, quiescent beauty (Fig. 17).

Comparable sentiments were held by the German sculptor, Wilhelm Lehmbruck, whose nudes before 1912 show strong affinities with those of Maillol. After Rodin, it is only Lehmbruck who continues the nude as a carrier of pathos. Believing that a truly contemporary art could not grow out of a revival of old styles, he eschewed ancient formulas for showing tragic figures. In his *Seated Youth* and *Fallen Youth*, man is shown defeated not by gods or physical pain, but through the breakdown of the spirit that is mirrored in the entire body (Fig. 18). Their anonymity makes them symbols of a generation dying in places like the bloody maw of Verdun. Before the war Lehmbruck shared with French sculptors a concern with the dilemma of how to continue the nude while liberating it from academic systems for posing and proportioning the model. Like so many of his French colleagues,

memories of the antique with its faith in a perfectable humanity helped shape quiet fulsome figures who disposed their weight in the classical hipshot stance. By 1912 Lehmbruck's individuality emerged in measure and silhouettes that preserved idosyncratic body detail and less athletic stances.

In contrast, Matisse never wavered in his loyalties to *académies*, standard studio posturings.[8] Unlike Rodin, he did not believe that the sculptor could discover "new truths" through de-

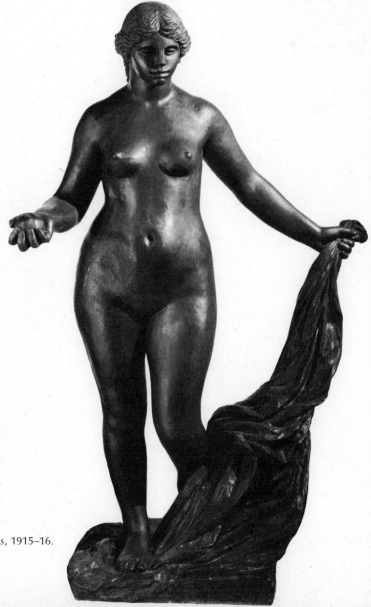

17. Pierre-Auguste Renoir, *Venus Victorious*, 1915–16.

piction of sculpturally unprecedented movement. The truth to which he dedicated his nudes, frankly undisguised models, was qualitative rather than quantitative, unreferrable to a canon. Surface and proportional veracity were weighable against esthetic intuition and his feeling distilled from long contemplation of the subject. Rodin was faithful to perceived sensations, whereas Matisse responded more to internalized sensations. The achievement of this truth was more important than Platonic beauty. Matisse made the nude opaque in the sense that one could not see through it to some philosophic proposition.

Artistic truths sought by both Degas and Matisse could be found in the arabesque in depth, the silhouettes of the figure turned in space (Fig. 19). For Degas they were inspired by certain types of movement, those of a trained ballet dancer or the habitual gestures made by the model in the daily care of her body, none of which symbolized the dominance of intellect, but rather disciplined or reflexive movement. Matisse insisted upon the stationary pose, as he and Maillol and other advanced sculptors rejected the idea of stationary sculpture portraying strenuous, transitory movement (Fig. 20). But he also insisted upon vigorous

18. Wilhelm Lehmbruck, *Fallen Youth*, 1915–16.

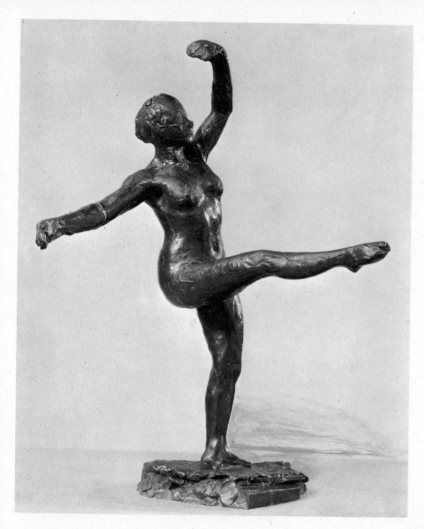

19. Edgar Degas,
 Developpé en avant, 1909.

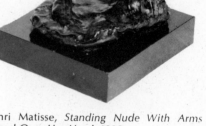

twisting of the body in space, such as Michelangelo had introduced to Western sculpture, without the latter's meaning of spiritual distress. Sculptural, not psychological, drama satisfied Matisse and Degas.

Memories of the antique were closest to the surface and poses of Elie Nadelman's nudes (Fig. 21). It was not the Greek love of living human beauty that he celebrated, but the beauty that he believed could come from thinking in more sculptural terms.[9] As the models who lived with him could have testified, Nadelman did work from life, but ultimately his sculptures were modeled from art and his mind, and if they referred to anything, it was ge-

20. Henri Matisse, *Standing Nude With Arms Raised Over Her Head*, 1906.

ometry. His sculptures were tributes to the perfectability of sculpture, not humanity. In this, Nadelman was continuing a tradition from the Renaissance of making the feminine form in sculpture an object of contemplation.

Except for those of Degas and Rodin, the nude in early modern sculpture had a decided look of a para-

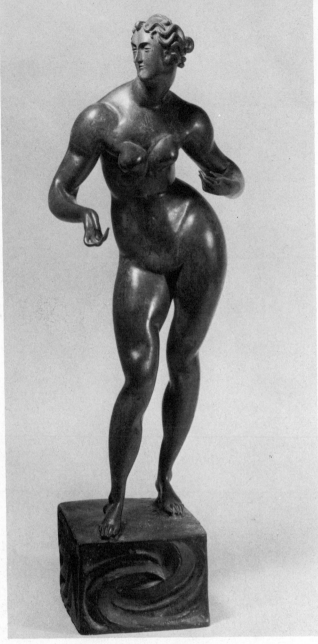

21. Elie Nadelman, *Standing Female Nude*, c. 1905–09.

phrase of older art. After its beginning in Gauguin's sculpture with its mixed ancestry in oriental, Indian, and Polynesian sources and in the exposure of artists to African tribal art after 1905, the paraphrase was broadened, and there was a further adulteration of the Greek-based heritage of Western art. Directly and indirectly, tribal art had liberating influences for early modern sculptors who were concerned with alternatives to illusionism in art and positivism in thought (Fig. 22).[10] The art of African and other "barbaric" people, as Gauguin and Gaudier-Brzeska referred to pre-Greek classical cultures, seemed appropriate models for restoring a sense of the mysterious and awesome in life, the primordial nature of man and matter, the irrational force that had made sculpture potent. In the art of Gauguin and Epstein this led to the making of surrogate idols, modernized Buddhas and Egyptian-like solar deities that were never to know the prayers of a supporting cult (Fig. 23). Epstein's fanciful glosses on the history of religion, footnoted in West African Fang fig-

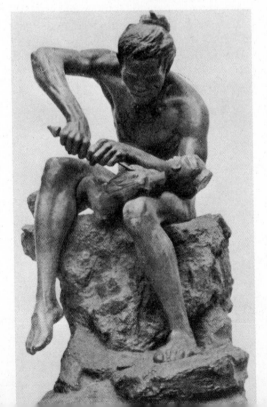

22. Herbert Ward, *The Sculpture of Idols*, before 1911–12.

ures, included asking himself what Venus would look like in an Africanizing style. More fruitful for these and other artists such as Derain, Picasso, Brancusi, and Gaudier was the experience of a collectively based art, an impersonal style, with no pretensions about individuality and virtuosity, which presented the human figure visually balanced by proportions wildly alien to the canons of Vitruvius, free from operatic gesture and ballet movement, innocent of imitation of flesh and physiognomic psychology: in short, figures that did not do anything significant with their bodies but which confronted the beholder as powerful human presences. Egyptian and tribal art helped modern sculptors bring a halt to man in motion. It was for exactly this reason that Boccioni criticized the emulation of tribal art. While he acknowledged that the wood carvings of African Negroes "have helped to free us from classicism, they are still harmful to the development of a completely modern plastic outlook." Boccioni saw these carvings as representing still another "obsession with the past, a cultural phenomenon related to the influence of the classical world." Mindful of the appeal of primitivism to the Fauves and his rivals the Cubists, but eschewing its regressive implications, Boccioni paradoxically called himself and the other Futurists "primitives" of a new sensibility because they were "untainted" by the "archaism" of tribal art. Boccioni claimed that they sought inspiration from "a barbaric element in modern life." This element could not be manifested in static, idol-like figures, only those whose "lines and outlines . . . exist as forces bursting forth from the dynamic actions of the bodies."[11]

To these artists who felt that sculpture should be made anew, tribal art

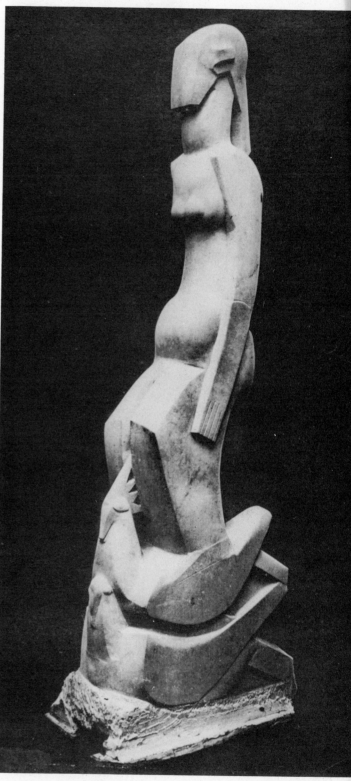

23. Jacob Epstein, *Venus With Doves.*

19

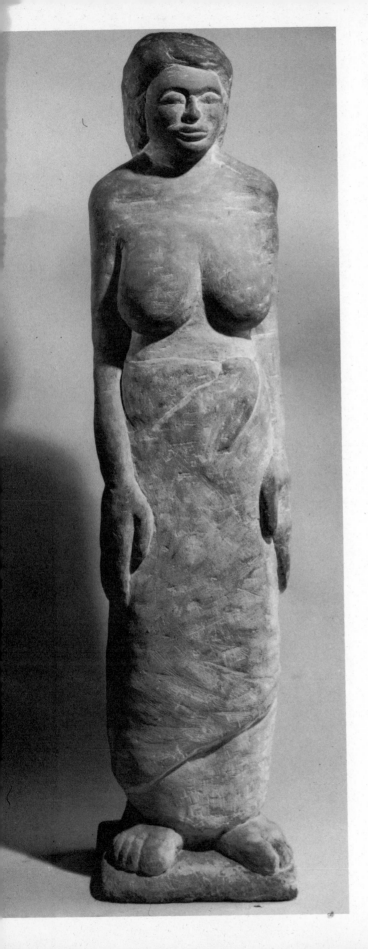

seemed a lesson in the fundamentals to which the human form could be reduced in order to keep its identity while being liberated from centuries of overrefinement. To artists already committed to reductivism or incipient abstraction, the example of African purification of heads to pointed ovals, necks and torsos reduced to cylinders, and motion reduced to a bent leg posture, was compelling. In modern sculpture, such as that of Epstein, Gaudier-Brzeska, Brancusi, Picasso, and Modigliani, parts of the body such as eyes, necks, breasts, and buttocks received a new visual emphasis. Seen in Gauguin's gray limestone *Woman*, made in the 1890s and first owned by the Paris art dealer Ambroise Vollard, symmetry was a genuine alternative in Western sculpture for the first time since the Middle Ages (Fig. 24). The results of primitivizing were sometimes a curious grafting of such diverse traditions as hieratic frontality and the Greek hipshot pose, as in Derain's 1906 *Standing Nude* (Fig. 25). Gaudier-Brzeska's *Red Stone Dancer* displays "barbaric" sources in its large head, squat figure and bent-legged posture, but also an un-African torsion of the body and Greek-derived gesture of a raised arm framing the head (Fig. 26). As early as 1910, in a letter to his friend, Dr. Uhlemayr, Gaudier-Brzeska admired the "ampler and bigger" form of tribal as opposed to Western art, but he also felt that modern men could not be truthfully shown as acting in "one movement as with the primitives," but rather in a "composed" movement whereby "different parts of the body move in opposed directions."[12] The sculptor also observed that the conventional form of the primitives resulted in expression limited to "serene joy or exaggerated sorrow," and he confessed boredom

24. Paul Gauguin, *Figure of a Standing Woman*, 1890s.

25. André Derain, *Standing Nude*, 1906.

in seeing tribal art in large quantities, by contrast with Western sculpture in similar numbers. Gauguin's cylinder-like carved wooden figures, one of which, *Père Paillard*, is an unprimitive caricatural portrait of a priest, reflect his desire to emulate the "naiveté" of native proportioning and simple means of treating simple forms. Thematically he sought to restore innocence of sin to the nude and uncomplicate its form, corrupted, he thought, by classical Greek art. The result was an unsteady synthesis, a mixed marriage of European knowledge and taste with primitive form and materials. It is possible that Gauguin's example may have encouraged Picasso's few attempts at Africanizing the nude, which he gave up either because of impatience with carving or satisfaction with having extracted what he needed for his art. Picasso was untouched by the craft of native carvers but moved by what he thought was their infusion of feeling in the figure that resulted in a magical object mediating between man and the terrors of his environment (Fig. 27).[13] Brancusi, conversely, distrusted the "demonic" as a model, but ranked Negro craftsmen with Rumanians in the carving of wood. While Brancusi's figures, such as the *Little French Girl* (Fig. 28), may not be referrable to specific African styles, his contact with tribal art came at a crucial time when he was breaking with the imitation of nature.[14]

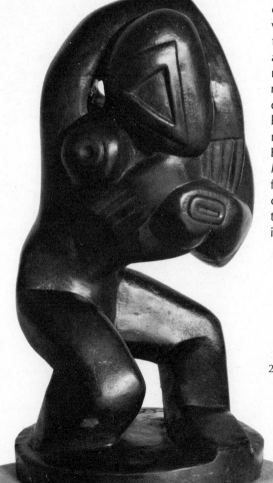

26. Henri Gaudier-Brzeska, *Red Stone Dancer*, 1913.

A new sexual candor

African art encouraged but did not in-
itiate or dominate Epstein's self-libera-
tion from some of the inhibitions of
Western sculpture and social conven-
tions of propriety in art. In his epic
Strand series of 1907–08, in which he
symbolized the history of man, Epstein
had the audacity to show a naked
pregnant woman who was not Eve,
and in a naturalistic style.[15] His subse-
quent primitivizing maternity images
accentuated self-conscious sexuality
and pregnancy. The un-African erotic
Rock Drill may be seen as a kind of
modern Priapus image. Unlike the birds
treated by Salon *animaliers*, the beau-
tifully carved *Doves* are copulating
(Fig. 29.)

Salon sculpture had centuries of
tried and true devices for treating the
erotic with discretion so as to raise
eyebrows but not protests. The aca-
demically approved means for ex-
pressing purely sensual instincts was
through the use of inferior beings such
as satyrs, fauns, sirens, and centaurs.
With these subjects it was thought ex-
pression could replace beauty. Rodin
partially observed this maxim and
some of his most sensual scenes are
played by mythological figures, but
in the *Gates of Hell* and many of
its offspring, he gave unprecedented
focus to human passion and was tire-
lessly inventive in the unexpected cou-
plings of his lovers without showing
actual intercourse (Fig. 30). His marble
Kiss and *Eternal Springtime* still seem
to be purified idealistic statements
about love unless one knows that the
"slung leg" posture of the woman in
the former has signified intercourse
from antiquity to "Felix the Cat," and
the woman holding her own foot in
the latter relates to the French slang
for orgasm.[16] In the early small ver-

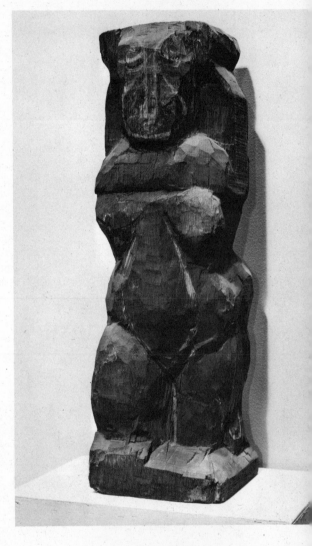

27. Pablo Picasso, *Figure*, 1907.

28. Constantin Brancusi, *Figure (Little French Girl)*, 1918 (?).

29. Jacob Epstein, *Doves*, 1914–15.

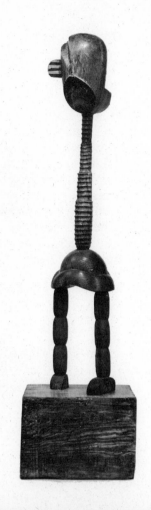

sion of Maillol's *Night*, the woman's sex organ is shown as open, which, as much as the pose, evokes the title.[17] Both Maillol and Derain made small sculptures of intercourse between human beings (Fig. 31). There is no coy indirectness, no abeyance of the sexual act in a version of the *Kiss* Brancusi thought it appropriate to offer in 1910 as a cenotaph for a young Russian girl buried in the Montparnasse Cemetery (Fig. 32). Epstein fared less well when a plaque was put over the genitals of his symbolic figure of the Oscar Wilde memorial in *Peré Lachaise* cemetery. Brancusi was showing how traditional themes took new life from new forms that had resulted from his personal poetic vision of a new wholeness for sculpture. Primordial form was appropriate for a primal act. Henri Bergson may have been for Brancusi what Baudelaire was to Rodin. Brancusi's art was responsive to the climate in Paris, influenced by Bergson, that saw life as lived in the irrational, expressed in vital urges, and which affirmed intuition as a reliable

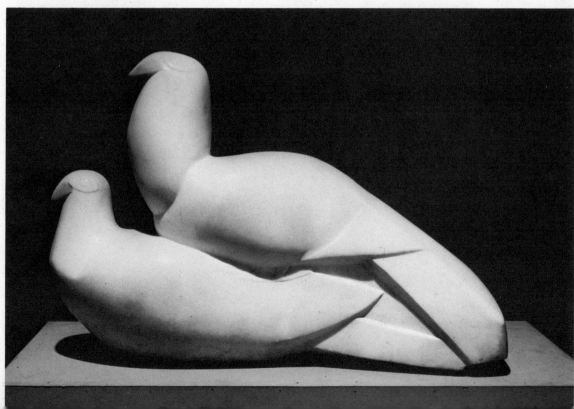

path to truth. His sincerity and simplicity of nature gave integrity and conviction to his erotic *Birds in Space*, *Torso of a Young Man* and *Princess X*. Eroticism was not self-conscious, not a substyle intended for a certain private clientele, but the sincere and direct manifestation of the artist. Early modern sculptors passed on to generations after the first war a new candor and sophistication in treating human sexual life.

La vie moderne

Interest in a new frankness about the model and a desire for greater universality drew most early modern sculptors to the nude, but a few concerned themselves with contemporary clothed figures. As early as 1882, in his *Kiss Under a Lamp Post* and *Unemployed*

Street Singer, Medardo Rosso modeled remembered images from the streets of Brera and later Paris. Even as an academic art student for eleven months, Rosso showed a distaste for working from nude models and was expelled from school for assaulting another student who petitioned for nude feminine models.[18] These early sculptures reflect his authentic acquaintance with poverty, but were not maudlin. Rosso never sought pathos. His motifs were of city people, on an omnibus, reading a newspaper or racing form, sitting in an English garden, or walking on a Paris boulevard at night, always shown from a discrete distance that permits the remembrance of their individuality but does not encourage involvement (Fig. 34). Unlike Salon sculptures, which might show a street accident, a worker fallen from a roof and consoled by his neighbors, Rosso's work is anticlimatic, barely episodic, moments detached from a continuum of customary conduct. Rosso's goal was a unity of his forms with their enveloping world.

By contrast, Ernst Barlach's subjects are backward people in a second-class rural environment near the Baltic, one

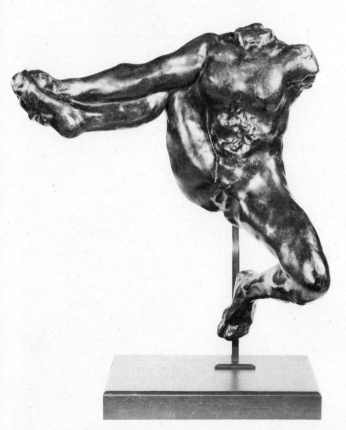

30. Auguste Rodin, *Iris, Messenger of the Gods*, 1891–92.

31. Aristide Maillol, *Night*, 1902.

that the artist felt put man closer to the capricious moods of God (Fig. 33). In form and subject, this self-styled "Low German" sculptor cherished his own type of primitivism that involved places and people he knew, and which encouraged his life-long epic of the spirit's travail. In the costumes of Baltic peasants and townspeople, Barlach discovered the evidence through "masked movement" of true feeling.[19] Folk types provided him with "problematic characters," the grotesque in form and conduct, demoniacal reactions, uninhibited ecstasy, all in genuine rude gestures that mimed human insecurity, perversity, and endurance. These were people who satisfied Barlach's need to feel pity and to give the world an art of consolation.

As Barlach committed his life to people who show what they feel, Nadelman chose subjects who perfectly masked emotion. Barlach's rough-cut

33. Ernst Barlach, *Russian Beggarwoman*, 1907.

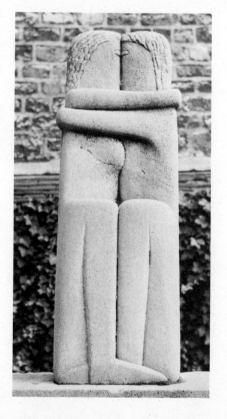

32. Constantin Brancusi, *The Kiss*, 1910.

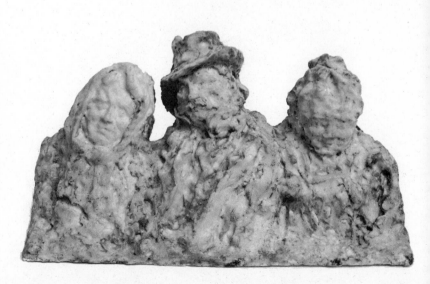

34. Medardo Rosso, *Impression of an Omnibus*.

peasants and Nadelman's polished sophisticates polarize the social spectrum. The Polish-born sculptor found the modern equivalent of Praxitelean grace in the urbane gestures of tango dancers, a feminine pianist, and a high society host and hostess. Barlach's people are not performers, but rather victims of a quixotic deity who causes them to balance on the edge of sanity. Nadelman's *Acrobat*, which was an actual portrait of a well-to-do young man who loved gymnastics, defies gravity for a sports-addicted society.[20] In Lehmbruck's youthful tribute to miners, Minne's intensely descriptive workers after 1910, Barlach's commiseration with the peasant and pariah of society, and Manolo's figurines of stolid Spanish peasants, modern sculpture had its early champions of the popular classes. In the painted wooden figures of Archipenko, *Caroussel*, *Medrano*, and the early Cubist sculptures of Lipchitz and Laurens, there is a continuation of the modern painters' fascination and often identification with the performer. Rodin had made many small sculptures after Can-Can dancers, admiring their vitality and audacious movements unspoiled by habitual studio posturing. Degas had similarly sought out dancers from the Paris Opera who could give him movement not limned by sculptors. In men younger than Rodin and Degas, such as Picasso and Lipchitz, there was still an enthusiasm for the circus of Paris and Seurat's paintings of this subject. Committed to avoiding strenuous motion, Lipchitz opted for stationary musical clowns, *Pierrot, Harlequin With an Accordion*, or passive guitar-strumming sailors, and a posturing *Toreador*, a souvenir of his trip to Spain with the sculptor Manolo (Fig. 35). Archipenko's now lost *Medrano I*, also titled *The Juggler*, and Laurens' *Clown* of 1915 suggest by their daring manipulation of multiple forms in space affinities between the two types of artist (Fig. 36). It is tempting to analogize the precarious life and the performances before an often apathetic public, performances that involve incessant defying of physical and artistic law, but the analogy is one more appropriate to Picasso as a painter inasmuch as the motif is neither frequent nor sustained in modern sculpture.

Alternatives to the monument: some exemplary figures in modern sculpture

Until Rodin, great sculptors throughout history provided images by which their sponsors obtained a sense of identity. Statues and reliefs were eternal reminders of those who had founded and defended the religion, laws, and culture of a society. The

35. Jacques Lipchitz, *Sailor With Guitar*, 1914.

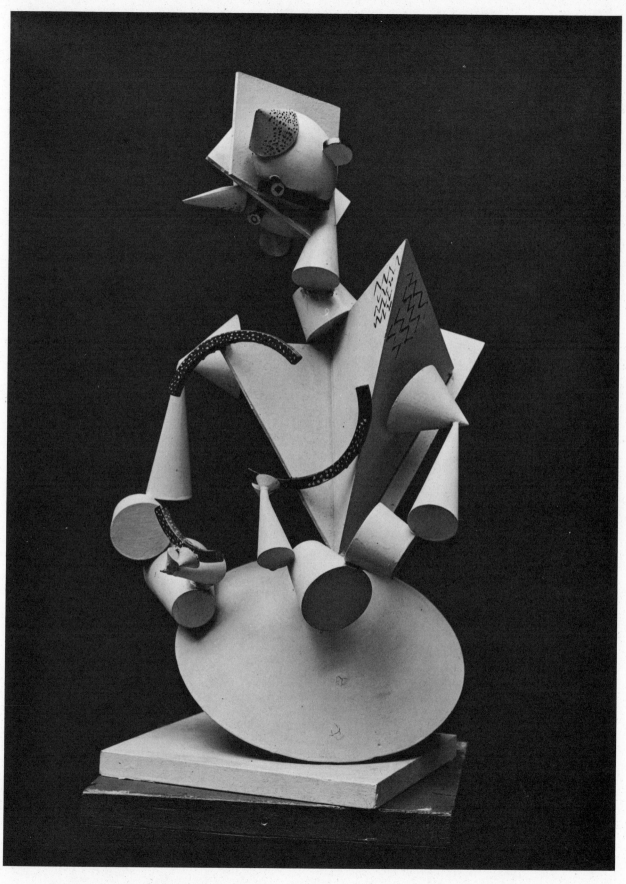

36. Henri Laurens, *The Clown*, 1914 (?).

sculptor's culture came from the city, court, or cult that commissioned the work. Polyclitus was influenced by Athens, Gislebertus by the Cluniac order, Claus Sluter by the Duke of Burgundy, Donatello by Florence, Michelangelo by the Medici Humanist court, and Bernini by Rome and the papacy. In the United States, Bartholdi's *Statue of Liberty* and Gutzon Borglum's *Shrine of Democracy* continue that tradition, and these works have had an enormous sentimental and patriotic appeal to the nation, even if, paradoxically, the public can't recall the artists' names. What has been broken in this century is that part of the tradition in which *great* sculptors played a role. Ironically, the change focuses on Rodin, who neither by intention, training, nor opportunity sought this distinction. It is with Rodin that we encounter in modern sculpture, in the late Barnett Newman's words, "culture without cult"; the artist who realizes in sculpture a vision of his subject not shared with his patrons. In Rodin's case the visions were of heroic self-sacrifice (*The Burghers of Calais*), defense of one's country (*La Défense*), and genius (the *Monument to Balzac*—Fig. 37). The disappointed sponsors whose views were shared by the public and most critics were the city of Calais, the French government and the *Société des Gens de Lettres*. Rodin came to epitomize, at modern sculpture's beginning, the clash between sculpture made from private values, and expectations based on public norms. Yet his position was not always unequivocal, for in certain commissions, such as that from the city of Nancy for a monument to Claude Lorrain, he made concessions in style to the historical and cultural character of the region.

Monumental sculpture was the highest goal to which the traditionally trained sculptor could aspire. Usually the state, a society, or friends of a great or not-so-great man would commission a monument that with an accompanying inscription would proclaim the subject's merit and incur the respect of the beholder. The man's deeds and the sculpture were to represent the triumph of virtue and art over time.[21] Rodin's *Monument to Balzac*, exhibited in 1898, fulfilled the spirit if not the letter of the classical monument, for it was rejected by its commissioners in a scandal. The work was variously attacked for the ignominious empty-sleeved dressing robe, the tilted stance that was not "plumb" and which academicians argued would not "carry," and for the dramatic modeling of the head that seemed caricatural to critics but which was exaggerated by the artist to accommodate the distance and lower angle from which it would be seen without losing Balzac's identity and mood. With bitterness and pride Rodin commented, "By convention, a statue in a public place must represent a great man in a theatrical attitude which will cause him to be admired by posterity. But such reasoning is absurd. I submit there was only one way to evoke my subject. I had to show Balzac in his study, breathless, hair in disorder, eyes lost in a dream, a genius who in his little room reconstructs piece by piece all of society in order to bring it into tumultuous life before his contemporaries and generations to come."[22]

As the new century opened, the more thoughtful young sculptors recognized that there was a problem of what to do with subject matter. Realism and traditional allegory seemed the only alternatives, but they did not inspire the urgency and conviction that would lead to the hoped-for mod-

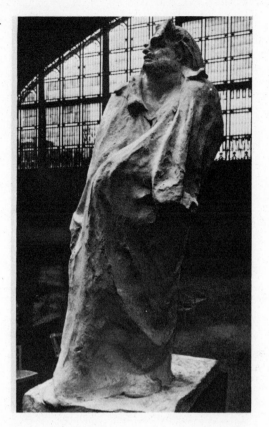

ern art. By his personal example and works such as the *Balzac*, Rodin had shown the viability of a middle ground, what might be termed a realistically-based visionary art, or a personalized allegory or metaphorical image: the artist need not lean on appearances nor "prop" art.

The furor over the *Balzac* also excited young sculptors because it confirmed not only the importance of Rodin, but of sculpture. It could still be looked to as a way by which society imaged itself. Rodin's audacious imaging of the classical ideal of "the soul in full action," and his phallicizing of the figure to evoke creative force won the artist admiration from younger men, but not emulation. Except for Epstein, Brancusi, and Maillol commissions for monuments did not come to the independent sculptors, due perhaps to their youth and the antinaturalistic drift of their styles. While they often did portraits, they did not monumentalize their subjects in the classical sense. It was Rodin's *Thinker*, enlarged and reexhibited after 1900, and his *Walking Man* that provided antecedents if not direct influence on younger artists who evolved what might be called a modern equivalent of the classical heroic monument to an individual: the exemplary figure that was either anonymous, a modern type, or a spiritual self-portrait. By this means, rather than glorifying the dead, artists could convey their hopes, ideals, and convictions about man in modern society. These exemplary figures were usually not destined for enlargement to life-size or larger, nor were they to be supported by architectural pedestals bearing inscriptions. This was not to be message art in the old sense, as the meaning of the figure is largely unparaphrasable, residing in the eloquence of such formal means as silhouettes, planes, and volumes. There were no familiar rhetorical gestures, no posing for the crowds.

Wilhelm Lehmbruck's *Rising Youth* exemplifies in a more than life-size sculpture what the artist's writer friend Theodor Däubler read as "ethical verticality" and was paradigmatic of "modern self-contemplation." (Fig. 38).[23] Similar to Rodin's *Thinker*, when detached from the *Gates of Hell*, Lehmbruck's injunction to society was to be more reflective and to remember the tenet, "know thyself." In the 1890s the Belgian George Minne had developed a new iconography for the individual in his anguished adolescents whose involuted gestures were internally generated. Minne's complex youths such as the *Little Relic Bearer*, are the offspring of a modern disinherited religious art; neither saints nor sinners,

they are questing spirits who have discovered that truth must be sought in fathoming the self (Fig. 39). They are kin to certain pathetic introverted figures in Rodin, Van Gogh, and Munch, artists who sought to give humanity that status of saintliness formerly conferred by the halo, and before which one would instinctively remove one's hat. Minne's examples were not lost on Lehmbruck. Building upon academic teaching in which the artist was told to emulate the articulated structure and logic of architecture, Lehmbruck's model for his monument to introspection was gothic rather than classical. His athlete was not modeled and proportioned after those celebrated by Polyclitus and who issued from the Greek palestra, but rather northern medieval saints, gymnasts of the spirit, athletes of moral virtue and courage. After 1912 there is an expressive leanness to Lehmbruck's figures by which he cuts close to the bone in theme and form. Man's personal life is brought nearer to the surface; trimmed away is insulation against disguise and death; and as in a medieval *memento mori*, he shows man as carrying both life and death within himself. The locked stance suggests man braced against fate. The conception is born of the artist's personal experience and private emotions concerning the modern soul, all of which he sought through sculpture to make meaningful to humanity at large. This was how Lehmbruck tried to handle the problem of what to do with subject matter that would transcend realism but avoid the traps of traditional allegory.

Elie Nadelman's *Man in the Open Air* of 1915 (Fig. 40) is the antithesis of Lehmbruck's *Youth* in ancestry and ideal, although both men were influenced by Adolf von Hildebrand's book, *On the Problem of Form in Painting and Sculpture*. Nadelman's ideal man is undisturbed by psychic self-search or spiritual tension. He is a bowler-hatted, bow-tied modern Apollo, a paragon of poise. Here is modern man, relaxed and at home with himself, in skin-tight fashion and the out-of-doors, impervious to the effect of a tree growing through his right arm.

Both of the foregoing works at least satisfied the formal demands of the classical monument by the moderation of gesture and stationary stances of their subjects, their potential for movement, and strict confinement to their bases. Those that follow threatened the classical ideal of "durability." Rodin's *Walking Man* (Fig. 41), first shown in its original and less than half life-size in 1900, enlarged in 1905, and exhibited as the "*clou*" (the work most likely to be talked about) in the Salon Nationale of 1907, was a sculpture that even Rodin's strongest detractors in the avant garde could not ignore. Many felt they had to react by remaking it. Rodin had given heroic scale to a partial figure, a nonperson. It was his celebration of the life force as well as good modeling that became more important to him in later life than the *St. John the Baptist* figure that derived from it in 1878. The figure is in full stride, unlike classical heroes whose weight is carried on one foot that is plumb with the head. To Rodin, photography, such as Muybridge's frozen motion, and his sculptures were a resumé of successive movements. The image of a powerful figure whose legs scissor space, whose past and future are measurable only by his tread and not his name, haunted the imaginations of sculptors as diverse as Maillol, Duchamp-Villon and Boccioni.

When he was commissioned in 1905 to make a monument to the socialist Auguste Blanqui, who spent almost

39. George Minne, *The Little Relic Bearer*, c. 1897.

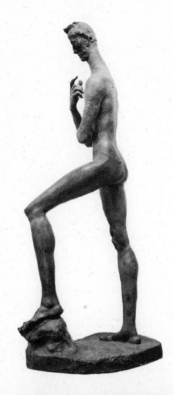

38. Wilhelm Lehmbruck,
 Rising Youth,
 1913.

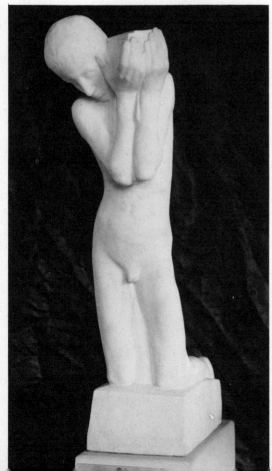

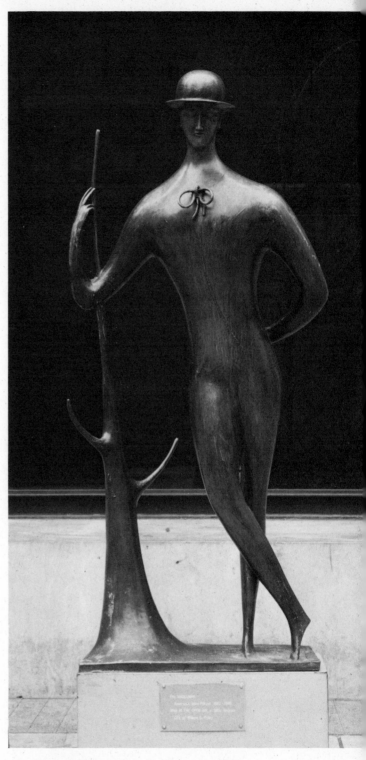

40. Elie Nadelman, *Man in the Open Air*, 1915.

31

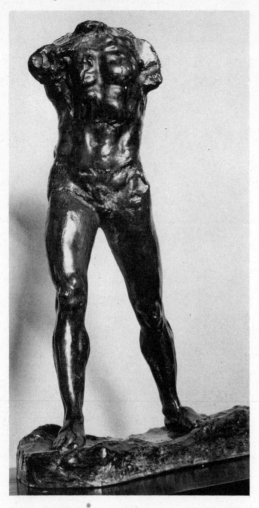

trated esthetic force but broader celebration of human beauty (Fig. 97).

Ernst Barlach's *The Stroller* of 1912 is unlike Rodin's naked figure, being clothed and anatomically intact (Fig. 42). Since his student days, the north German sculptor could not abide the nude as being too inexpressive of the spirit, but paradoxically found in certain types of contemporary costume the means to achieve "spiritual nakedness." The expressiveness of late medieval carved and robed figures confirmed this view for Barlach. The *Stroller*, as the *Thinker* and Lehmbruck's *Youth*, is a philosophical seeker, unlike the traditional monumental subject who has found the answers. Like all men, Barlach's exemplary figure walks between heaven and hell in search of himself, the meaning of humanity, salvation, and God. Unlike the *Winged Victory* that Barlach had seen in the Louvre, the wind in the stroller's garments does not symbolize the favor of the gods, but rather exposure to the elements, restlessness, the vulnerability of the wandering soul.

The early modern exemplary figure combines or alternates between the contemplative and active life, a vigorous ideal of youthfulness perhaps related to the new century and artists' hopes for a rejuvenated art and a more rational society. Rather than celebrate individual achievement, a *res gestae*, theirs was a call to their contemporaries to act, not in a patriotic, militaristic way, but with intelligence and resolve. Duchamp-Villon's *Torso of a Young Man* (Fig. 43), cut down from an earlier full figure, is the translation of the "power of life in action."[24] In its partiality and meaning it is connected to Rodin's *Walking Man*, but Duchamp-Villon was challenging that work's battered, antiqued

half his life in prison, Maillol sought an idea that would embody this totalitarian democrat's passion for freedom. *Freedom in Chains* resulted from this idea and was Maillol's challenge to Rodin as a sculptor of movement. The personification of *Freedom in Chains* was a link with tradition, but the heroic striding feminine nude was Maillol's response to Rodin's vehement masculine drama. For the former, only the feminine form was capable of beauty. The torso version of this project makes an even stronger claim in this regard, for, divested of its head and limbs, it achieves more concen-

42. Ernst Barlach, *The Stroller*, 1912.

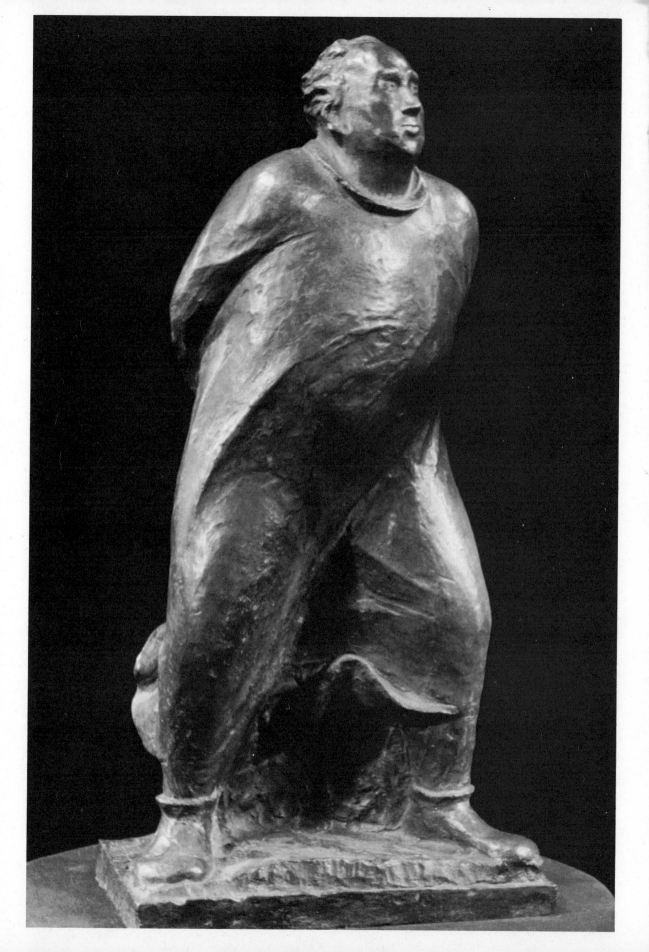

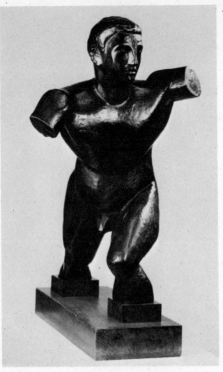

finish and modeling which he felt "no longer belonged to the domain of sculpture." He argued that modeling was dominated by a response to "grossly imitative sensation," and hence excesses of sensibility. His *Torso*, which bears the idealized face of his brother, Marcel Duchamp, testified to his faith in a new rationalized sculpture that placed demands on the intelligence of the beholder to recognize newly invented harmonies of the body. What Duchamp-Villon was exemplifying in the lines, planes, and volumes of his sculpture was "a reaction against our era of business where money is the sovereign master. It seems to me that simplicity, even austerity, are the indispensable virtues and that our ideas of the beautiful should be clothed in them."

Duchamp-Villon was disturbed by the "unbridled activity" of his time and commented that "the spectacles sought for by our eyes are all of motion." Academic theory proscribed the figure in feverish movement for public statuary. For Umberto Boccioni, however, movement meant modernity. His *Unique Forms of Continuity in Space* (Fig. 44) is the irreverent offspring of the *Winged Victory, Walking Man,* and *Torso of a Young Man.* By contrast with G. F. Watt's late nineteenth century equestrian personification of *Physical Energy* (in London's Kensington Gardens), Boccioni fantasized a superman of the future who would attain undreamed of speeds and have his very body transformed by prolonged violent contact with his environment.[25] In the Salons before 1914, one could see monuments to dead aviators with broken airplane wings suggesting the fate of modern Icarus. Against his morbid and pessimistic view of man's new adventures with time and space, Boccioni showed an unquestioning optimism. Racing cars and airplanes, not horses, would be the vehicles and symbols of this transformation. The force that hollows Boccioni's still muscular, Nietzschean figure is wind, not from the Greek gods but the artist's pseudo-scientific notions of space. Like Futurist manifestoes, his sculpture was a personal exhortation to his countrymen to rouse themselves from dreams of the past and to militantly meet the future, which he was to do at the cost of his life.

As with the classical monument, early modern sculptors sought by their exemplary figures to engage our thought and passions, to move us, if not nobly, certainly not basely. The work's moral lesson came not from the conduct of a deceased hero, but from the artist, from his views on the new morality needed for making art and a more realistic confrontation with modern life than was possible in Salon art, which was imprisoned in its own armory of attributes and inscriptions that

contrived nostalgia for the past. Successful monumental art presupposed a sympathetic and knowledgeable public. While the pioneers often sought the attention of society, as did their academic colleagues, they soon discovered that meanings which could not be inscribed on pedestals or given in titles, but which were invested in sculptural means, did not translate into public acceptance. Quotations on pedestals for such figures as Lehmbruck's *Rising Youth* were irrelevant, as the ideas in the sculpture were derived from the artist's own experience. In terms of credibility, however, the times were as much against the pioneers as the farmers of traditional sculpture. Skeptical about the very possibility of what he was doing, as well as what he saw in the Salons, Duchamp-Villon wrote in 1913, " . . . in an epoch of floating ideas and aspirations there can be not definitive or durable monument."[26]

Changes in what gives sculpture meaning: the modern sculptural metaphor

Part of the early modern drive to simplify sculpture, to make it more immediately apprehensible to the viewer, was the repudiation of what in Salon terms was called "erudite" sculpture.

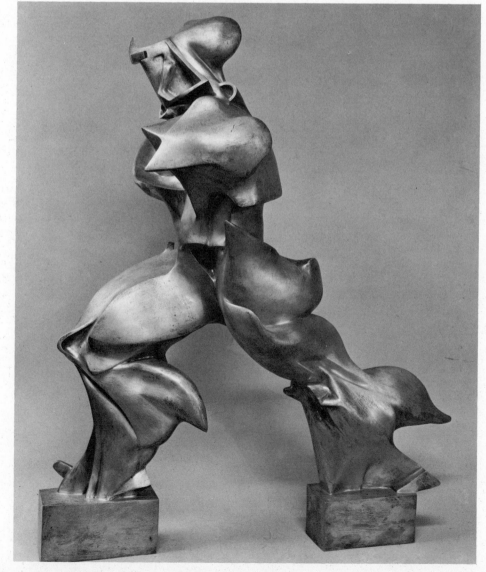

44. Umberto Boccioni, *Unique Forms of Continuity in Space*, 1913.

When, for instance, Bourdelle did his *Dying Centaur* in 1914 (Fig. 45), he commented, "He is dying because no one believes in him."[27] Bourdelle may also have realized that younger artists did not believe in his type of sculpture which illustrated inherited ideas, repeated the figures of older myths, or dealt with experiences that the artist himself had not lived. The new ideal written about with passion by Gaudier-Brzeska and precision by Duchamp-Villon was sculpture that showed the power of the mind, not to synthesize old symbols, but to conceive ideas directly in a new language of sculptural form. The evolution from the old, or rehabilitated, traditional metaphorical figure to the new sculptural metaphor is seen in successive works by Jacob Epstein, the *Tomb of Oscar Wilde*, carved in 1912, and the *Rock Drill* of the following year. The former was inspired by the great Assyrian winged bulls in the British Museum and Wilde's own exotic symbolism. Epstein synthesized "a flying demon-angel, across the face of the block, a symbolic work of combined simplicity and ornate decoration," that included such accessories as personifications of intellectual pride and luxury.[28] Scandalized authorities caused it to be covered with a tarpaulin, which the artist's friends removed at night. The tomb was a *tour de force* of direct carving and symbolic improvising on an heroic scale, but its ambitious footnoting of the past gave Epstein no basis for coming to terms with his own time. The *Rock Drill* (Figs. 46, 47) expresses Epstein's short-lived but still powerful "ardour for machinery," and interest in the "discipline of simplification of forms, unity of design,

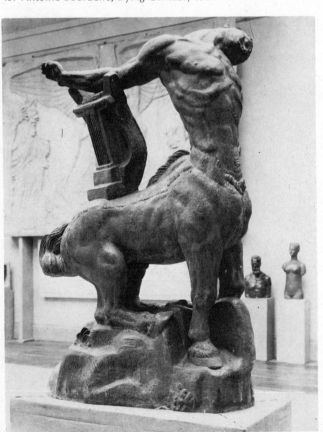

45. Antoine Bourdelle, *Dying Centaur*, 1914.

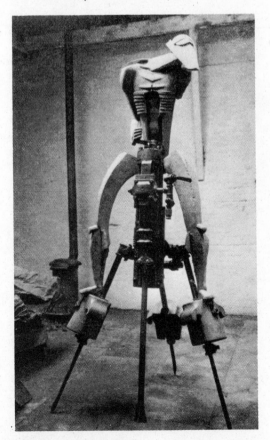

46. Jacob Epstein, *The Rock Drill*, 1913, original version in plaster and with pneumatic drill.

and coordination of masses."[29] The source of the components for the "visored and menacing machine-like robot, carrying within itself its progeny, protectively ensconced," included his prior sculptures of a naked mother holding a child against her body and a visored self-portrait. His mechanizing of the body in the *Rock Drill* is not obvious or predictable and both front and back surprise by the artist's gift for analogizing. There are qualities of the inspired and of invention that do not again appear in Epstein's work. He was to reject this side of his imagination and the motives for making the sculpture when years later he described it as an "armed sinister figure of today and tomorrow . . . no humanity, only the terrible Frankenstein monster we have made ourselves into."[30] In 1913, Epstein, under the influence of the English Vorticists, shared Boccioni's enthusiasm and optimism for the modern machine. When he removed the pneumatic drill on which the figure stood, he grafted a drill-like bit on to the arm of the robot, which amplified the mechanical reference while giving greater self-sufficiency and consistency to the sculpture. To Epstein's credit was his imaginative departure from his own sculptural sources and creation of a forceful, mysterious new entity whose attributes were not applied accessories, external to the figure, but rather were integral to the sculptural form. Epstein was one of the pioneers of the new physiognomic in sculpture that depended not on sophisticated knowledge of objects, their identification or classification from the past, but on the beholder's intuitive understanding of

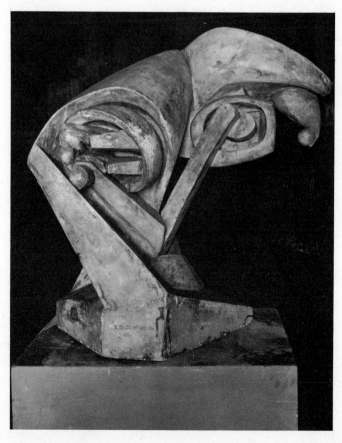

48. Raymond Duchamp-Villon, *The Horse*, 1914.

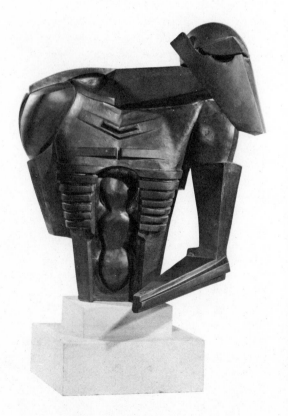

47. Jacob Epstein, *The Rock Drill*, 1913 (?), revised version.

nonverbal ideas expressible in planes, edges, and masses and the analogizing of structures.

The challenge to give tangible form to the concept of the machine and its energy was compelling enough for Duchamp-Villon to create his masterpiece, *The Horse*, a touchstone in the history of the modern sculptural metaphor (Fig. 48). His own statement applies to Epstein's *Rock Drill* and defines the new metaphor: "The sole purpose of the arts is neither description nor imitation, but the creation of unknown beings from elements which are always present but not apparent."[31] In the process of analogizing equine anatomy and mechanical shapes the artist so transformed his sources as to make them inseparable and almost unrecognizable. Duchamp-Villon broke with the sequential or linear logic of the tradition behind Bourdelle's *Dying Centaur*, and in *The Horse* one does not see where anatomy ends and mechanics begin. The whole is unpredictable on the basis of its sources. The final sculpture is not of a speeding or jumping horse, and there is no rider. The creature is not in movement, but is coiled upon itself, compacted with a potential energy. It is a metaphor of modern horsepower.

Even before and independently of Dada and Surrealism, early modern sculpture achieved a new freedom for fantasy by revolutionizing the sculptural metaphor. Duchamp-Villon and Boccioni pioneered a *terra incognita* of fantasy shortly before their deaths during the First World War. Brancusi made some of his most important contributions to the sculpture of fantasy in such wooden pieces as *Prodigal Son* of 1915 and *Chimera* of 1918 (Figs. 49, 50). More than his work in stone and bronze, Brancusi's thematic concep-

tions in wood resist tracing to a source in nature and may reflect the irrational side of his poetic intuition. In her recent dissertation for the University of Pittsburgh, entitled *The Sculpture of Brancusi in the Light of His Rumanian Heritage*, Edith Balas argues that the source of *Chimera* may be in the Rumanian folk tradition of the raven as an ill-omened bird of feminine gender. *Chimera* may be compared to Rodin's *Centauress*, as Duchamp-Villon's *Horse* invites comparison with Bourdelle's mythological hybrid. Unlike Rodin, Brancusi departs from the mythological definition of chimera as a she-goat to make a creature that is closer to a girl-bird, not by a human-headed, female-breasted winged being, but by a double image which invites us to read a single form in two different ways. But this optical experience presupposes a drastic reduction to the basic structure or minimally credible configuration of a long-beaked bird and a young girl with a pig-tail. It is possible that neither of these references was in Brancusi's mind when he made the upper part of *Chimera*, and its final totality may have been a stacking of separately conceived parts defying logic or thematic connection.

The *Prodigal Son* of 1915 was to that date Brancusi's work most complex in form and inscrutable in theme. To see or imagine this sculpture as a kneeling figure wearing a knapsack, head thrust forward, may require wit, as Sidney Geist says, but it also demands faith and intuition.[32] It is somewhat helpful to see this work in the context of previous sculptures in which Brancusi was contracting the body. It may be relevant to know that the sculptor traveled with a knapsack and that he returned to his fatherland in 1914 after a five year absence. The *Prodigal Son* may

have been a metaphorical self-portrait.

In the modern metaphor the whole is inspired by two or more disparate entities which are fused in the sculpture in such a way that they lose their original distinctiveness. The result is then a new entity, unpredictable on the basis of its parts. What makes this a modern sculptural metaphor is its open-ended interpretability, the absence of public or literary sources to circumscribe or substantiate its meaning.

Self-portraits of the sculptors

The making of self-portraits by sculptors goes back to the legendary Daedelus. At times, as in the case of Michelangelo, the sculptor would portray himself in the role of supporting actor in a religious drama. In early modern sculpture there are both direct and indirect or surrogate self-portraits. Rodin's identification with the *Thinker* is confirmed by its placement over the artist's tomb at his own request. Gauguin did a profile self-portrait in relief (Fig. 51) and included his own image in the autobiographical *Soyez Amoureuses*. The painters Kokoschka and Schiele modeled self-portraits which are as psychologically compelling as their drawings and paintings of themselves (Fig. 52). Rosso early depicted himself as the unemployed *Street Singer* and later as the stout standing speaker in *Conversation in a Garden* (Fig. 53), where he addresses a woman he admired.[33] We may be seeing Picasso's romanticized self-portrait in his early *Mask of a Picador With a Broken Nose* (Fig. 54). According to Gaudier-Brzeska's friend Brodsky, the *Head of a Fool* is the sculptor himself (Fig. 55). Lehmbruck and Barlach repeatedly mirrored themselves in their work: the *Rising Youth* is Lehmbruck, and the *Stroller* is Barlach.[34] Sidney Geist is convincing in seeing Brancusi as the male lover in *The Kiss* and the sculpture as a kind of wish fulfillment.[35] The now lost *Head of a Young Man* of 1907 by Elie Nadelman, with its researches into new facial inflection, was a narcissistic image as were perhaps all his androgynous figures and heads according to Athena Spear. Perhaps it is not too much to see Epstein's visored self-portrait (Fig. 56) as the clue to the real identity of the masked figure in the *Rock Drill*. These actual and disguised alter-images tell us of continuity with older sculptural practice and of the intimate personal relationships these sculptors had with their art.

The portrait

Portraits were a staple of Salon fare, a sure sign of sculpture's eternal relevance to society. Economically the portrait remained the most consistent means of livelihood for sculptors. In a time of strong anticlericalism in France, the portrait bought the bourgeois after-life insurance. Brancusi, Lipchitz, and Duchamp-Villon joined Rodin in being *sociétaires*, the term meaning that they exhibited (and advertised) in the annual *Sociète Nationale des Artistes*. For artists such as Picasso and Matisse, who did not receive commissions, portraiture was a means of expressing friendship, admiration, or love. Traditionally, when one sculptor portrayed another, as Rodin did in many cases, it was to honor the profession as well as the person. Rodin's portraits of Dalou, Falguière, and Guillaume give these sculptors the same upright dignity or gravity as the statesmen he modeled. Paradoxically, it was

49. (left top) Constantin Brancusi, *Prodigal Son*, 1915.

50. (left bottom) Constantin Brancusi, *Chimera*, 1918.

51. (left) Paul Gauguin, *Self-Portrait, Oviri (The Savage)*, c. 1893.

52. (below) Oscar Kokoschka, *Self-Portrait as a Warrior*, 1907-08.

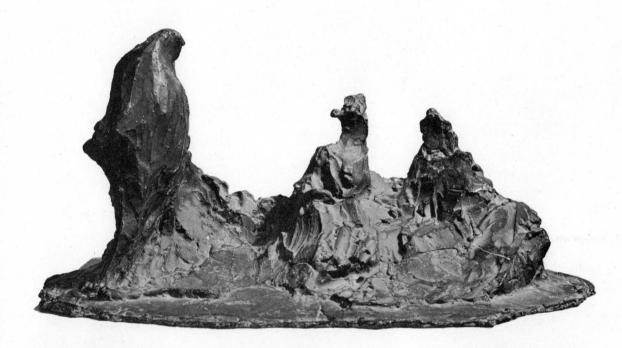

53. (top) Medardo Rosso, *Conversation in a Garden*, 1893.

54. (left) Pablo Picasso, *Mask of a Picador (with a Broken Nose)* 1903.

55. (center) Henri Gaudier-Brzeska, *The Fool (Self-Portrait)*, 1912 (?).

56. (right) Jacob Epstein, *Self-Portrait with Visor*, 1912.

portraiture's successful history of like-ness to a living model, its focus on the individual, that was to cause its decline from favor even before the First World War. A new generation of artists was beginning to believe that sculpture should only resemble itself and rise above the celebration of individuals.

During and after his lifetime Rodin stood as the master of the psychological portrait. Internationally, he was the most sought after portraitist in history. No sculptor had ever made the face more responsive to the spirit. His marble "soul portraits" of socially elite women appealed to Victorian ideals of discretion and ethereal beauty. Rodin seemed to have effortlessly mastered the fusion of the great variety of shapes and surfaces of the face into absolute unities of meaning. Portraiture was viewed by the artist as the source of his greatest agony and his sternest test, however. His genius was to make the facial parts appear involved with the life process, to grasp the potential of lively interaction of the parts, their mutual dependence, and how the whole should appear pervaded by the subject's mind. Such portraits as those of *Baudelaire*, (Fig. 57), *Clemenceau*, and *Clementel* were hard won, reminding us that even for Rodin mastery did not have tenure and had to be perpetually earned. For men, but not women, unless they were models, having one's portrait done by Rodin was the closest one could come to psychoanalysis outside of Vienna.

It was Rodin's style to appear to have no style, only different subjects. Rodin began with intense study of the course he would have to master, which meant the subject's profiles searched from every angle. As would an academician, Rodin first established the physical form of the face at rest, before animation. This was called establishing the *caractère*. If it was a commission from an important person, the next step was in academic parlance, "to raise the subject to the type," orator, soldier, statesman, making him greater than he was. Agony came from animation, from the search for the clue to personality that would lead to the inspired touch, such as the untempered lumps above *Baudelaire's* right eye that unmade an otherwise finished sculpture, but brought it to life. Rodin welcomed the contingencies of shifting light and focus as a means of avoiding the frozen look of academic portraiture. His surfaces accommodate chance and accident so that under changing conditions the sitter would seem to alter expression.

Artists close to Rodin, such as Bourdelle and Despiau, faced the dilemma of how to surpass him or preserve their own identity. At his best, in several of the *Beethoven* heads, Bourdelle relied upon his natural talents as a modeler and intense feeling for his subject. In the large *Tragic Mask of Beethoven* however, he tried to out-dramatize the master and reached the vaguely defined limits of caricature when he sought to exteriorize the notion of the music in the composer's mute features. Despiau chose the more limited option of underinter-pretation which was personally congenial, as shown in the fine delicate head, *Young Girl From Landes*. Epstein followed Rodin's example after about 1915 by working from the subject, and seeing himself as modeler, he imposed his personality but not style on his men and women and even children. Lehmbruck quieted the surfaces of his portraits to indicate the self-possessed and durable nature of his subjects, and in the portrait of *Fritz von Unruh*, he

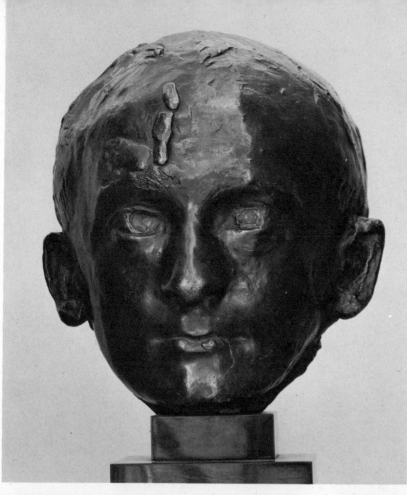

57. Auguste Rodin,
 Portrait of Baudelaire,
 1892.

58. Wilhelm Lehmbruck, *Portrait of
 Fritz von Unruh*, 1917.

59. Medardo Rosso, *Ecce Puer*, 1906.

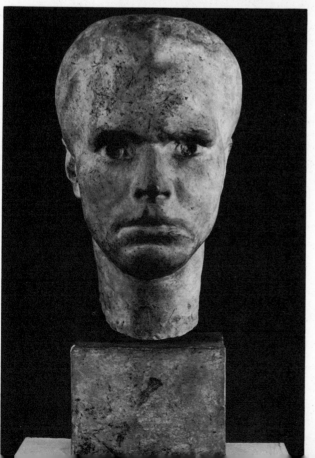

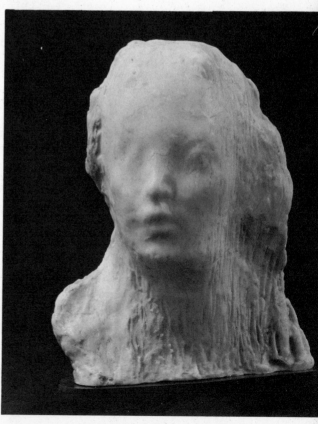

allowed the fixity of the eyes to be uncontested, the whole head being the support for the intense expression of the eyes. Late in his life, Egyptian art, with its solemnizing immobility and hieratic erectness of the head, inspired Lehmbruck in his portraits of women possessed by transcendent vision or in prayer, which he felt was man's only solace (Fig. 58).

Even before 1900 the portraits of Medardo Rosso constituted a new concept of unity in the history of portraiture. In Rosso's terms Rodin's portraits were too objective, simply a matter of making something from a model. Rather than prolonged direct confrontation of the model, many of Rosso's portraits were inspired by a rapid glimpse of a subject, such as the *Ecce Puer* (Fig. 59), and then done from memory.[36] Rodin delimited the head from surrounding space by capturing the profiles. Rosso wanted fugitive profiles, a unity of surface, light and air. There were no binding or circumscribing contours. Little or nothing is verifiable by touch. Unlike the Impressionists, with whom his art is always compared, vision and memory focus and filter past impressions and information. He often worked in the model's absence. There is a calculated underseeing in his work. No attempt was made to first establish the *caractère*, but, paradoxically, the goal was characterization, as in the portrait of *Yvette Guilbert*. Unlike Rodin, Rosso does not invade his subject's privacy. All of his subject's form and mood are given to us from one fixed viewpoint, and the work is not to be seen in the round. Sometimes only the tip of the nose seems in focus. When fixing on the nose of *Madame X*, one is less conscious of the absence of featural delineation of the eyes and mouth in the same way that one concentrates on the eyes in a Renoir portrait to obtain correct registry of the whole. Rightness and resemblance do not depend upon roving focus in the head of *Yvette Guilbert*. Reflecting his own compassionate temperament, Rosso's portraits have an unassertive nature. They emanate a gentle innocence. To a "banal world" Rosso offered his images of "purity."[37]

Matisse saw portraiture as research into his subject's hidden character. Just as they were for Rodin, the early stages of a portrait, such as those of Jeannette (Fig. 60), were reconnaissances of facial topography. Exact facial measurement, Matisse felt, was appropriate to criminology, not art. He sought the asymmetry and rhythm peculiar to his model which when accentuated, he felt, constituted the resemblance. Where Matisse departed from Rodin was in the phases following surface survey. Abandoning the model, he believed in imagination to enrich what had been seen and in figuratively closing his eyes, holding the vision, and working from sensibility. No feature was ineligible as a carrier of character, and even the head's design was not inviolable, as he proved in *Jeannette V*. Matisse figuratively went through Rodin, rather than away from him, in order to continue psychological portraiture but bring it into accord with his views on decorative art. He wanted his sculptures to have both an inner psychological and an esthetic life.

That balance of feeling and intellect that stamps Matisse's portraits as his own was an impure mixture for Duchamp-Villon. For Matisse, the work of Duchamp-Villon was chillingly cerebral. Even in his early, somewhat coldly naturalistic portraits, the latter showed no talent or inclination for the psychological portrait. It is with the

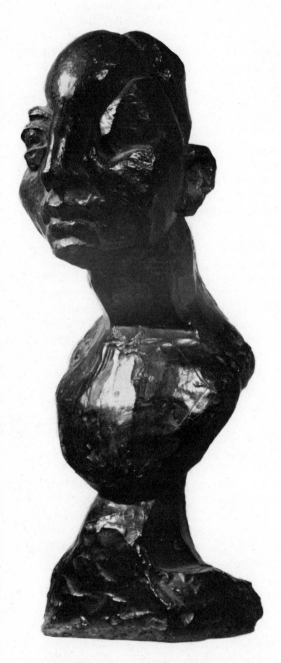

60. Henri Matisse, *Jeannette V*, 1913.

portraits of *Baudelaire* (Fig. 61), *Maggy*, and *Dr. Gosset* that he makes his mark on portraiture. The new form sought by this tragically short-lived artist denied to portraits the possibilities of liveliness, or the appearance of being on the verge of speaking, as in Rodin's *Balzac*, and the subjects appear psychically withdrawn from the viewer. Rationalized redesigning of sculpture caused new handling of planes, insolation and rhyming of features in *Maggy*, a head which sits peninsula-like atop the pole of a neck. There is a tough-minded distillation of character and form which gives the *Baudelaire* and *Gosset* heads an indescribable tautness and density of matter. The hygienic mask and widely separated eye sockets give the nugget-sized portrait of Dr. Gosset a skull-like mystery, made poignant by the artist's death shortly after the work was made.

If one just examines the transformations of the eye in these early modern portraits, one can find the miniaturizing of styles and thinking. The eye loses its capacity for normal sight, its perfection as an organ, and its mobility along with the iris and eyelid. The eye is abnormally enlarged, smoothed into an egglike orb that makes indefinite whether the eye is open or closed. It is replaced by empty cavities or merged with the whole facial surface. The eyes may lose or have an accentuated symmetry and may continue as windows of the soul or be opaque apertures. Their outline whether fiercely insisted upon or dissipated, their familiar distance from the nose, can no longer be counted on. No artist was more inventive in reconstituting the eye than Picasso.

Although academically trained in drawing and painting, Picasso came to sculpture having to choose his own exemplars, but discovering that, as in

45

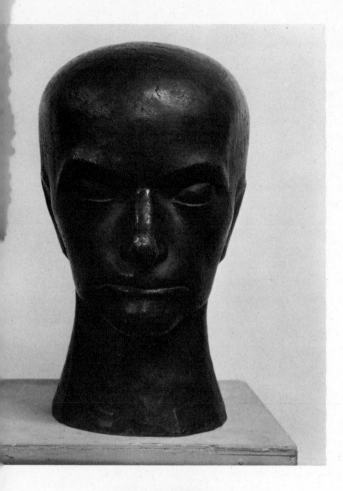

painting, sculpture was a matter of individuality. His brilliant portraits that culminate in the Cubist *Head of Fernande Olivier* of 1909, show the early dependence of his art on self-transformation and renewal (Fig. 62). With no belief in rigid standards, Picasso felt: "We are all autodidactics."[38] The making of sculpture depended on how one understood it, and at the beginning Picasso relied on emotion and sensibility and a manual facility that rivaled Rodin's. As did the older man, Picasso learned to suppress finesse. The first portraits of the *Blind Man* and *Mask of a Picador* show a precocious gift in reconstructing the natural nuance and *caractère* of the face. Despite the marvels of which his hands were capable, Picasso showed he had the means to resist what came easily and avoid repetition. No two portraits have the same surface texture, and there are no formulas for forming the eyes, while paired motifs are individualized so that each half of the face has its own identity. Picasso shared with Maillol and Matisse the sense of freedom which allowed them to make sculpture as if it had never been made before. With the nub end of a brush or sculpture knife, for example, he incised his *Head of a Woman* of 1908. In his Cubist *Head of a Woman* (Fernande Olivier) a year later, that had been almost blueprinted in his drawings and paintings, Picasso was shaping the artist's declaration of independence from nature. Without losing the memory of the model he loved, Picasso infused the head with artistic muscle, exaggerating and at times inverting normally concave and convex areas, disrupting continuity, and making the normally passive areas of brow and cheeks as expressive as the eyes. He gave to all areas of the head a new formal interdependency without total

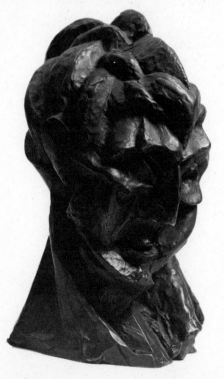

61. Raymond Duchamp-Villon, *Head of Baudelaire*, 1913.

62. Pablo Picasso, *Woman's Head* (Fernande Olivier), 1909.

loss of the psychological mutuality of the features. His drastically inflected, coruscated surface invited decomposition of light and drastic shifts of mood as illumination changed, going beyond Rodin's recreations of Balzac's head.

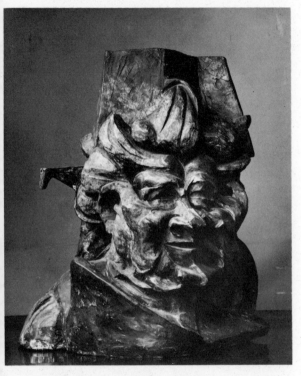

63. Umberto Boccioni, *Portrait of the Artist's Mother, Antigraziosa.*

This sculpture and Picasso's paintings helped Boccioni put distance between Rodin and himself and to realize the idea of an environmental sculpture. In the portrait of his mother, *Antigraziosa*, Boccioni fused the woman's head with a building to demonstrate the integration of matter (Fig. 63). Rodin's portrait of *Athena* showed a Greek temple, intact, sitting atop the beautiful head of the goddess. The Cubist demolition of closed form al-

lowed Boccioni to build a sculpture that joined the subject and her environment in a new artistic logic that defied traditional ideals of beauty. Historically, Boccioni's building-blocks included Rodin's drastic atmospheric modeling that allowed the subject to appear to change expression in keeping with the shifts of light and viewpoint and also Rosso's example of denying the total isolation of the head. The title *Antigraziosa* denounced the tradition of graceful sculpture as defined by flowing beauty, to which Elie Nadelman had been dedicating himself for many years.

Gertrude Stein portrayed the handsome, narcissistic Nadelman, saying, "He was one needing to be one completely loving women."[39] Nadelman portrayed woman as a modern day Venus displaying a classical Hellenic composure. The sculptor's view of "true plastic beauty" required an emotionless calm and perfect rhythm. His willingness to assume one of the most overworked themes from ancient art (which Athena Spear views as "parodies"), rested on a confidence that he had found "true forms" and that the enjoyment of art was not a matter of resemblance to nature. "Abstraction" for Nadelman took the form of applying geometrical elements such as curves in a way that achieved accord and opposition and gave him what he felt was the means to interpret nature and achieve "significant form." His cosmetically paradigmatic heads do not impress as the bearers of active minds. When he wrote, "I intend that the life of the work should come from within itself," he meant by means of the alchemy of his surfaces that were in harmony with the potential or "will" of his materials.[40]

In 1909, Nadelman made an abstract head, now lost, completely divested of

47

facial features (Fig. 64), and which, while not exhibited, was sold to Leo Stein out of the artist's show that year at the Druet Gallery. Athena Spear believes it is possible that Brancusi saw this almost egg-like sculpture and may have been encouraged to further his own purification of the face in his heads of *Muses* and portraits of *Mademoiselle Pogany* (Fig. 65). Brancusi's adventures with the head start historically with naturalistic likeness, and then with the closing of the eyes (by changes due to polishing), as in Rosso's portraits of children, personality and awareness of the outer world are shut off. This introversion of his feminine subjects is accompanied by the paring away of surface details, loss of even potential facial mobility, and development of a symmetry inspired by rationalization that confounds because subjects such as *Mademoiselle Pogany* do not lose all individuality. It is possible that new sculptural means allowed Brancusi to realize a goal introduced to him at the *École des Beaux-Arts*, where he had studied, and where Charles Blanc's text called for the raising of the individual portrait to the type and then the pursuit of the essential, or the subject's "primitive essence."[41] Blanc's Neoplatonic views saw the personal human form imprisoning true beauty, and the artist's task was its liberation. His insistence upon freeing the subject from the accidental to achieve the permanent was not alien to Brancusi's objectives any more than was the academic dictum that

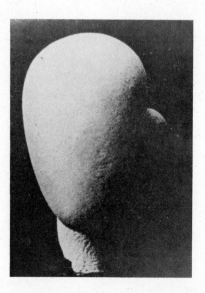

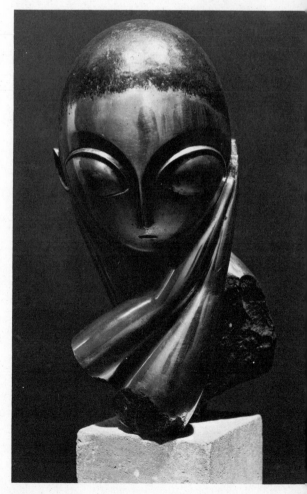

64. Elie Nadelman, *Abstract Head*, 1909 (?).

65. Constantin Brancusi, *Mademoiselle Pogany*, 1913.

style was the imprinting of human thought on nature. Brancusi's own nature, as Geist has pointed out, and the contemporary examples of Picasso, Derain and Nadelman, as well as tribal carvers, were the more immediate and influential incentives for Brancusi's breakthrough. It is not inconceivable, however, that his academic experience helped shaped his goals, which were not to fool the eye but to touch the soul.

Gaudier-Brzeska's 1914 portrait of *Ezra Pound* (Fig. 66) recalls the rapidity with which this alert, precocious artist moved from the robust vigor and subtle observation of his naturalistic portrait of *Brodsky* to the hieratic style that aligned him with early "barbaric" peoples uncorrupted by Western classicism. Pound was apotheosized in the manner of an Easter Island godhead such as stood in the British Museum. Following the lead of Epstein both in carving and the study of art from early cultures, he effected his own synthesis of the contemporary interest in abstract planes and volumes with the sharply designed rigid effigies of the past. Suppressing a manual finesse that caused Pound to say, "He could tie knots in Rodin's tail when he liked," Gaudier-Brzeska informed his sitter that the "forthcoming portrait will not look like you. It will be the expression of certain emotions which I get from your character."[42] Historically, sculptors have, always invested something of themselves in portraits of others, but in this century the imposition of the artist's mind and feelings on the subject was made more explicit. Originally projected as a phallic image, the final version of Pound's portrait that still manifests a residual likeness, was read by the poet as possessing "great calm. . . . It has infinitely more strength and dignity than my face will ever possess." But there were other artists who did not feel the need to synthesize likeness with abstraction and were more interested in conjuring purely fictive, idollike heads.

The evocative head

The tendency of many early modern artists to de-psychologize the head and the persistent claim of the human against the possibilities of abstraction led to a refinement in the history of this subject. Widespread admiration for the nonportrait tradition in tribal and ancient art gave momentum and historical models for the creation of sculptures that evoked the human head. In previous Western sculpture there had been heads that were symbolic or used for decorative purpose, often in conjunction with architecture, including the contemporary French apartment houses whose architects borrowed from the gothic use of fictive heads to animate the terminals of

66. Henri Gaudier-Brzeska, *Hieratic Head of Ezra Pound*, 1914.

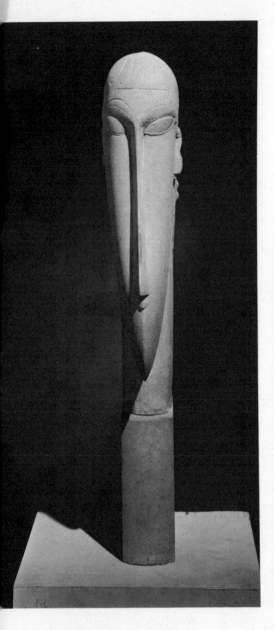

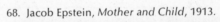

67. Amadeo Modigliani, *Head*, 1911–13 (?).

68. Jacob Epstein, *Mother and Child*, 1913.

arches. The new modern form for the head was detached from architecture and may have had private symbolic meaning to the sculptor, as in Brancusi's *The Muse*. They were to be contemplative objects, even disturbing presences. Sculptors such as Derain, Modigliani, Brancusi, Epstein, and Lipchitz had been moved by the stark power of inexpressive, immobile heads in museums and by their universal reference to humanity. Modigliani dreamed of a temple to human beauty populated by the heads he carved, sometimes from hashish-inspired visions (Fig. 67). At night he would occasionally put candles atop the heads.[43] Baule masks and Iberian and early Chinese heads inspired Modigliani to reproportion and shift the emphasis of human features not only in drawings, but directly through his impatient chisel in the stone. While it exists now only in an early photograph of the artist in his studio with his carvings, a sculpture by Derain was perhaps the earliest evocative head which could have encouraged Modigliani to carve his own. Epstein's marble *Mother and Child* of 1913 (Fig. 68) has African ancestry and showed him the way for the moment to universality without sentimentality. Pablo Gargallo's small copper masks of 1911 may have had a combined African and Oriental inspiration, but the formation of the hair and features was decidedly western. Brancusi eliminated the neck in his *Sleeping Muse* of 1910, giving the head a new self-sufficiency (Fig. 69). Its purification recalls Picasso's drawings by which he assimilated African masks into his own style. With their reference to the private world of dream, Brancusi's muses are spiritually closer to the floating heads of Redon's visionary drawings and prints than the idollike inscrutability of Modigliani's carvings.

Another source for the evocative head was the interest of sculptors and painters in developing a new vocabulary and grammar of flat planes which would allow them to infer subjects like the head without submitting to the imitation of nature or facial likeness. In 1913, Archipenko made a *Head* consisting of flat and curved planes butted together in an overall configuration that signified the subject of the title (Fig. 70). With this type of construction, there was no evocation of the past, no references to idols or individual identities. The young Czech sculptor Emil Filla took his lead from Cubist painting and contrived a blockish *Man's Head* from thick and thin geometrical slabs (Fig. 71). He could not bring himself in 1913 and 1914 to consistently forego the natural sequence of features or their total elimination. A more tough-minded approach was

69. Constantin Brancusi, *Sleeping Muse*, 1910.

taken by the self-taught Hungarian sculptor, Joseph Csaky, who adopted a Cubist style as early as 1911. His *Head* of 1914 (Fig. 72) is a brutal, asymmetrical reconstitution of the motif that submerges featural identity by a logic of thrusting planer forms. The result, unlike that of Filla, is a redesigning of the head that is no longer dependent upon a frontal confrontation for the most revealing view, and the consistency of this invented sculptural context discourages trying to project missing features on the blank planes. The blunt forcefulness with which the head is shaped and thrusts in and out suggests that Csaky had looked not only at Picasso's earlier painting and sculpture, but also at African tribal masks whose exaggerated features and simplified design accommodated the need to be seen at a distance and to evoke strong feeling.

For Jacques Lipchitz, similarly inspired by Cubism, his own *Head* of 1915 (Fig. 73) solved the problem of how to make sculpture that had the rational qualities of architecture and preserved the human in abstract form. He was confirmed in his desire not to lose contact with nature and was reassured that abstract shapes permitted retention of human qualities, notably a "feeling of monumental dignity."[44] Neither Lipchitz's nor Naum Gabo's efforts resulted from the influence of tribal art, for, as the latter pointed out, Cubism presupposed a refined culture, a sharpened and cultivated capacity for analytical thought, and willingness to perform a violent revolution, not merely a reform. In a small group of heads made between 1915 and 1918, under Cubist influence, Gabo broke with the formal unity of the external world by eradicating the familiar contours and surface planes that had been guides to identification (Fig. 74). His

70. Alexander Archipenko, *Head*, 1913.

demolition of the external integument of the head allowed him imaginative construction of the form to give it an "inner mechanism of cells" (as he described Cubist paintings), which was continuous with the space around the form.[45] These heads convinced Gabo that he could move entirely from reference to visible nature into a new, but not platonic, view of reality.

Objects as subjects

The traditional definition of sculpture insisted upon the selective and tasteful imitation of living forms. The depiction of objects by sculptors in the past

71. Emil Filla, *Man's Head*, 1913.

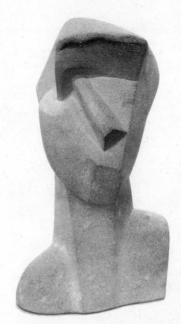

72. Joseph Csaky,
Head of a Man, 1914.

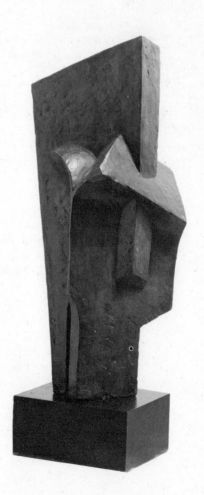

73. Jacques Lipchitz,
Head, 1915.

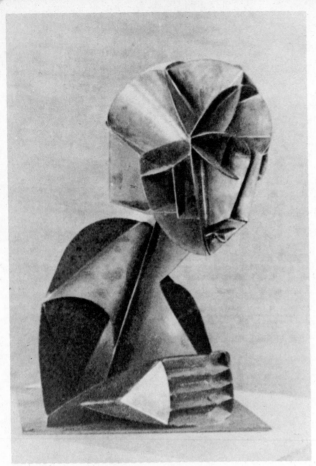

may have resulted from Picasso's desire to rehabilitate the object in his art after its progressive disintegration. To have extended his ideas into three dimensions in 1912 precluded work in stone and bronze, and sheet metal gave him both planer thinness and relative ease of manipulation. By choosing a guitar as a subject, Picasso was able to demonstrate in sculpture the Cubist's right to reform even the most traditional object. What separated the *Guitar* from the world of objects, to which Picasso had brought sculpture in unprecedented proximity, was its uselessness for anything but art.

Umberto Boccioni's *Development of a Bottle in Space* (Fig. 76), also of 1912, helped change sculpture's history by making objects the central focus. To Boccioni nothing was static or inanimate, and in using a bottle to give form to his dynamic view of existence, he was leveling the ancient hieratic attitude that made man not only the noblest but almost exclusive subject of sculpture. What more eloquent way of saying that modern sculpture should not concern itself with heroes

had been special cases, involving trophies of war, symbols of professions, and attributes of gods and mortals. It was the sculpture of painters that broke the barrier against making sculptures of things with no ulterior motive. Picasso's sheet metal *Guitar* of 1912 (Fig. 75), and its model in cardboard derived from preoccupations with still life in painting and it now appears even preceded his first collages.[46] Artistic problems and possibilities, not primarily a desire for novelty, motivated the making of *Guitar*, as its dislocated, flat planes, sharp edges, and wire "strings" are extensions of Picasso's drawings and oils of this time. These analytic and atmospheric Cubist works had progressed by 1912 almost to abstraction, and *Guitar*

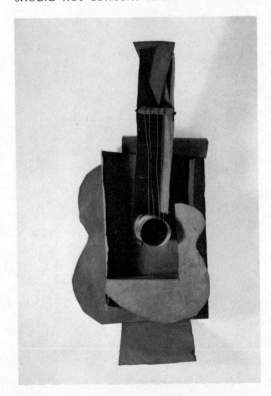

75. Pablo Picasso, *Guitar*, 1911–12.

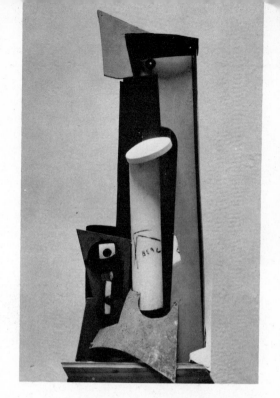

77. Henri Laurens,
Bottle of Beaune, 1918.

and allegories? Sculpture more than painting gave Boccioni the means to show how an object interacts with actual light and space.

After 1915, Archipenko, Lipchitz and Laurens did a few reliefs with still-life subject matter (Fig. 77). Lipchitz remembers that one incentive for him was that it was not considered the thing for a sculptor to do. For full-time sculptors such as these men, objects were not viable nor of lasting interest. That they took up this subject was due to the mutuality between painters and sculptors. It was Braque who had introduced Laurens to Cubism by making drawings on his studio wall. Braque had also been making cardboard constructions at the time.

76. Umberto Boccioni, *Development of a Bottle in Space*, 1912.

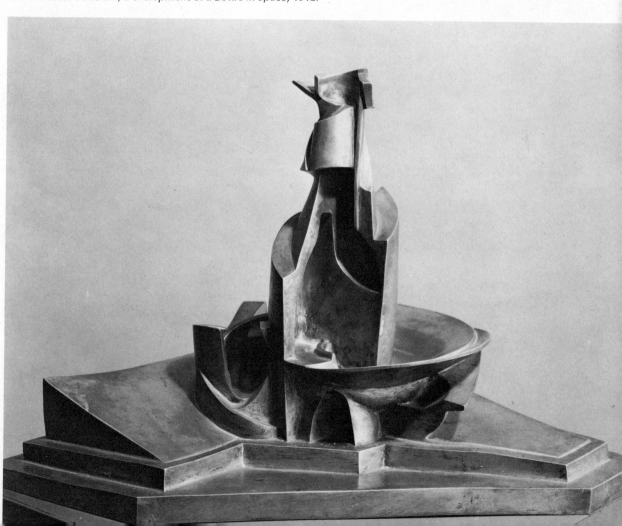

Boccioni undoubtedly learned much from Picasso's sculptures, but in his writings were voiced strong criticism that reflected honest and fundamental differences, and which help to explain why his sculpture is more sensual, dramatic, and evocative of energy. Claiming that there was no such thing as rest, and that objects have "inherent motion," Boccioni sought to show "the living object in its dynamic growth" as a result of empathizing with the subject. "We Futurists are right inside the object, and we live . . . the motions of its inner forces."[47] Picasso's work seemed to him restricted to the construction of an object, not the object's "action." *Guitar* and its companion Cubist constructions may have appeared to Boccioni to lack a deeper sense of reality, "the definitive" sought by the Italian. Never intended as scientific illustration, Boccioni's "force-forms" that defined the object and its "driving force" were poetic cognates of invisible reality. To Boccioni, Cubism seemed an unfeeling, intellectual analysis that imposed formulas on the object and reduced art to a frigid sign language, or a dissected corpse. "Emotion in art needs drama" was his sally.

Between 1917 and 1921 Brancusi carved four large wooden *Cups*, of varying proportion, none of which were hollow. The sculptor denied their utility and tacitly proclaimed their purpose as contemplation. No pedestals were made specifically for them and their manner of display in the home, particularly a dining room, was a matter of taste or wit. The earliest *Cups* (Fig. 78) precede the experiments of Malevich, who in 1920, began designing cups and teapots for industrial manufacture thereby bringing the benefits of abstract research in art to the service of the Russian masses. Brancu-

si's sculpture did not have similar Utopian motives and according to Geist may have been inspired by Eric Satie's example of writing "furniture music," intended to serve as a casual background sound. As Geist further observes, "*Cup* is a modest creation modeled upon a commonplace artifact; by the simplest means it releases a poetry of the object. After the *head as object*, and the *torso as object, Cup* is the *object as object*; the gambit is quintessentially Brancusian."

Reportedly in 1914, the Italian artist Alberto Magnelli made a still life composition in which a Cubistlike series of plaster planes composed the setting for an actual bottle and stone bowl (Fig. 79). His own painting was then abstract and the intrusion of these unreformed, actual objects was surprising, but not their situation as a still life. This early use of found objects contrasts with the more problematic function of Duchamp's Readymades.

Marcel Duchamp's *Bicycle Wheel* (Fig. 80), of 1913, and *Bottle Drying Rack* the following year, appeared shortly after Picasso's and Boccioni's first sculptures of objects. Whereas the latter put their ingenuity, wit, and skill to the service of reforming common objects, Duchamp chose objects made by machines as a logical step in his pursuit of a depersonalized art, or more precisely, the quest for a form of expression that answered the question of whether or not an artist can make something that was not art. Reacting against what he thought was excessive emphasis upon sentimental subjects, taste, and miracles of craft, Duchamp selected his subjects by his esthetic "indifference" to them. Their industrial manufacture made them independent of art-world esthetics. Picasso, Boccioni, and Duchamp were each concerned with tearing down catego-

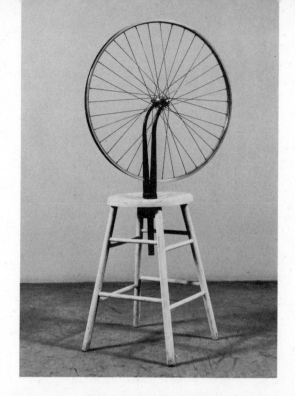

78. Constantin Brancusi, *Cup*, 1917.

79. Alberto Magnelli, *Still Life*, 1914.

80. Marcel Duchamp, *Bicycle Wheel*, 1951, third version, after lost original of 1913.

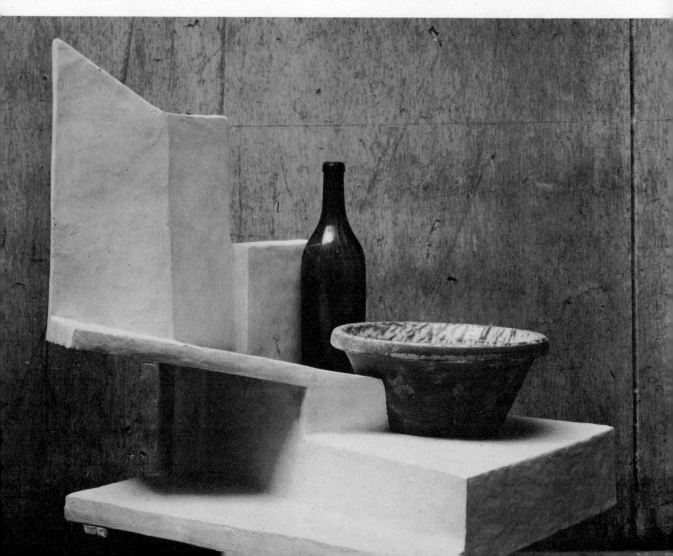

ries between the arts, and "de-mythologizing" the artist's role as well as the esthetic object, thereby exposing the conceptual poverty of Salon art. Duchamp went further and created what might be called art's double. At the time he selected his *Bicycle Wheel* and *Bottle Rack*, he did not claim them for art and they were kept in his studio. The tireless wheel, in motion at the owner's whim, served the artist as stimulation for speculation about links between levels of reality. (He compared the moving wheel to flames in a fireplace that induced poetic trance.) *The Bottle Rack*, whose original title Duchamp later forgot, may have been a pun on a figural torso as well as phallic shapes. By his Readymades, Duchamp proclaimed a Utopian view that the distinction between artist and layman, in so far as manual skill and taste determined it, had been eliminated. Many have claimed Duchamp's Readymades as sculpture and argued unpursuasively that they are more beautiful or interesting than what sculptors were then doing. These objects did exert an influence on later sculptors, but in 1913 and 1914, the artist was creating "a new thought for the object." They belonged to a new category of considerable relevance today, namely, that of other things artists do besides painting and sculpture.

81. Vladimir Tatlin, *Relief*, 1914.

Abstraction

The object as subject and abstraction were the thematic revolutions of early modern sculpture. Abstraction appears a few years later in sculpture than in painting. Its emergence in Tatlin's reliefs of 1913 (Fig. 81) presupposes not only Picasso's constructions in metal and wood, but the climate of abstract painting and theorizing to which this artist had been exposed in Russia before 1914.[49] Paradoxical as it may seem, Tatlin's change from painting to abstract sculpture was inspired by the desire to convey reality. The sheer physical literalness of his materials mounted on a flat vertical background gave Tatlin a new tangibility and link with material existence. Though they were conceived independently of one another, there is a similarity between Duchamp's Readymades and Tatlin's first "painterly" reliefs in that Tatlin

would often use an object as it was found and, as did Duchamp, simply change its context or give it a new syntax. Picasso's influence caused Tatlin to make that context one of several formal relationships deriving from multiple components. Tatlin's materials were more heterogeneous than Picasso's and not reconstituted into a still life, nor is there ambiguity about their scale, as they do not allude to cups or musical instruments.

It was in Russia that abstraction appeared in a number of sculptures by different artists, all of whom, like Ivan Puni, were originally or primarily painters, and sculpture without traditional content became a movement. This phenomenon was definitely linked to the pre-Russian Revolution ardor of artists for dramatic change in the arts that would portend social upheaval. Artists had a mutuality of interests with poets and musicians who were questioning the conventions of meaning and harmony in their respective media. Baranoff-Rossiné was a musician as well as a painter, which helps to explain the title of his astounding and recently rediscovered sculpture, *Symphonie no. 1, of 1913* (Fig. 82).[50] Baranoff-Rossiné, who was twenty-five years old when he made this sculpture, was working in Paris in 1913 and exhibited a second version in the *Salon des Indépendents* a year later. Discouraged by its reception, he tossed it into the Seine. Figural only in overall configuration and not in its parts, *Sculpture Symphonie no. 1* verges on abstraction. The young musician had found in Picasso's Cubism the example and incentive to orchestrate shapes like sounds, to break with melodic line in favor of discordant harmonies of colors, textures, and forms.

Uncertainty of dates, the loss or un-

82. Vladimir Baranoff-Rossiné, *Symphony no. 1*, 1913.

availability of the sculptures themselves make it hard to appreciate and credit the achievements of other Russian artists such as Alexander Rodchenko, Lev Bruni, and Kasimir Medu-

83. Alexander Rodchenko, *Construction*, 1917.

84. Kasimir Meduniezky, *Abstract Construction no. 557*, 1919.

85. Henri Gaudier-Brzeska, *Ornament*, 1913 (?).

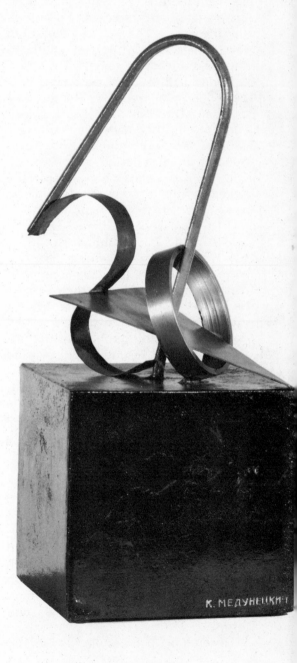

niezky, who broke through to abstraction. Before his and Tatlin's conversion to making art useful to the masses, Rodchenko seems to have fabricated at least one free standing *Construction* (Fig. 83), less figurelike than Baranoff-Rossiné's piece, but its stance and gesture echo those of a human or animal form. The simple slitting of planes for joining and piling up of disparate flat shapes to evoke but not imitate bulk made Rodchenko's piece prophetic of post World War II welded totemic themes such as those of David Smith. Meduniezky's sculpture, *Abstract Construction no. 557*, of 1919 (Fig. 84), takes advantage of the tensile strength of metal to produce configurations that deny figural associations and bring a new openness to sculptural form. Working in Moscow, most of whose houses were still built of wood, and during a war and revolution, sculptors such as Lev Bruni made

60

ture passed from an art of subject to object matter.

Rather than the fanatical total commitment of the Russian vanguard to abstraction, European artists saw it as a fascinating but not compelling option. For Gaudier-Brzeska, whose mind was filled with exciting discoveries in tribal art as well as what he observed in the work of contemporaries in Paris and London, abstraction was something to which he did not want to be tied, but that must be tried. He saw simple geometric forms as an antidote to the clutter of eclectic motifs in such decorative objects as door knockers. His beautiful little *Ornament* (Fig. 85), carved in unpatinated bronze during 1914, suggests the counterfeiting of the human form by means of geometric shapes. For the base of his stone *Embracers* of 1912, he had carved a prism, but *Ornament* was a more compelling design. Gaudier's tragic death does not allow history to show if what had been marginal in terms of sculptural base design, would have become truly and consistently central to his art at a later date. His many abstract drawings invite an affirmative speculation in this regard.

Having converted to the possibilities of Cubism in his painting while in Paris, when Max Weber returned to New York before World War I, he did a few modest plaster sculptures around 1915 in which he ventured into total abstraction. Like many pioneering efforts with new ideas, these sculptures were small and of inexpensive plaster, and only many years later was the torsolike *Spiral Rhythm* enlarged and cast in bronze. There is little in the Weber literature about these pieces, and their motivation. One might conjecture that trained in painting from the figure, Weber made his small abstract models to discover the

wooden constructions that were probably models pending the time when artists could realize their dreams of engineering large works in metal. Bruni's small scale *Construction* is feasible in wood, but steel would have allowed him to employ large scale cantilevering devices to pivot the planes in all directions while the form sprang from the ground on a narrow shaft. In the work of intrepid Russian artists, sculp-

effect of geometric forms in the round, and despite their crude finish one is struck by the intelligence of overall design. On the other hand, the Italian painter Alberto Magnelli did achieve abstraction in his painting, as had Weber, and his plaster and copper *Rhythms* of 1914 or 1915 is among the first Italian abstract sculptures. Weber's *Air-Light-Shadow* construction (Fig. 86) implies making palpable the elements of a Cubist painting, but by the angular stacking of his painted plaster planes he could avoid Cubist frontality and achieve dramatic projections of shadow. Magnelli's contact with Parisian Cubists rather than with his Futurist countrymen, may account for the focus on purifying rhythmic form to curved and straight elements and an admixture of materials.

Mutual support among artists also helps to account for the appearance of abstraction in Italy. Not Boccioni, but the painter Giacomo Balla created some of the first abstract sculptures in Italy of which one survives, *Boccioni's Fist: Lines of Force*, from 1915. Originally made of wood and cardboard and painted red (since repaired and cast in an edition of bronzes), the sculpture's form came directly out of Balla's abstract paintings and invention of signs for speed, an interest shared with Boccioni. The title and sculpture were a revolutionary symbol of the Futurists' aggressive hopes for bringing Italy into the twentieth century. Now lost are constructions, called *Futurist Reconstruction of the Universe* in fragile material that he and a painter named Fortunato Depero respectively made in 1914 and 1915, inspired by Boccioni's encouragement of mixed media (Fig. 87). Balla wrote that these works resulted from his paintings in which he claimed to have discovered the essential laws and lines of force: "I

86. (top) Max Weber, *Air-Light-Shadow*, 1915.

87. (bottom) Fortunato Depero and Giacomo Balla, colored "Noise-Motion," 1914-15 (destroyed).

understood that the single plane of the canvas did not permit the suggestion of the dynamic volume of speed in depth. . . . I felt the need to construct the first dynamic complex with iron wires, cardboard planes, cloth, and tissue papers."[51] Known to us only in photographs, the "new object" created and assembled by these two artists conveyed their optimism and sense of a joyful world. Their 1915 manifesto, "Futurist Reconstruction of the Universe 1915" which resonates with hopeful energy, enthusiasm and brashness, says in part, "We will give skeleton and flesh to the invisible, the impalpable, the imponderable and the imperceptible. We will find abstract equivalents for all the forms and elements of the universe, and then we will combine them according to the caprice of our inspiration, to shape plastic complexes which we will set in motion." Old photographs make it hard to discern the makeup and workings of their "plastic complexes" but the manifesto inventories at least some of the materials and gives an ambitious scenario for its performance that was intended to destroy sculpture's silence and stillness. Whether or not it functioned according to plan, and for how long, we don't know (their hopes seem to have outdistanced their mechanical skills), but in word and daring deed they had established the premises that sculpture by resembling only itself could be autonomous; that sculpture could contain its own colored light made available by the electrical energy that powered the whole; that sculpture could move; that sculpture could have multisensory appeal by also rewarding smell and hearing. Abstraction killed the nostalgic connotations of traditional representational art for the Futurists. It prepared the base for not only persuading young and old to accept the present, but in proposed Futurist "toys," that Balla and Depero wanted to design along the principles of their plastic complexes, to also be conditioned to a life of laughter, danger, and war.

The abstraction of Brancusi and Van Tongerloo did not emerge in the furor for political and social revolution, but was the quiet, logical culmination of problems that were artistic in origin. Both men sought to free sculpture from entanglements in politics and social issues. Brancusi's first *Endless Column* of 1918 (Fig. 88), evolved from reminiscences of Romanian vernacular architectural decoration and the artist's earlier interest in redesigning the pedestals for his sculptures. The height of *Endless Column* is sufficient to prevent its confusion with a pedestal. It was his first work devoid of natural allusions. Conceptually and in later versions it grew to be the artist's inspired design for a link between earth and sky, a kind of miniaturized world axis. The artist's processes of forming the wood are more evident than in most of his previous sculptures. The rough finish seconds the intuitive reckoning of the proportions, as Brancusi refused to submit to pure geometry on those infrequent occasions when he departed from nature.

By contrast, in 1917 the Belgian artist Georges Van Tongerloo began to arrive at artistic expression by means of geometric forms that he thought of as the creation of a new "crystal." The crystalline analogy was of interest to Lipchitz in his almost abstract images of about this time, and in 1914 Gaudier-Brzeska had used a crystallike base for his figural sculpture of *Lovers*. Neither of these last two artists could bring themselves to make the abstract implications of the crystal the basis of

63

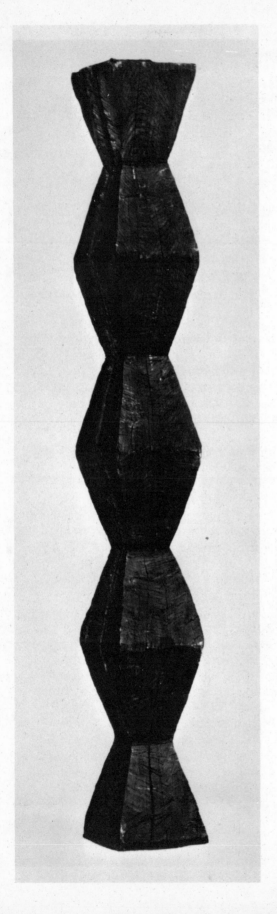

their art. Van Tongerloo, however, formulated a new premise for his life's work: "There is no need to express art in terms of nature. It can perfectly well be expressed in terms of geometry and the exact sciences." This did not preclude sensitivity in art, as the artist could introduce the "unknown" (a word he preferred to "intuition") as a variable in his formulations. He saw the use of geometry as important to true creation, not the reproduction of nature or imaginative fantasies. Mathematics he saw as a means, an instrument, "used as one uses a hammer and chisel to cut marble," to get closer to his values than by guesswork. Neither Cubism nor the machine led this Belgian artist to abstraction: "It was solely his conception of universality and of the plasticity most suited to its expression. The abstract was least conducive to confusion and worship."[52]

To conclude that these artists were solely motivated to *épater le bourgeois* is to forget that cynicism is not the basis for a man's life in art or revolution. You don't nourish a plant on just acid. To the Alsatian-born Jean Arp, art was the fruit of man, a natural issue from thought and feeling. Rather than as abstractions, he viewed his collages, reliefs, and later sculpture in the round as concretions of his experience with nature. Writing about his work of 1915–1916 in Zurich, Arp explained, "Our works are constructions of lines, surfaces, forms, colors. They attempt to approach reality. They hate artifice, vanity, imitation, tightrope walking. . . . Art should lead to spiritualizing, to a mystical reality."[53]

The "shock of ideas" with which the man on the street was to be confronted in early modern sculpture included reflections on art and society, man and nature, and the nature of reality, conceived and rendered by sculptors in the first person.

88. Constantin Brancusi, *Endless Column*, 1918.

II

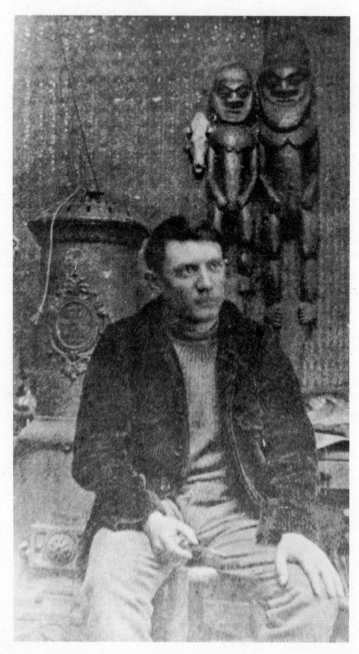

89. Picasso in his studio, 1908–09.

The revolution in form

The formal revolution of early modern sculpture was even more dramatic and consequential than its thematic differences from traditional art. What was being assaulted were powerfully entrenched official educational systems and generally accepted attitudes about sculpture's appearance that had resulted from over four hundred years of refining classical and renaissance ideals and the most sophisticated naturalism ever seen in world sculpture. As Boccioni put it in his sculpture manifesto of 1912, "The artist copies the nude and studies classical statuary with the simpleminded conviction that he can find a style correponding to modern sensibility without relinquishing the traditional concept of sculptural form."

The new challenge to traditional concepts of form was a more extreme idea of *unity* that defied traditional expectations of finish and detail, anatomy and expression, harmony and order. Simply stated, the premise accepted by all the early rebels of modern sculpture was that *the overall quality of a sculpture dictates the treatment, logic, and number of the parts*, and not the reverse. Boccioni phrased it succinctly: "Sculpture is a world in itself with its own laws," that for the militant Italian Futurist entailed "harmony measurable only by the creative imagination." Maillol and Matisse believed that Rodin sacrificed unity by focusing on units, which though marvelously fashioned, failed to resolve themselves into an integral whole. Matisse had his own view about how the whole of a sculpture could be greater than the sum of its parts, " . . . I could only envisage the general architecture of a work of mine, replacing explanatory details by a living and suggestive synthesis." For Raymond Duchamp-Villon, modern sculpture meant a more "effective presence of the creator in his work as the indication and proof of its value . . . the realizing of the processes of thought." For Van Tongerloo, sculpture was no longer a matter of reproduction, but of creation. Early in this century artists displayed a new candor about what a sculpture was, how it was made, and who they were.

All over Europe for hundreds of years, academically trained sculptors

had been enjoined to work for a harmony of the ensemble and to strive to make clear the essential lines of their composition. Both in form and subject, these maxims were based on knowledge, whereas the new sculpture presupposed understanding and intuition. The change was in how a sculpture was conceived, how it was to be viewed, and to what it could refer. Traditional sculpture was conceived in terms of anatomical possibilities, to be read emphatically as a frozen theatrical mime, judged against historical prototypes. The new sculpture moved away from mute theater and often the "noble" materials of marble and bronze. Also left behind was the inductive formation of the figure out of precisely finished explanatory details that presupposed the inviolability of the human form. For sculptors such as Maillol and Matisse, the beginning came with a vision of the whole, and while thereafter maintaining recognizability of the figure or abandoning it for objects or abstraction, the sculpture was submitted to strong personal esthetic systems, new harmonies inspired by the unique spirit of each work. In Boccioni's words, "In art the human figure and objects must exist apart from the logic of physiognomy." What had been true for exceptional artists of the past became accepted practice for the independents: rules were made by and for the individual sculptor.

Just as did their counterparts in painting, the most venturesome sculptors sought to eliminate sequential reading of their compositions, to eliminate hierarchies of interest or avoid focus arrested on one area, in order to accelerate apprehension of the whole. At the end of the last century, in painting such as that of Gauguin, this was accomplished by flattening and simpli-

fying shapes and often by creating large areas of unmodulated color and clear linear contours. In the Neo-Impressionist mosaic style there was an enlarged and uniform microstructure of rhythmic, colored touches that conveyed simple motifs. These two styles had their counterparts in sculpture as roughly exemplified by Maillol and Matisse and corresponded to the two contrasting Salon styles of the "classic" and "picturesque." Rodin, Rosso, Degas, Bourdelle, and Matisse, for example, shared characteristics of the picturesque, which meant that they opted for strong effects of light and dark in their modeling. Matisse's work in sculpture as well as painting contributed to the modern esthetic that places equal responsibility for harmony on all parts of the composition.

Sculpture developed its equivalent for the pronounced but not exclusive surfaceness of turn-of-the-century painting. There was an Art Nouveau small sculpture, seen in the work of Pierre Roche, Théodore Rivière, and others, that to more thoughtful artists seemed a stylized naturalism that evaded sculpture's real problems and unexplored possibilities. Whether by strong modeling that stopped short of description or by the smooth and more explicitly planer surfaces pioneered by Maillol, the avant garde in sculpture was to academic sculptural taste as Impressionism had been to the *École des Beaux-Arts* ideals of painterly finish. Completeness, meaning fulfillment of the conception, replaced finish. The explanatory detail or *"rotule"* (observance of such anatomical details as the patella) could be abandoned. Unlike the academic criterion of the sketch, the sculpture of Degas, Rodin, Rosso, and Matisse was not intended to be carried to further definition or considered preliminary to

another and final work. The rawness of preserved facture was intended to compliment vision in the case of Degas and Rosso and feeling or sensation for Matisse. Except for Rodin, the surfaceness of early modern sculpture derived from an aversion to imitating nature and was directed towards a new responsiveness to thought and feeling that often included affirmation of the physical existence of the sculpture itself.

Questions that lead to the premises of early modern sculpture

What stayed sculpture from stagnation, its perpetuation as an art of souvenirs and frivolous decoration, was the explosion of creative energy before World War I. Several young artists rejected the past's preoccupation with answers. The necessity of posing new questions became a way of artistic life. Ironically, it was not their answers but the example of questioning, often the unanswerable, that altered the course of sculpture and brought it to the present crisis of identity and survival. If heroism is measurable by the energy and urgency, the scope and depth of rebellion against a powerful force dedicated to the preservation of things as they are, then the years between the 1890s and about 1918 were the heroic period of modern sculpture. Before 1914 the *École des Beaux-Arts* and the Academy were still worthy adversaries. The rebellion began with many artists who had not been trained in the former and did not aspire to the latter. They asked questions that theorists and instructors at the *École des Beaux-Arts* believed were about the unquestionable, either because they were convinced of the answers or

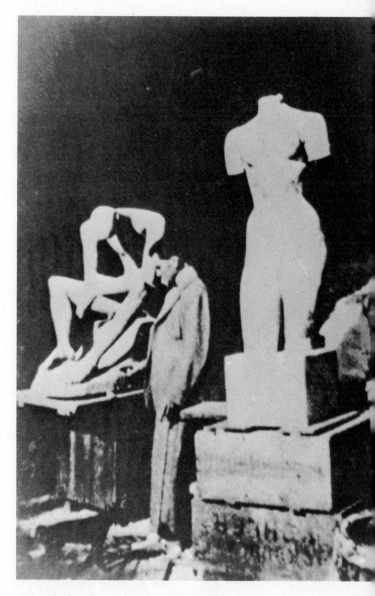

90. Lehmbruck in his studio, Zurich, 1918.

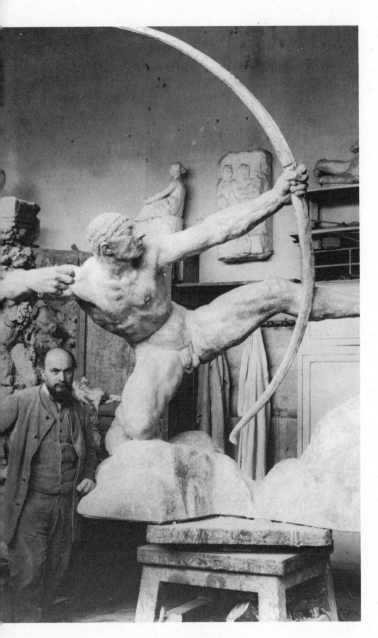

91. Bourdelle in his studio next to *Heracles the Archer.*

could not see that the questions applied to sculpture as it had been known in Western art since antiquity.

The questions hereafter posed have been formulated in many cases from artists' statements and often deduced from their work. It is not lost upon us that the language of the sculptor's working experience is different from that of verbal discourse and that some of these questions may not have been actually verbalized. A question may have been a conscious one for an artist only after having worked from intuition, when he then pondered his departure from convention. During a time when sculptors were unanimous in opposing all forms of the "accidental," however, their revolutionary works may be viewed with some assurance as solutions to definite if often unvoiced problems. Many of these questions were similarly posed by painters, whether or not they also made sculpture, or were evoked in sculptors by seeing what was happening in the work of their painter friends. In early modern art, painters and sculptors tended to be mutually supportive.

In the mid-eighteen-eighties Gauguin was asking, how do you liberate the "creative centers of thought?" When he came from Russia to Paris in 1909, Archipenko was concerned with how an artist could be inventive and not imitative. With the invention of collage in 1912, Picasso and Braque were in effect asking in reference to art's "*trompe l'oeil*" history, can't sculpture "fool the mind" instead of the eye? Cubism helped Picasso with the question of how to restore mystery to art and make it freer to fantasy. First Gauguin and then younger artists such as Derain, Picasso, Brancusi, Epstein, Modigliani, and Gaudier who haunted the ethnographic museums, the Lou-

vre, and the British Museum were wondering after 1905, why should artists restrict formal inspiration to Egypt, Greece, Rome, and Florence? What does tribal sculpture, folk art, preclassical and early Eastern art offer to artists who want their work to be both personal and have universal reference? Beginning with Rodin, those who did not have academic training in sculpture, such men as Rosso, Matisse, Duchamp-Villon, Modigliani, and Gaudier, were faced with the question of how a modern style may be individually acquired. Maillol, Brancusi, Duchamp-Villon, and Van Tongerloo recognized a problem of uncomplicating sculpture and making it into an art of simple but meaningful forms. Maillol, Matisse, and Brancusi thereby found their answers to the question of how sculpture can give joy. Brancusi's meditations on what the essential in nature looked like gave new replies to an old academic question that referred the student to the study of classical Greek sculpture. All pioneering sculptors asked themselves, what is sculpture's primordial nature, its essence, and how should sculpture be redefined? Nadelman neatly plotted the question in 1910: is it resemblance to nature or form itself which gives us pleasure? What is the true form of art?

No avant garde sculptor could ignore the question of whether or not sculpture must serve society and be a moral, educative force through its subject matter in order to be important. Lehmbruck's soul was tried until his suicide over what cost academicians no sleep: could sculpture serve country and humanity? In 1913 the German artist complicated the question: can sculpture serve *self*, country, and mankind? Duchamp-Villon asked in 1913: how can monuments be made in a time of flux and absence of true he-

roes? In his *Gates of Hell*, begun in 1880 and unfinished at his death in 1917, Rodin had set himself a question that Barlach was to pose during a trip to Russia in 1907; can sculpture interpret the human spirit confronted by modern life? Answers to the questions of whether new symbols or metaphors are possible for modern life and how can sculpture come to terms with the machine were offered by Epstein, Boccioni, and Duchamp-Villon between 1912 and 1914. A year later young Russian sculptors like Ivan Puni were asking why sculpture should show order and not the disorder in the world. Uninterested in new subjects, Matisse, Brancusi, and Archipenko posed the question of whether new means could give fresh meaning to old motifs. In his letters and writings Gaudier-Brzeska came to grips with how meaning is conveyed in a sculpture and whether it must have subject matter. With the development of his Cubist sculptures of 1915, Lipchitz was forced to ask himself if human qualities could be imparted by abstract forms. As he faced abstraction in 1917, the Belgian, Van Tongerloo, was confronted with the issue of whether sculpture that was not centered on the human figure could be important. Part of his response was another question: why must only nature be the sculptor's inspiration? With the exhibition of Boccioni's *Development of a Bottle in Space* in 1913 (Fig. 76) and Picasso's *Guitar* on view in his studio in 1912 (Fig. 75), artists were asking themselves, why not objects as the sculptor's subjects?

In 1900, Rodin was sixty years of age, and he continued to exhibit and make sculpture almost until his death in 1917. For many young artists seeking to grow and establish their own identity, Rodin was the problem. Bran-

92. Derain in his studio, 1908–09.

cusi would not work for him, as he questioned whether new trees could grow in the shade of a great old one. Rodin's own problems included wrestling with how to draw attention to "pure sculpture," the beauties of modeling the figure without the distraction of subject. In 1889, with what may have been the first exhibition of his partial figures, he was in effect asking, must sculpture show the whole man? Can just part of a figure make a complete sculpture? He was not to resolve his doubts until around 1900.

Questions of how and what we see occupied Degas and Rosso in the nineties. Degas wanted to know what true bodily movement looked like in stationary sculpture. Rosso built his art on the questions of what does sculpture look like that corresponds to the way we actually see, and do we really experience a free-standing sculpture or life itself from all sides?

Fundamental to many early modern sculptors was the question of why sculpture should continue to be considered a precious object as signified by the pedestal. In the nineties Rodin had answered his own question of when could the sculptor dispense with a base and pedestal. In 1912 Archipenko and Boccioni were querying how the base could be more effectively integrated into the sculpture's design. Brancusi's questioning altered sculpture's foundation: why must the pedestal be either imitative of architecture or a cube? Why should sculpture have a base and pedestal? Questions of the necessity of the pedestal and base accompanied those posed by Picasso and Boccioni of how can sculpture be meaningfully united with the real world. Duchamp's questions of 1912 are still being answered: What is the difference between a sculpture and a utilitarian object? What is art?

The heretofore unquestionable was rejected by Matisse between 1900 and 1903, when in his *Serf* (Fig. 102) he posed and answered the question of whether expression is limited to the hands and emotions mirrored on the human face. Why illustrate the thoughts and feelings of others? Should any part of a well-made sculpture be inexpressive? Why not *self*-expression?

All figural sculptors, but notably Nadelman and Duchamp-Villon, wanted to know who and what determines proportion. Why should artists believe that the findings of Vitruvius, Leonardo, and Dürer had resulted in perfect proportion? Brancusi raised the question with his *Sculpture for the Blind* of 1916 (Fig. 109), of why sculpture should consist of more than one part, and what are the minimum conditions for making a serious sculpture? What does absolute form look like? After looking at tribal art, Picasso had

72

to wonder why sculpture must have "museum beauty." Why not express hate as well as love?

To the artist who wanted to free himself from Rodin's influence, a pressing problem was to convey individuality without evidence of the forming process of the fingers. How can sculpture have a "skin" that does not imitate flesh? Brancusi and Archipenko pondered the sculptural surface and wondered how light could be more effectively used on sculpture. Should it be further decomposed or more unified in its reflection? In 1912 Archipenko questioned the inviolability of the body when he asked himself what happens when the figure is penetrated by space. He, Boccioni, Picasso, Lipchitz, and Gabo wondered where does sculpture end and where does space begin? Can voids produce volumes?

It is apparent that many of these questions were interconnected, and their answers prompted still further questions. For example, Gauguin as early as 1882 in his reliefs, then Derain in 1906, and Picasso and Brancusi in 1907, asked why wood and stone could not be carved directly without the intermediary of a drawing or plaster model. This lead to the question of whether there was an intrinsic character to the material that invited or dictated certain types of form. When sculptors such as Archipenko, Boccioni, and Picasso asked if the artist must restrict himself to traditional materials, the result influenced the question of whether sculpture can be made other than by carving and modeling. No academic artist questioned the eternalizing function of stone and bronze sculpture, but by 1913 Picasso had asked if materials must be permanent. These last-mentioned artists could not accept the maxim that paint-ing and sculpture were separate categories, and they along with Lipchitz and Arp wanted to know what happens when color is applied in a nondescriptive way. Finally, most of the pioneers wondered what were the still-to-be-explored possibilities of relief. Must a relief be tied to architecture?

It was the example of questioning, more than the answers, that made the deepest impression on sculptors after World War I to such an extent that many felt, and feel today, that sculpture can no longer be defined externally, only internally, as something a sculptor does by way of thinking and making.

The partial figure

It has been characteristic of avant garde movements in this century that they not only were motivated by a desire to react against a strong force, but also to build on the most advanced

93. Archipenko.

ideas of their predecessors. To younger sculptors after 1900, Rodin supplied both. They decried his fidelity to the model, his literary titles, passionate gestures and thumbing of the clay. He was too close to nature for Brancusi, and to the Greeks and Michelangelo for Boccioni. But there is no mistaking that Maillol, Matisse, Brancusi, Lehmbruck, Boccioni, Duchamp-Villon, Epstein, and Gaudier-Brzeska developed ideas from the new premise Rodin established for sculpture: a complete sculpture need not presuppose the full figure, and parts of the human body are dispensable to the sculptor.[54]

Before Rodin the history of the partial figure was a special case in sculpture, comprising the portrait bust, religious symbolism such as ancient phallic-cult images, and decorative art where it took the form of the caryatid. Beginning in the sixteenth century, sculptors imitated the ruined fragment of antiquity for personal instruction and as souvenirs for collectors. For over two hundred years students, including Rodin, were taught drawing and sculpture from casts of ancient fragments, but with the understanding that their goal should be the whole figure. Rodin's *Thinker* is partly derived from the famous *Belvedere Torso* in the Vatican, for example. His own art was a recapitulation of the previous uses of the partial figure, including the simulation of an ancient ruin, but by 1900, and in several torsos such as his *Torso of a Young Girl* (Fig. 94) and *Prayer* thereafter exhibited in the *Salon Nationale*, he established by his will and works the validity of the partial figure as central to serious sculpture. After years of questioning and perhaps doubt, the absence of heads and limbs allowed him and his audience to concentrate on what he felt were the beauties of *métier*, the "raw result" of work, his "researches" into "planes and modeling" of the torso. "A well-made torso contains all of life," he argued in the belief that he could endow the body with an expressiveness equivalent to that of the face.[55]

The partial figure liberated sculpture from the conventions of subject matter, the claims of culture, the conventional rhetoric of expression. In removing the comprehension of sculpture from the domain of knowledge, by which a work's identity was verified through reference to textual sources, he opened it to understanding. Since the source of Rodin's partial figure was the living human body, we are given the factor that makes the sculpture true or false in Rodin's terms, and our acquaintance with the body rather than erudition is required for its understanding. He thus made sculpture accessible to the public in a new way and to artists who favored a modern subject matter based on their own experience.

Just before his death, Rodin caused a plaster cast to be made of his right hand, and into which he then put a small feminine torso. (Fig. 95). This was his last will and testament, rather than the legal document he signed under dubious circumstances when, as friends later testified, he was not mentally competent. The life-cast may have been an ironic reference to the accusation that he had so made the *Age of Bronze* and parts of the *St. John the Baptist* early in his career. The tiny torso dramatized how much life there was in his art compared to the result of mechanical reproduction. The torso symbolized what he wanted future sculptors to study, life itself, in order to make realistic sculpture.

Not only completeness, but traditional norms of beauty and perfection

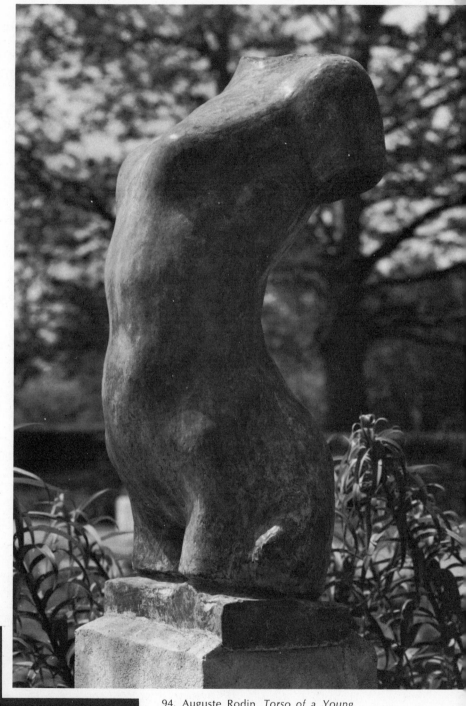

94. Auguste Rodin, *Torso of a Young Girl*, 1909.

95. Auguste Rodin, *Cast of the Artist's Hand Holding a Small Torso of a Woman*, 1917.

were challenged by the partial figure. The classical ideal, for instance, presupposed the harmonious relation of the parts to each other and to the whole human body. Brancusi built upon the partial figure as well as the portrait tradition to produce sculptures that sometimes had but one part and which realized a new beauty and perfection. He felt that salon nudes were like "toads," but focusing on one area of the body such as the lower torso of a man or woman allowed Brancusi to come to the figure on his own terms. With his *Torso* of 1908 (Fig. 96), Brancusi made the first partial figure that was not the result of actual or conceivable subtraction nor intended or used, as was Rodin's *Torso of a Man* of 1875 or 1877, as a *pars pro toto*. (The last became incorporated in the *St. John the Baptist* as well as the *Walking Man*.) Rodin's partial figures may also have influenced Brancusi's elimination of features of the face so that the head approached the form of an egg, and this purification of form opened new possibilities of metaphorizing by the increased susceptibility of his work to associations with other forms in nature having a similar generalized structure. Brancusi's phallicized *Torso of a Youth* and *Portrait of Princess X* marked the breakthrough in art to a new sexual candor. Rodin's example of cutting off limbs liberated Maillol from his own psychological difficulties with arms. "Arms are my calvary," were the artist's words. No longer need the sculptor agonize over feet or hands, disguise them with drapery or see the work suffer by inconsistency of inspiration. Maillol preferred most of his statues in their torso form (Fig. 97). Archipenko was one of the first sculptors, another was Brancusi, to make figures whose missing limbs were not subtracted after the fact of the work's

making, but which were conceived as partial figures (Fig. 98). There were no raw stumps and traces of amputation in his sculptures such as Rodin had left on *Meditation*, when he brutally edited enlargements made by his assistants. For Archipenko, the missing limb won him a new continuity of arabesque and elegance and a space consciousness on the part of the viewer, who instinctively looked for the entire figure. Duchamp-Villon employed the partial figure when he broke with the rhetoric of gesture and sought a new formal terseness in his *Torso of a Youth* of 1910, that would appeal to the mind fatigued by excesses of all forms of expression. It also gratified his ideal of intellectual intervention in art.

What Rodin had not foreseen was that in the mind and hands of Duchamp-Villon and Epstein in their *Horse* and *Rock Drill* (Figs. 47, 48) reduction of the living form would

96. Constantin Brancusi, *Torso*, 1908.

97. Aristide Maillol,
Torso of Freedom in Chains, 1906.

lead to new metaphorizing by inciting analogies between the truncated living form and machinery. For all his denigration of Rodin as a "Renaissance sinner," Boccioni showed the master's influence when in his Futurist sculpture manifesto of 1912 he wrote, "We proclaim . . . a leg, an arm, or an object,

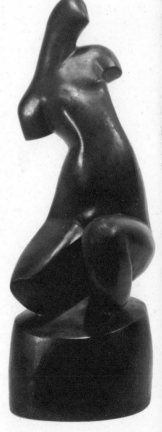

98. Alexander Archipenko,
Seated Black Torso, 1909.

99. Georges Van Tongerloo, *Spherical Construction*, 1917.

having no importance except as elements of plastic rhythm, can be abolished, not in order to imitate a Greek or Roman fragment, but to conform to the harmony the artist wished to create.'' To the new researches into the intrinsic logic and physiognomy of the sculpture, as in Boccioni's *Unique Forms of Continuity in Space*, and sculpture's increasing self-referral for the truth of proportion and order, the partial figure was crucial. As seen in Van Tongerloo's *Spherical Constructions* (Fig. 99) and Gabo's *Torso* of 1917 (Fig. 100), the partial figure was a step between naturalism and abstraction, the break with nature and the demand for its external likeness. For Jacques Lipchitz, who backed away from abstraction, the partial figure offered a new mystery in art and also

100. Naum Gabo, *Torso*, 1917.

101. Jacques Lipchitz, *Half Length Standing Figure*, 1916.

was an aid to conceptualizing, as he constructed the equivalent of the human form in his crystalized structures of 1915, such as the *Half-Length Standing Figure* (Fig. 101). Later in his art, as in that of many artists between the two world wars, the partial figure was vital to the opening up of body imagery to sexuality and fantasy.

Expression

Matisse's employment of the partial figure, beginning with such works critical for his sculpture as *The Serf* (Fig. 102), not only gained him the opportunity to compose his figures more freely and to take liberties with proportion, as in *La Vie*, but to enact his views on expression. For the academician, expression meant primarily the interpretation of the thought and feelings of the subject by means of the face and gestures. It was an *École des Beaux-Arts* maxim that the most powerful means of expression is gesture. Free-standing figures were supposed to be moderate in their use of gesticular rhetoric. When Matisse closed the eyes, lowered the head, and removed the forearms and hands of his *Serf*, he was opting for a new physiognomic, a total expressiveness in his work. Matisse took a historic stand against sculptors illustrating the feelings or thoughts of others in favor of working directly from what he called a distillation of his own sensations derived from contemplation of the model. To have worked from first impressions, momentary sensation, Matisse felt was to deny the potential of his mind. There is no question that his famous "Notes of a Painter" of 1908, was written with Rodin in mind as the example of the type of expression he opposed.

"What I am after above all is expression. . . . I am unable to distinguish between the feeling I have for life and my way of expressing it. Expression to my way of thinking does not consist of the passions mirrored upon a human face or betrayed by a violent gesture. The whole arrangement of my picture [sculpture] is expressive. The place occupied by figures or objects, the empty spaces around them, the proportions, everything plays a part. Composition is the art of arranging in a decorative manner the various elements at the painter's disposal for the expression of his feelings. . . . I could mention the name of a great sculptor who produces some admirable pieces but for him composition is nothing but the grouping of fragments and the result is a confusion of expression."[56]

By 1900, Rodin had come to prefer several of his partial figures, such as the headless and handless study for *Pïerre de Wissant*, and the *Walking Man*, over their full-figured versions, and Matisse's reading of the older man's work did not take into account the latter's concern for the expressiveness of the whole. But Rodin never thought of his work as self-expression. Thanks to Matisse, modern sculpture acquired a new axiom: Expression consists in the total arrangement of a sculpture. It is what the sculptor does and not his subject that is expressive. Frequently Matisse repeated work from a model in two sculptures such as *Madeleine I* and *Madeleine II*, and their differences relate to changes of mode in his style that were inspired by his moods, not those of his model. Except for Elie Nadelman, self-expression was an ethical imperative for early modern sculptors who had seen too many Salon artists deny or obscure their own identity by affecting historical styles to attract sponsors. In the

102. Henri Matisse, *The Serf*, 1900–1903.

paintings of the Fauves, Picasso and Braque, as well as Matisse, there was usually a passivity to the subject that contrasted with the vigor and expressiveness of the rendering. Picasso's *Head* of 1909 dramatizes how he was beginning to "take over from nature, not just to look to it for information and good advice."[57]

Barlach, Lehmbruck, and Nadelman stand out as the only innovative sculptors who continued gesture as a principal means of expression. While the first two continued to seek postures of pathos, Nadelman built upon Seurat's ideas of impersonal expression, the physiognomic of means; and it is the silhouettes, for example, rather than the faces and hands of his figures that are the carriers of expression. Nadelman also tacitly agreed with the academic injunction to the sculptor to "cover your fire," whereas Matisse and others believed that they must remedy the Salon disease of false emotion emanating from the sculptor.

One of the many absorbing claims for our attention from early modern sculpture is that several artists realized that there was a problem with expression, opened up by the revolution in form and the artist's new prerogatives: To what extent and how do considerations of formal expressiveness override the depiction of thought and feeling by the subject? Should physical fact prohibit spiritual inference in sculpture? Should figure sculpture be completely literal and materialistic, hence devoid of any expression from the subject? We take self-expression in art for granted, but the pioneers were just beginning to grapple with such questions as, do claims of the self totally preempt those of the human being represented in one's art? The opportunity for pure self-expression may have added to the attraction of the themes of objects and abstraction, and possibly the partial figure, for there were no counterclaimants to expression.

Brancusi's art mediates between old and new views of expression. In a number of works, *The Kiss, Prometheus* (Fig. 103), the *New Born* (Fig. 104), and *Princess X*, he chose themes of passion, pain, and revery for which over the centuries artists had developed an extensive repertory of gestures and facial expressions. Brancusi abandoned most of the pathos formulas, and in *Prometheus*, for example, he retains only the traditional expressive tilt of the head. *The Kiss* stills the eager hands of lovers. The bawling babe's mouth in the *New Born* has become one of several abstract shapes that wittily contrive the head. Brancusi introduced a new discretion in expression, muting but not eliminating what others in the Salons made melodramatic at the expense of good sculptural form. Brancusi and Gaudier-Brzeska both may have seen in tribal sculpture a largeness of movement that conveyed the essence of the subject's experience. In *Princess X* there is no mistaking the mood of self-absorbtion, or Brancusi's genius in finding a form that bridged African and European sculpture. Isolated, neckless heads, such as Brancusi's *Sleeping Muse* series, invite being called objects. To do so without such qualification as object-like, is to deny all trace of humanity to his subject, which was surely not Brancusi's aim. When he wanted to make pure objects, he made his *Cups*. Least of all was Brancusi a materialist!

In 1910, at age 20, Gaudier-Brzeska wrote to Dr. Uhlemayr, "Art has no moral aim. . . . a statue has nothing to say—it should only have planes in the right places—no more."[58] Ironically, the young sculptor, then still a mode-

81

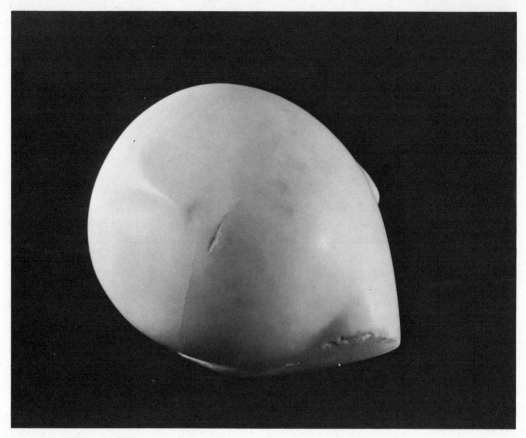

103. Constantin Brancusi, *Prometheus*, 1911.

104. Constantin Brancusi, *The New Born*, 1915.

ler, was like Pygmalion, dreaming of making "a statue of a single body, an absolute truthful copy—something so true it will live when it is made, even as the model himself lives." (It was at this time that the artist was excited by such Rodin figures as the *John the Baptist*.) In the next four years while his figures would strike poses and effect gestures, their increasing simplification and quieting of movement testified to Gaudier-Brzeska's study of expression in ancient Chinese as well as tribal sculpture. His convictions about self-expression and the physiognomic of sculptural elements and how they were to be conveyed, were written in capitals to Ezra Pound in 1914 who published the letter in *Blast*: "I SHALL DERIVE MY EMOTIONS SOLELY FROM THE ARRANGEMENTS OF SURFACES. I shall present my emotions by the ARRANGEMENT OF MY SURFACES, THE PLANES AND LINES BY WHICH THEY ARE DEFINED."[59]

The attitude held among some of the pioneers such as Duchamp-Villon, that the subject was of "little importance" compared to the need for decorative harmony, further sabotaged the traditional basis of expression. Formal harmony took priority over gesticular mime in Duchamp-Villon's thought, when he cut off the arms of his *Torso of a Young Man* in 1910. He wanted sculpture to "LIVE AT A DISTANCE" through the harmony of volumes, planes and lines. It is interesting that the one outdoor sculpture he praised as being successful was Rude's *Chant du Départ* on the Arc de Triomphe, which was a paradigm of classical views of expression. This selective screening of an older sculpture by a young artist before World War I is comparable to the literalist reading of Brancusi's work by contemporary abstract sculptors today as part of their historical self-justification.

The stricter unity sought by the early moderns was not for Boccioni a matter of taste, but a life attitude, not unrelated to Brancusi's views. For this Futurist artist expression in sculpture had to be understood in terms of how one perceived reality. As written in 1914, for Boccioni reality presupposed motion, and sculpture had to excite emotions through the suggestion in three dimensional form of the subject's "pure motion." The emotive elements that he felt could be brought together in sculpture were not "based on the arrangement of the gestures of a figure, nor on the expression of eyes, faces, stance (all old literary debris which we scorn)." It consisted of a rhythmic distribution of forces and objects, dominated and guided by the energy of the state of mind to combine emotions.[60] Though not always clear in his meaning, it is apparent that Boccioni was opposed to sculpture as traditional theater, the figure in arrested movement. "If the plastic potentialities of bodies excite emotions which we interpret through their motions, it is these *pure motions* that we shall hold fast." What was being expressed for Boccioni was both inherent in the subject and his interpretation of it, and previously ignored in sculpture. Plastic or sculptural means afforded him to express what was verbally unparaphrasable. He could not agree with his French peers that subject was of little importance.

The new objective of wholeness that eliminated psychological expression or minimized the microstructure of facture and marvels of the hand also influenced the apprehension of quality. Rodin had warned artists not to surrender all detail, for the work would become lifeless, and, it is fair to assume, he meant it would suffer a loss of quality. To those accustomed to quality resulting from the accumula-

tion of small areas on the surface that offered surprising deviations from the expected, rich irregularities and skillful summaries that transformed anatomical information into esthetic delight, sculpture such as Brancusi's, Nadelman's, Gaudier-Brzeska's, and others working in broad areas, would have been disappointing or without quality. But quality persisted as subtleties remained in proportion, silhouette, and surface taper; in harmonies of balanced areas, manipulation of light, and purification of shapes that tensed between nature and geometry.

Proportions

One of the many forces against which the pioneers protested was academic norms of proportion, based upon a reconstructed classical Greek canon, or the story of Leonardo and Dürer. The modern alternative is that all sculptural proportion is personal and dependent upon compositional necessity. Early modern sculptors believed in and recognized the necessity of proportion and rules, but as Matisse saw it, "Rules have no existence outside of individuals."[61] Maillol, who had spent several years at the *École des Beaux-Arts*, said, "The canon is a rule that varies with each artist. I have mine."[62] Maillol came the closest to formulating a figure type of fairly constant proportions, inspired, as Rodin saw it, by Mediterranean women of "good measure." Unlike Rodin and Matisse, who varied proportion with the model or feeling, Maillol sought models that measured up to his own ideal.

No artist more passionately threw himself into researching the proportions of the human figure than the young Polish sculptor, Elie Nadelman, who believed that his personal system had been derived from the sources rather than the actual classical Greek canon of Polyclitus. Searching study of sculptures in the Louvre, coupled with experiments with geometry first done with the aid of a draftsman's compass, helped produce his sensational first exhibition at the Druet Gallery in 1909, that critics such as Gide dismissed as "demonstrations" or theorems. Nadelman, just as Brancusi and others, including academicians, believed in absolutes of beauty and perfection. Through calculated and intuited subdivision of the body by intersecting and balanced curves, Nadelman sought sculpture that did not imitate nature but stood as tribute to intellectual artifice. He became obsessed with the idea that Picasso's contribution to Cubism had been stolen from his own researches that shaped the now lost self-portrait of 1907 (Fig. 105).[63] Nadelman could never see that his method of subdividing the head inscribed within a circle was deductive and that Picasso's *Head* of 1909, was

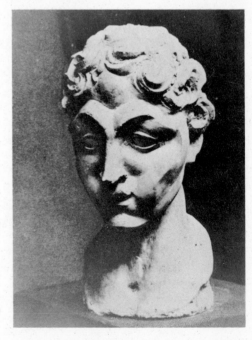

105. Elie Nadelman, *Head of a Young Man* (Self-Portrait), 1907.

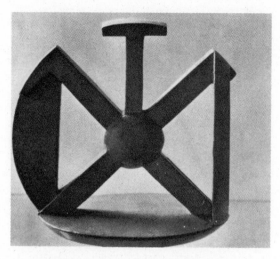

106. Georges Van Tongerloo, *Construction in a Sphere*, 1917.

empirically improvised so that proportions evolved as the work took shape and were not referable to an external norm or geometrically oriented. Picasso's ruthless and more pervasive subdivision of the head was anatomically more improbable than Nadelman's and had slowly evolved through numerous paintings and drawings.

Duchamp-Villon, who believed that each generation could not invent its entire esthetic, was fascinated with renaissance study of proportion. He saw the inquiries of Vitruvius, Leonardo, and Dürer not as proscriptive, but as incentives to new research. His emulation of Dürer is most noticeable in his corrected drawings of sculptures such as the *Torso of a Young Man*. Whereas an academic sculptor would correct the proportions of his live model in accord with traditional norms of beauty and credibility of characterization, Duchamp-Villon's criterion was economy, clarity, and firmness of design of his anonymous figures. Common to his systematic personal researches was a belief in a rationalized measure for beauty.

Van Tongerloo's *Compositions Inscribed Within a Circle* of 1917 (Fig. 106) recall Leonardo's studies of the perfectly proportioned man circumscribed within a square and a circle. If Leonardo's circle stood in part for the divinity, Van Tongerloo's reference was to geometry itself. He sought to liberate geometry from the simulation of the living human form. "Geometry serves to formulate the relations of a new crystal, a creation, a composition," he was to write a few years later.[64] Much like Nadelman, Van Tongerloo never relied entirely upon formulas and always claimed to have imparted an "incommensurable" element to his work in order to transform it into a spiritual body. His use of geometry to study proportion, he felt, in turn liberated his imagination from the material claims of nature and allowed him to approach the sublime. Rodin and Maillol repeatedly talked about using geometry to aid them in constructing their works, and they meant in part visualizing the limits of the sculpture within a pyramid and cube respectively. Duchamp-Villon sketched geometrical skeletons, but later robed them in natural form. With Van Tongerloo geometry more explicitly enters into the sculpture itself.

Matisse and Lehmbruck saw proportion in less rational terms. Whether to solve the problem of opening up the arabesque of his once plump *Serpentine* (Fig. 107) or to convey his passionate feelings about *La Vie*, Matisse relied upon intuition to right the relationships of his masses. Lehmbruck was convinced that all sculpture was a matter of proportion, and modern man required a new measure in sculpture.[65] Northern European medieval sculpture reminded Lehmbruck of proportion's history of relativity and subjectivity. *Rising Youth* and *Kneeling*

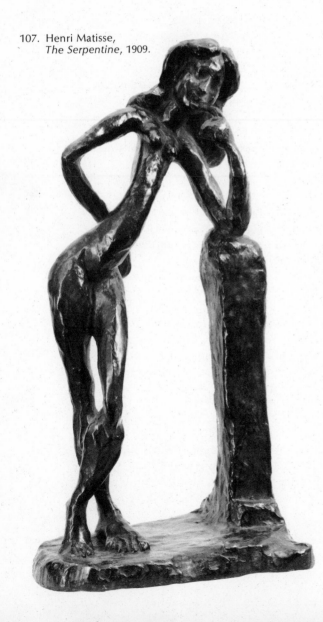

107. Henri Matisse,
The Serpentine, 1909.

Woman (Fig. 108) were elongated to counteract physical emphasis and gravity and to metaphorize their spiritual orientation.

When in 1916, Brancusi made his *Sculpture For the Blind* (Fig. 109), he achieved the most audacious challenge to the traditional notion of beauty, which was the harmonious relationship of parts to each other and to the whole. By eliminating all but one part, Brancusi had broken through to a new harmony, a new beauty, based upon sculpture having a single continuous surface. But in so doing he had not abandoned proportion, as one can intuit the perfected relationship of width to length to depth. (First exhibited inside a bag through whose holes one could touch but not see the work, the surprise was in feeling a surface that Brancusi described as "seething with tiny cubes.") It was more characteristic of Brancusi to have two or more shapes in a sculpture (and not to rely solely on touching it), and his extraordinary sensitivity to proportion may have been nourished by his experience of tribal art that for him as well as Picasso, Derain, and Matisse, revealed alternatives to the classical ideal of a figure measurable as seven to eight heads high. These alternatives to Western "museum beauty," where proportion was referable to the human body itself, provided the aforementioned sculptors and artists such as Gaudier-Brzeska and Epstein in their carving, with the license to vary proportions according to the necessities of design. To Picasso and Matisse, tribal sculpture may also have stood for proportion guaranteed by the artist's feeling. Just as compelling was the possibility of abstraction, which encouraged Cubist sculptors such as Lipchitz to proportion their planes according to compositional urgency

86

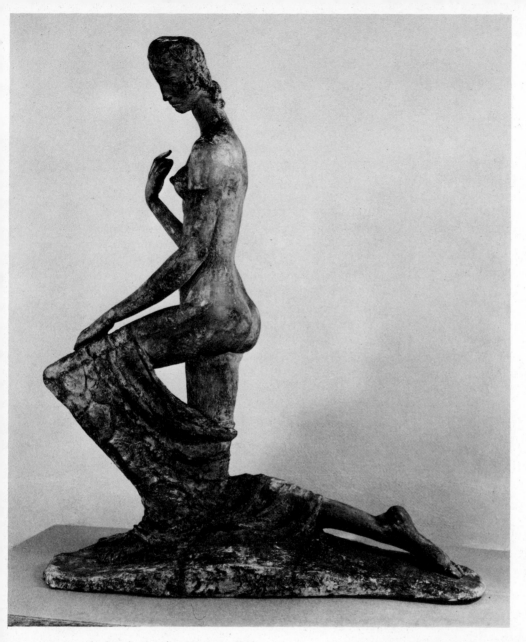

108. Wilhelm Lehmbruck, *Kneeling Woman*, 1911.

109. Constantin Brancusi, *Sculpture for the Blind*, 1924.

rather than loyalty to bodily forms. Proportion had become a matter of esthetic intuition detached from requirements external to the sculpture.

New skin for sculpture

The transformations of the surface of sculpture that begin in the 1890s tend to move from what academicians considered "analytical planes" to what many independents considered "synthetic" planes and finally by 1918, to abstraction. Sculpture was thereby given a "skin" that did not imitate or evoke flesh, muscle, and bone. To the academically trained artist the science of sculpture resided in a study of the bones of the human skeleton. One could take liberties with musculature by thickening or thinning it, but not with the skeleton. It was the fixed point in a sculptor's studies, for it was always the same dimension and embodied the laws of movement or mechanics. The rest of the body was elastic and subject to endless variety.[66] In the final sculpture the limits of the skeleton were expected to be manifested in the body's surface planes. The insistence of academicians upon *aplomb* or the corrected aplomb, (rectification of the figure with a plumb line and calipers) was in part to reiterate the natural internal architecture of the upright human form and to increase its dignity through the way the figure carried itself. Along with analogies to the rationalized construction of architecture and the clarity of its structural axes, the corrected aplomb was part of what academics saw as the "architectonics" of sculptural order. Sculptors who observed these rules were credited with making an "analytic" body surface and were evaluated on their scientific knowledge and astuteness of observation. Although not academically trained as a sculptor, Rodin brought the analytic surface to perfection, and his surface planes were equivalents for the inflected, nuanced textured planes of living flesh (Fig. 110). For Rodin, modeling rested on the "science of planes," their formation and interconnection. He insisted that planes reflect the external limits of the skeleton and muscular system. Critics and other artists respected his knowledge, but felt that he often violated the architectonics of sculpture and surrendered to an indiscriminate acceptance of human movements that did not observe the corrected aplomb. They could not conceive of his sculpture as suitable for architectural decoration. The subtlety of observation and finesse of execution by which Rodin formed his bodies came to be looked upon, even by such close associates as Bourdelle, as lacking in clear, firm order. The surfaces seemed insufficiently architectural and too natural.

A favored word among modelers at the turn of the century was "synthesis," which generally meant not working directly and entirely from the model, but at a certain point suspending knowledge in order to wed conception and feeling to observation. Surfaces should be a blend of anatomical and esthetic decisions. The artist was supposed to take possession of his subject by its thoughtful digestion over a period of time, thereby filtering out unessential anatomical information. Before the cessation of the Salons in 1914, critics observed the increased tendency for sculptors as diverse as Maillol, Bernard, and Bigonet to exhibit synthetic surfaces wherein there was little or no reference to skeletal protrusion. These changes coincided generally with trends towards more re-

110. Auguste Rodin, *The Crouching Woman*, 1892.

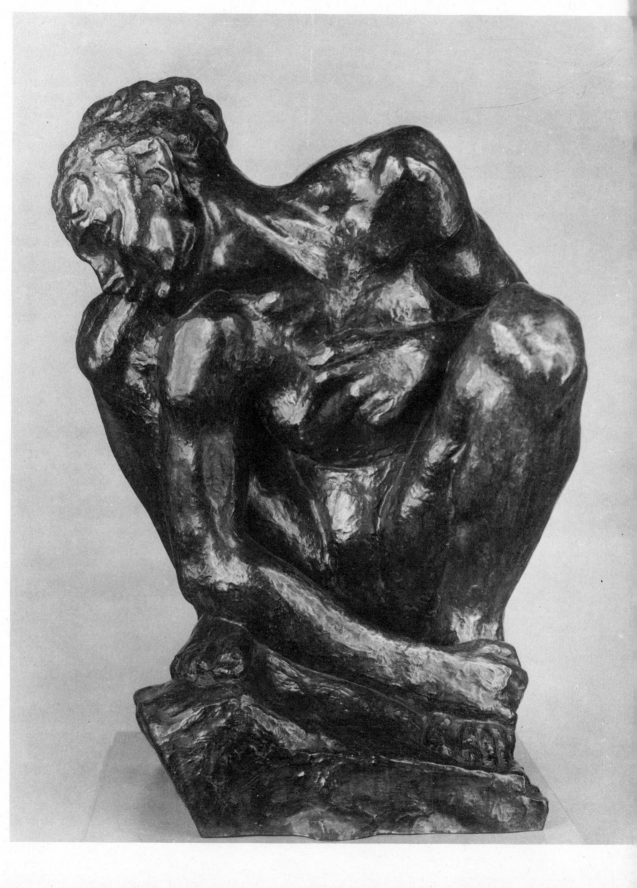

strained subject matter, more passive figures, lighter *effets*, and the renewed interest of sculptors to have work shown in the *plein-air* where they would have to hold up from a distance.

Maillol pioneered the synthetic surface beginning with his wooden sculptures of the 1890s, that were in turn derived from his simplified arabesques; within these, which first appeared in his paintings and tapestries of women, there was often little or no interior modeling. His involvement with the Nabis and symbolism early conditioned Maillol to avoid Rodin's naturalism, and to think in terms of planes deduced from observation and shaped by a concept of fluent fulsome wholeness. Even before Hildebrand's 1893 essay *On the Problem of Form in Painting and Sculpture* was translated into French, Maillol shared the German sculptor's view that the "functional values of nature," [motion and rest of the body] must be submitted to the demands of "total visual form." The clarity of Maillol's surfaces and volumes, coupled with an avoidance of twisting movement, so that the limbs generally moved parallel to each other, earned his work a more manifest architectonic order than Rodin's. Matisse saw this last as timidity, but felt closer to Maillol than to Rodin.[67] Cézanne's invention of a faceted and explicitly planar surface structure influenced Matisse, who sought to go beyond Rodin in at once achieving a richer, more expressive surface, but also a firmer fitting together of the parts. This can be seen in the *Serf* (Fig. 111) by examining the modeled and knife-cut planes. The cutting of flat planes was intended to emphasize the direction of the figural stance.

At the turn of the century Barlach had been involved with Art Nouveau, and in keeping with his later change to peasants as subjects, with their simple "antediluvian costumes," he developed his own synthetic surfaces that respected generalized but not neutral figural masses. The faceted planes of his carvings, like the surface of a Divisionist painting, were counterpoints to the big planes and imparted a consistent sculptural texture and animation to the whole (Fig. 112). Lehmbruck evolved from the pointedly analytical planes of his *Rising Youth* to the less nuanced, tougher and more generalized integument of the *Fallen Man* without losing the sense of the skeleton. This bony hardness in the late Lehmbruck works had its parallel in Duchamp-Villon's development away from naturalism that began with the *Torso of a Youth* and with its surface made of mashed pellets or "bullets" of clay and gave way to the cranial hardness of the *Baudelaire* and smooth finish of the studio wooden *écorché* that inspired the *Seated Woman* (Fig. 113). His corrected drawings bridged the analytic and synthetic surface.[68] Divesting surface planes of texture and nuance that reflected internal musculature afforded new possibilities for the action of light and achieved formal brevity crucial to Duchamp's modern esthetic.

Picasso's ruggedly sculpturesque, faceted figures found in his paintings of 1907 and 1908 appealed to many sculptors as the way from Rodin and the kneading of clay.[69] Archipenko, for one, was aware of them, and they inspired his movement to surfaces sufficiently abstract as to be recognizable only in the totality of the figure sculpture. Before they took on a somewhat stylized hardness, Archipenko's surfaces had to pass through a synthetic phase and then one analogous to geometrical forms, so that when he came

90

111. Henri Matisse, detail of *The Serf*, 1900–03.

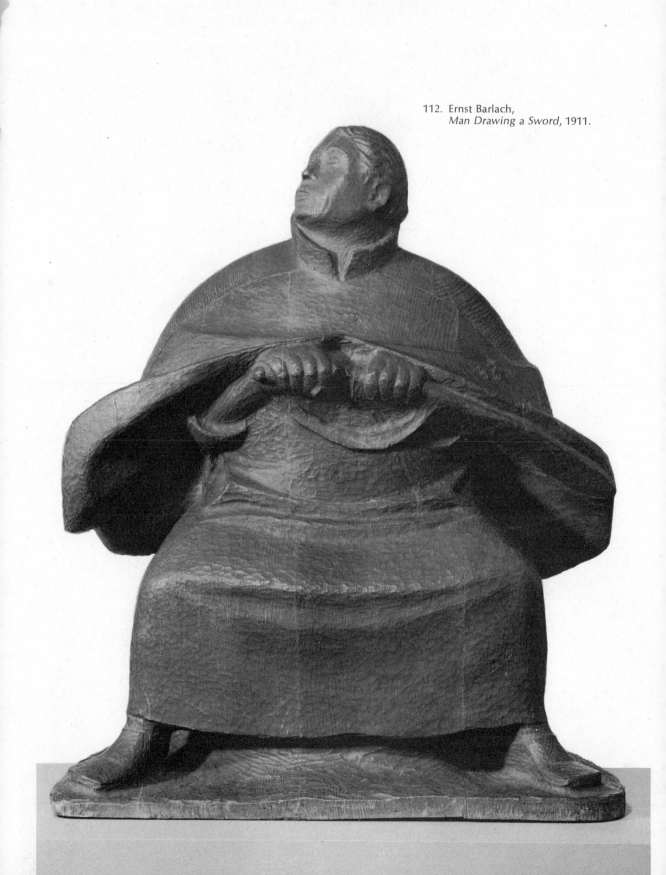

112. Ernst Barlach,
Man Drawing a Sword, 1911.

to cutting sheet metal and plastic in his relief constructions their Euclidian look was consistent with his style. Perhaps the most important influence of Picasso's painted planar figures before 1909 was on stone carvers who, like him, had been looking at tribal sculpture and preclassical carving to which the literal imitation of nature was unknown. Derain had evolved in his painting to an awareness of plane due to the influence of Cézanne and Picasso, and he found by 1906 that the use of broad, flat planes encouraged direct carving. The basic aspects of the simplified figure could be blocked out on the uncut surface. In Hildebrand's terms he eliminated evidence of the body's functions other than being at rest. That the young sculptors were not neutral towards the new planar surfaces is evident along with an explosive enthusiasm and self-assurance expressed by Gaudier-Brzeska in his letter to Ezra Pound quoted earlier. In such works as Derain's *Standing Nude* and Gaudier-Brzeska's *Boy With a Coney*, there was enacted the early modern sculptor's premise that sculpture should give the appearance of being constructed rather than being derived from the directly seen.[70]

For Brancusi, the sculpture surface inherited from Rodin suffered from an excess of sensibility. By Hildebrand's definition, Brancusi was the most tactful of the early modern sculptors in deciding between his internalized vision and what he saw. His vision of a new sculptural unity or wholeness lead him in a relatively short period, 1907 to 1910, from the analytic surfaces of his portraits, through the synthetic surface of *Prayer* (Figs. 114, 115), to the surfaces in several heads that were purified of texture, hollows, joints and breaks. Brancusi gave sculpture a new, radiant skin that, divested of evidences

113. Raymond Duchamp-Villon, *Seated Woman*, 1914.

114. Constantin Brancusi, *Prayer*, 1907.

115. Constantin Brancusi, *Torso of a Young Man*, 1916 (?).

of the hand, became his signature. He collaborated with the natural qualities of his material, such as color, texture or grain, and susceptibility to polishing, but they were secondary in importance to the shape of the whole. Brancusi and Van Tongerloo in his fluid version of *Construction Within a Sphere* of 1917 (Fig. 116), pioneered the single continuous sculpture surface that Arp and others developed after World War I.

Brancusi's surfaces were the most sophisticated, but not the most influential. It was the detachment of the surface plane from mass and descriptive but not structural function in Cubist painting and sculpture that seemed imitable and viable to artists like Gutfreund, Filla, Csaky, Freundlich, Lipchitz, and the Russian Suprematists (Fig. 117). Brancusi's surfaces, no matter how abstract they might seem, still proceeded from his vision of voluminous nature. The Cubist flat plane or cylindrical surface was comparable to an impersonal building block, a product of the mind, like geometry, and not an imitation of nature. This type of plane was the basis for a common language wherein individuality resided in their varied combination. The abstract plane's possibilities for building a more explicit architectonic order are evident in Lipchitz's reflections on his figure sculptures of 1915: "In the free-standing sculpture it is necessary to emphasize the three-dimensional quality; and for this reason I organized the planes at right angles to one another. There is a kind of bone structure that exists firmly in space like a skeleton."[71] The *École des Beaux-Arts* insistence on the skeleton as the basis of sculptural order thus found its ironic continuation in an almost abstract sculpture made by an artist it had briefly trained. The nondescriptive

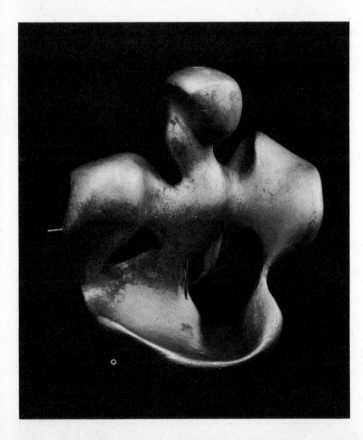

116. Georges Van Tongerloo, *Construction Within a Sphere*, 1917.

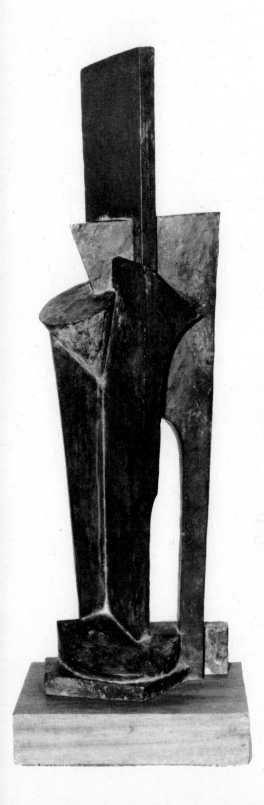

plane of Cubism could be thin as well as thick, which was important to Gabo and other Russian artists who wanted greater involvement of space within the sculpture (Fig. 118). The difference between traditional and Cubist-inspired sculpture is like the difference between wall-bearing and glass-curtained architecture made possible by steel frame construction.

Cubism introduced Boccioni to the abstract plane, and he saw the pressing problem of sculpture to be a "new construction of planes." The type of plane he wanted was not like that of Rodin, "for planes made with the thumb have a sense of lively immediacy . . . but remove from the work its character of universal creation." The abstracted plane had similarly impressed Boccioni and the foregoing artists as a means of broadening and accelerating the understanding of art and linking modern sculpture with the traditions of world sculpture that they thought did not prize manual dexterity. For Boccioni, planes were not to be descriptive nor totally abstract, but were to encode the interaction of space and material form, "the binding of ambiance to subject" that he recognized in the luminous vibrating surfaces of Medardo Rosso's sculpture. The interpenetration of planes was more expressive and meaningful to Boccioni than the twisting of muscles, but by a series of intuited analogies, the planes of his *Unique Forms of Continuity in Space* evoke rippling musculature. Boccioni's planes, best described by himself even before he made them in sculpture, are not passive, but alive, "spare, fundamentally severe, symbolizing the severity of steel that determines the lines of machinery."[72] For this artist, for Duchamp-Villon, Archipenko, and Brancusi the new sculptural plane was the

117. Jacques Lipchitz, *Half Length Figure*, 1916.

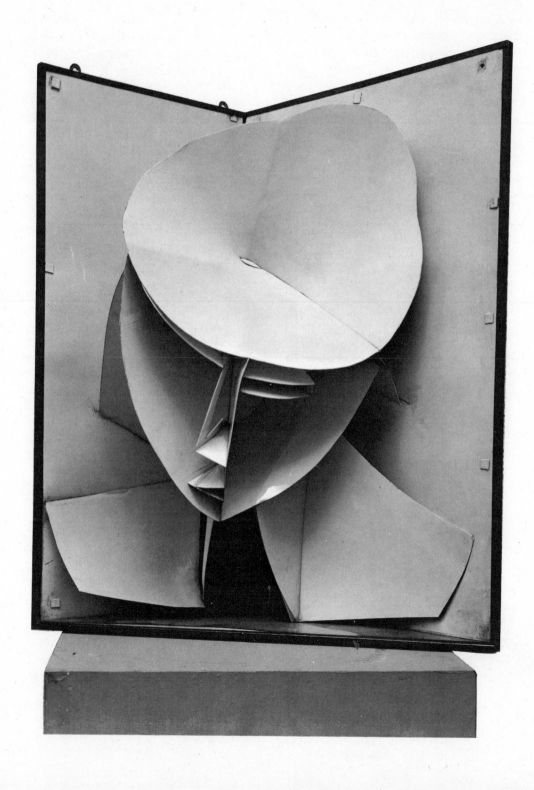

118. Naum Gabo,
Head of a Woman, c. 1917–20.

means of coming to terms with a machine age.

With the use of materials such as glass and celluloid by Archipenko, Boccioni, and Gabo, sculpture developed a new transparent skin, and in different ways were the old limits of sculpture dissolved. In the surface planes of early modern sculpture is recapitulated its development. They first respond to the artist's sensibility to nature expressed through inspired touch. They are then generalized as the artist seeks greater intellectual assertion over nature and desires to minimize manual skill. Finally, the planes move to self-referral, unless seen against a whole that has figural or object reference. For centuries sculptors had talked about the body and sculpture in terms of planes, but never had they been made as explicit and demanding of a new focus of meditation and esthetic.

Invention and the invasion of sculpture by space

The academic definition of sculpture was the selective and palpable imitation of nature. Selectivity was influenced by the classical ideal of tasteful generalization, and the preferred living forms were in themselves to be models of beauty and outstanding moral and physical character. For the rebels of early modern sculpture the imitation of nature became optional. The new ideal and premise championed first by Archipenko and the Cubists was that sculpture presupposes invention, not imitation. To someone trained at the *École des Beaux-Arts*, invention meant the first thought or idea, as well as the arrangement of the poses and limbs of the figure. The

skillful omission of details and simplification of light and dark masses traditionally qualified as "invention." Rodin and Maillol insisted they "invented nothing," but only "discovered" truth in art and nature. For a younger generation coming to maturity after 1900 art resided only in the artist and what he did. Invention meant developing a vocabulary and grammar of shapes that did not derive from biological sources, hence the preference for geometrical planes, curves, and volumes and their untempered, abrupt juncture. Charles Blanc had first written in 1863 about sculpture as "creating a life of images analogous to real life." While he could not have foreseen the figural art of Archipenko, Brancusi, Lipchitz, or Van Tongerloo, his words could be applied to their work, or be paraphrased thusly: Sculpture is the invention of alternatives to shapes in nature while contriving a form analogous to that of the human body.

The inventiveness to which early modern sculpture can genuinely lay claim includes the incorporation of space as a conscious element of design within sculpture. Until the twentieth century, space was generally taken for granted or thought of as something the sculpture displaced and was surrounded by or which constituted the interval between figures, limbs, and the torso. It was not even discussed by Charles Blanc. Hildebrand saw it as part of the composition to be contained within the block of stone the artist would work from. In Archipenko's words, "space was understood as a kind of frame around the mass ... sculpture begins where material touches space."[73] As Archipenko acknowledged, sculptors have been conscious of the influence of their work on its surrounding space for thousands of years. In public statuary the impos-

ing figure possessed its own body space, an area around its person just as do we, a kind of demilitarized zone which no one was supposed to invade. One is not tempted, for example, to approach and touch Rodin's *Monument to Balzac.*

The development of the partial figure by Rodin and others called attention to space that occupied the area where normally the missing head or limb would be, and beginning in 1909, Archipenko began making sculptures that deliberately sought this consciousness. In subsequent pairings of his partial figures such as the 1912 *Dance* and *Boxers* of 1914 (Fig. 119), the intervals between the forms began to take on a decided shape. He did not want these intervals to appear "acci-

dental" or unpremeditated in form. Referring to 1912, Archipenko wrote, "I experimented and concluded that sculpture may begin where space is encircled by the material." In his *Walking Woman* of 1912 (the original version of which is lost and exists in the artist's reconstructions), Archipenko hollowed out the interior of the figure, and its solid frame evoked the missing volume of the torso (Fig. 120). This he considered a "symbolic" use of space, giving sculpture "an associative center ... its own spiritual existence." Archipenko's was a pioneering effort in giving equivalent meaning and importance to space and matter in sculpture, and he quoted Henri Bergson to support his beliefs: " ... the object, once annihilated, leaves its place unoccupied; for by hypothesis it is a PLACE, that is a void limited by a precise outline, or in other words a kind of thing."[74] Archipenko's use in reliefs of translucent and reflecting materials furthered the new palpability and modern consciousness of space in sculpture. Similarly, Brancusi's highly polished reflecting surfaces seem to bring space into his forms, to dematerialize them, and without actually violating the continuity of his surfaces he was able to integrate space and matter.

According to Umberto Boccioni, "Traditionally a statue is carved out or delineated against atmospheric environment in which it is exhibited: We proclaim the absolute and complete abolition of definite lines and closed sculpture: We break open the figure and enclose it in environment."[75] Boccioni, who felt that the liberation of space in sculpture contributed to the history of the spirit, developed his ideas, largely influenced by Picasso and Cubism, in his Futurist paintings, that in turn had destroyed the isolabil-

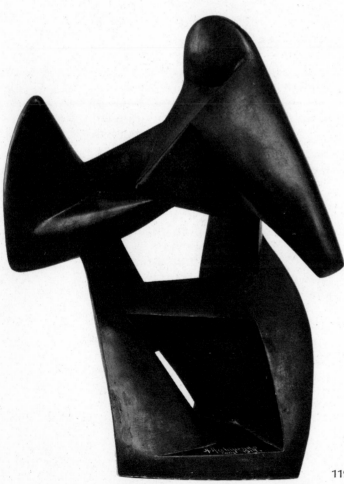

119. Alexander Archipenko, *The Boxers (Struggle)*, 1914.

ity of the figure and objects from their surroundings. His first sculptures of 1912 show surface excavation of the form reminiscent of Picasso's *Head* of 1909. Boccioni's most dramatic and literal breakthrough of the form barrier against the incorporation of space within solids was his *Development of a Bottle in Space* of 1912 (Fig. 76). Where he differed from Archipenko was in being more inventive in the avoidance of creating a void literally shaped like the familiar solid it displaced so that readability was never in doubt. Archipenko's inventiveness was in substitution. Boccioni sought to "give life to objects by making their extension into space palpable, systematic and plastic." In fact, he gave a shape to the atmosphere about the object, as if it were a material substance. This he did by creating an "arabesque of directional curves" that reformed the familiar bottle in surprising ways to suggest its evolution and susceptibility to the influences of ambiance. Even before he made this sculpture, he imagined and drew a bottle's "plastic thrusts" and those of its environment. Boccioni exploded sculpture into open form, giving it a new inside and a dynamic continuity with the exterior that has been fruitful for sculptors ever since. In 1914 and 1915 his ideas influenced Balla and Depero to make flat massless planes that divided space. Though lost and existing only in photographs, it was their work and Boccioni's ideas that established the premise: Sculpture may be occupied by and actually move in space.[76]

When Picasso began to "take over" from nature in his *Head* of 1909, he first showed in sculpture that "it is the rhythmic thrust of space on the form that counts."[77] His more dramatic breakthrough of space into what had previously been closed form came, as

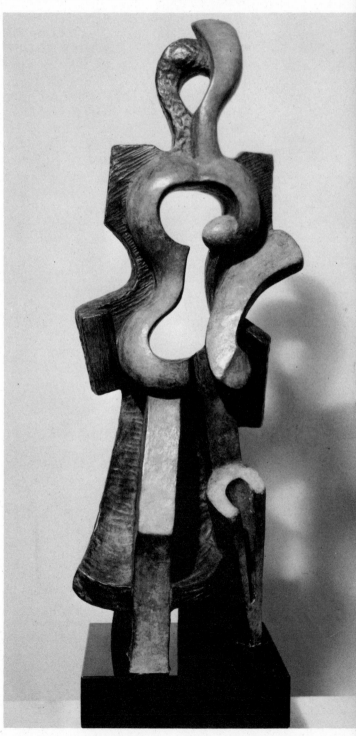

120. Alexander Archipenko, *Walking Woman*, 1912.

with Boccioni, not in the making of a figure, but an object, the *Guitar* of 1912. Consonant with Cubism's unwritten premises was Picasso's unwillingness to accept the given characteristics of the motif, and not only was it transposed into a new material, but reshaped and opened up to become an irregular receptacle for space. As part of his "fool the mind rather than the eye" maxim, Picasso did away with the outer lid of the sound box, but maintained the instrument's hole in the form of a cylinder, that gave its enclosed space greater tangibility. In the *Absinthe Glass* (Fig. 121) series of 1914, mistakenly viewed as the first "transparent" sculptures, Picasso ripped open the continuous surface of the subject in a less elegant way than Boccioni, whose bottle unwinds in a graceful spiral. Picasso was wittily substituting actual space for transparent glass. These and other constructions by Picasso proposed themselves to the viewer in the form of traditional sculpture violated.

After Archipenko's *Walking Woman*, and Boccioni's examples, other sculptors began to open the figure to space. Guillaume Apollinaire wrote about the now lost work of Agéro which he described as resulting from Futurist "forms of force that were equivalents of the expansive energy of the body."[78] In his *Spiral Rhythm* (Fig. 122), Max Weber built his torso-like form around a hollow, so designing the curving planes as to suggest energetic evolution in a manner reminiscent of Boccioni's *Development of a Bottle in Space*. The young Czech Otto Gutfreund, who had been a student of Bourdelle's in Paris and a witness to the emergence of Cubism, modeled a *Cubist Bust* of a woman in Prague during the winter of 1912–1913. By perforating modeled planes and their angular stacking, space was admitted. This entry was on a temporary visa, so to speak, as Gutfreund's inclination was later to rehabilitate solidity as the core of his work, and except for some further experiments with Cubism and abstraction in 1919, he moved towards a curious amalgam of folk art and academic commemorative sculpture at the service of his newly independent country and its heroes. In 1915, Jacques Lipchitz supplanted his arcuated masses with flat planar shapes in angular conjunctions. In the resulting intervals that would change from light to shadow, he saw that "the volume of the figure is created by the void between the planes," thus playing on the viewer's habits of seeing and expectations concerning the figure.[79] His *Man With a Guitar* of 1915 (Fig. 123), is connected front and back by a hole that stunned the critics. It was inspired perhaps by the opening of the guitar's sound box, and his curiosity about the results of such a breakthrough of solid form: ". . . it is no longer a circle indented in the surface but a hole cut right through the sculpture from front to back. The purpose of the hole is simple: I wanted it as an element that would make the spectator conscious that this was a three dimensional object, that would force him to move around to the other side and realize it from every angle. . . . It was . . . the assertation that this object is finally a work of sculpture not actually a human figure, even though it embodies important elements of humanity."[80]

The Cubist discovery that their sculptures were capable of an "inner life," not that of the mind and feelings so cherished by Rodin, but a mysterious new artistic existence, achieved by the changes of light's movement over the planar surfaces, made a deep im-

121. Pablo Picasso,
Absinthe Glass, 1914.

122. (left) Max Weber, *Spiral Rhythm*, 1915
(enlarged at a later date).

123. (above) Jacques Lipchitz, *Man With a Guitar*, 1916.

pression on Naum Gabo, who saw this work in Paris. In his busts and *Torso* made between 1915 and 1917, he continued the Cubist elimination of a frontal and continuous outer surface and the sculpture's dematerialization by suggested rather than actual volumes. The subdivision of his delicate armatures were traps for space as well as light and shadow, and in their making and in meditating on them, Gabo eventually came to see space as an entity in itself that need not be tied to the human form or a familiar object. In 1917, he began to make drawings of abstract constructions that led him to a more cosmic involvement with space and reality.

Thus, in the early years of this century the area around a sculpture became a militarized zone with mutual invasions by space and matter, ranging from strong surface interplay by aggressive modelers such as Matisse to outright supplanting of solids by voids. The introduction of space by substitution or descriptive intervals did not content more inventive artists such as Boccioni and Picasso. Brancusi's 1918 *Chimera* introduces holes that are both prosaic and poetic, and more integral to the total design and meaning than that of Lipchitz's *Man With a Guitar*. In their respective ways several venturesome sculptors violated the traditional impenetrability of monolithic sculpture, investing space with energy and mystery and making it a further means of destroying the physical and ideological isolation of sculpture from its environment. With Gabo there came to be proportionately and quantitatively more space than matter in sculpture, and the stage had been set for its new symbolic and formal use by the Constructivists and others after the war.

Color and sculpture

Throughout most of its history, sculpture has known the application of color for purposes of symbolism and verisimilitude. From the time of Michelangelo and Tilman Reimenschneider, most Western sculptors gave up the use of applied color. (Spanish sculptors were a notable exception.) Its reintroduction in statuary came at the end of the nineteenth century, partly due to the efforts of a painter who made a considerable number of sculptures, Jean-Léon Gérôme. His hand flesh-tinted marbles such as *Tenagra* were Salon sensations. By 1900, a number of sculptors including Barrias, Dampt, and Klinger were using a mixture of colored materials such as ivory, steel, bronze, and polychromed marbles for which there was a tradition that went back to antiquity (Fig. 124). Particularly among artists who made small sculptures for apartments, applied color and chryselephantine practice threatened to turn sculpture into an *"objet d'art"* in the eyes of conservative critics. The academic attitude was against the use of applied color on the grounds that it hid the sculptor's genius and brought his work into dangerous proximity to nature. Color only heightened the falsity of sculpture's attempts to imitate life; it was too much and not enough like nature. Polychromed sculpture was viewed as too close to actual movement and life and, as a result, revealed sculpture as immobile and dead.[81] The use of naturally colored materials was tolerated, but art students were taught that the "eternal function" of sculpture was to avoid all but the intrinsic color of the stone. Nineteenth century discoveries that ancient Greek and Egyptian sculptures were painted proved to be an em-

124. Louis-Ernest Barrias, *Nature Unveiling Herself to Science*, c. 1898.

barrassment to academicians and did not go unnoticed by the rebels.

Among the Salon artists, the practice of using artificial color and polychromed materials did not catch on and was not noticeably dying out by 1912. Rodin had always rejected the application of color, even to the use of colored stones, arguing that "color was the flower of modeling," and rejoicing in the "symphonic effects of light and shadow on his marbles."[82] In his bronzes, however, he did go in for rich and sometimes colorful patinas,

whereby color was achieved by chemical interaction with the heated metal. Besides renaissance black, after 1900 his patinas would display rich browns and greens, consciously emulating ancient bronzes distressed by interment. This esthetic of "antiquing" was not imitated by other independent modelers such as Maillol and Matisse.

Gauguin began painting his sculpture in 1882, inspired by his contact with Chinese decorative reliefs. His employment of color in such reliefs as *Soyez Mystérieuses*, differs from late nineteenth century painted sculpture by the avoidance of naturalism in favor of symbolism and decorative effects. He never used color to create perspective illusion or to augment figural volume by shading. Possibly due to the effects of time and light, his colored sculptural surfaces do not seem as brilliant as those of his paintings. Sometimes the paint appeared as a stain rather than an opaque layered surface. As Christopher Gray has pointed out, Gauguin was not indifferent to the quality of the woods with which he worked, and those of inferior nature forced on him by circumstance he would more heavily polychrome but without losing sight of the grain or masking nuance of carving.[83] Gauguin's susceptibility to nonclassical sources for sculpture and personalizing of the meaning of color had its counterpart after his death in younger painter-sculptors in Germany.

As early as 1910 the painter Ernst Ludwig Kirchner was carving in wood and painting the figure in an Africanized version of the Western beauty pose (Fig. 125). He applied strong color to delineate uncarved features, to vivify the sexual areas of the woman's body, and to convey his own heightened feelings. He may well have

covered first with gesso before painting, a technique he could have discovered in the Louvre department of antiquities. Nadelman preferred to paint a shirt, a tie, moustache or sideburns, rather than carve them in relief and disturb the elegant continuity of his form. This stylized use of color, which accentuated form and widened the applicability of his wit, helped Nadelman make the transition from celebration of the timeless nude to *La Vie Moderne*.

Archipenko was determined that color be reintroduced into sculpture in ways that were consistant with his imperative of invention: "... It would be ridiculous to unite the forms and the colors in the fashion of hair dressers' mannequins, for art is not an imitation of nature."[84] Accordingly he used color in various ways, at times painting an anatomical feature such as a symbol for a breast on a glass disc or using bright colors in flat passages that emulated a clown's costume, as in his *Carrousel Pierrot* of 1913 (Fig. 126). The Russian-born sculptor argued that "there does not exist in the world a single object which has not both form and color." He correctly cited the Greeks as well as Gothic artists' use of color, which academicians had chosen to ignore or conveniently forgotten. Above all Archipenko was interested in new optical effects gained by colors. He used varying hues and values that played with and against his sculptured shapes and surfaces and which reacted to changes in light sources and intensities. He sometimes used color to create the illusion of a plane or an abstract texture. It is not to detract from Archipenko's achievement to point to a contemporary precedent for applying color to sculpture. In the Salons when he came to Paris there were exhibitions of the painted and carved

been inspired by, but misinterpreted, African body color. With Kirchner's figures and Schmidt-Rotluff's more obviously tribal-like painted heads, color came into modern sculpture for self-expressive ends rather than descriptive realism. But this is one of early modern sculpture's abortive revolutionary developments. By contrast, for example, when Elie Nadelman began to paint his svelte wooden figures in 1917, his matte colors were as dispassionate as their owners. To preserve the smooth elegance of his surfaces, they were

126. Alexander Archipenko, *Carrousel Pierrot*, 1913.

puppets of Georges Lacombe and the hilarious birds of Alexandre Réalier-Dumas. Looking at Archipenko's *Medrano*, we are reminded of a puppet, and *Pierrot* by him is also a comic figure. Lacombe and Réalier-Dumas delighted Paris with their caricatural polychromed carvings and it would have been surprising if Archipenko had not joined in the laughter at their work when he visited the Salon des Humorists.

The adulteration of the differences between painting and sculpture owed much to Picasso's use of color in his wooden reliefs of still-life objects as well as his bronze casts of the *Absinthe Glass* (Fig. 127), all of 1914. Whether on canvas, paper collages, or wooden reliefs surfaces were eligible for Picasso's ideas about color. This entailed a logic of hue and texture dictated by intuition and the work itself and not description. He did not flinch from imparting a Seurat-like area of colored dots to one of the *Absinthe Glass* series. Color broadened the punning structural relationships that Picasso intuited between a wide class of objects and the human form.

127. Pablo Picasso, *Absinthe Glass*, 1914.

In early modern sculpture, the use of color by Archipenko and Picasso has a certain light hearted, insouciant, spontaneous character that contrasts with the ponderous, self-serious polemics about the appropriateness of certain colors to certain surfaces, shapes, and scales in recent minimal sculpture.

The early twentieth century use of color by full-time sculptors such as Lipchitz and Laurens was more deliberated and rationalized. These two artists applied their color in uniform segments, usually one to a plane, in order to affirm that plane's existence by demarcation from its neighbors. Lipchitz remembers that when he came to Paris he brought with him the idea that all sculpture was white, because of the plasters in Salon photographs. As with his use of the still-life motif, to which he sometimes added color,

there was the adventure of going against the rules. Laurens recalled, "I wanted to do away with variations of light by means of color, to fix once and for all the relationship of components, so that a red volume remains red regardless of the light. For me, polychrome is the interior light of the sculpture (Fig. 128)."[85] As with Lipchitz' perpetuation of the academic "skeleton," Laurens's views on color strikingly echo Hildebrand's justification for the coloring of architecture and sculpture: "Color contrasts are primarily significant to bring out form. . . . Light and shade become more effective than the actual form. These changes may be counteracted by the use of colors. . . . Form proportions may be made apparent by the aid of colors, quite independent of illumination, and indeed in spite of it. Proportions of form are expressed by these colors without regard for the special meaning which the colors may have in nature."[86]

Painters who made sculpture such as Picasso, and Boccioni in his *Horse plus Rider plus House*, 1914, tended to play color and sculptured form against one another without the concern for the "architecture" of the composition so important to Lipchitz and Laurens. In 1917 Van Tongerloo gave up painting for sculpture, and he tended to paint his wooden abstract compositions either in white or blue, as in the case of his figural *Composition Inscribed Within a Circle*. By completely covering the grain of the wood and removing texture as a guide to scale, he succeeded in making these small sculptures seem even larger than they were. A single, pure color grafted to his geometrical shapes enforced their distinctiveness from imitative art and their self-sufficiency, for the colors referred only to themselves.

Since so many of the early Russian

128. Henri Laurens, *Head*, 1915–18.

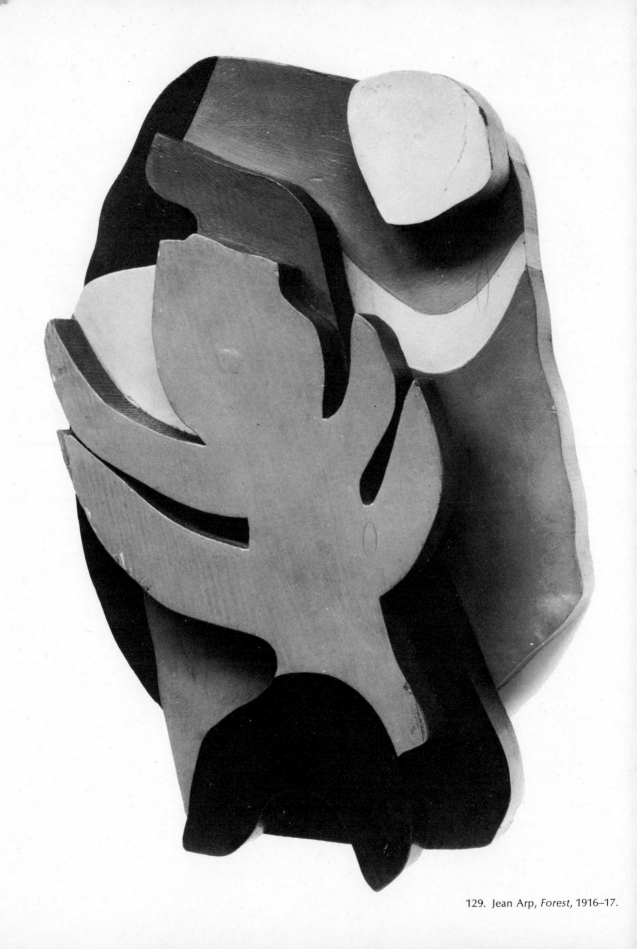

129. Jean Arp, *Forest*, 1916–17.

Suprematist reliefs survive only in old photographs, it is hard to judge their use of color. Baranoff-Rossiné's 1913 configuration shows his transposition to sculpture of ideas for orchestrating color that were analogous to his researches into sound. Picasso's work probably inspired his fantasies on a fugue of color and shape. Ivan Puni, who was primarily a painter, used strong primary colors to further emphasize the artist's role in symbolically remaking reality. But it was more in the range and choice of found material that the Russians made sculpture more colorful.

Jean Arp's earliest reliefs were often colored, as part of his desire to create an alternative to painting and sculpture while metaphorizing nature (Fig. 129). The flat application of color without reference to brush stroke was comparable to the rejection of modeling and evidence of the handmade. Arp never went in for merging colors, always keeping them distinct and thereby preserving the independence of color and sculptured shape by their frequent mutual contradiction as to location of an edge. The use of color by Arp and others was not to have further development until well after World War II, in the decade of the sixties. Their work does not strengthen the view of modern art that sees a continuous trend from Impressionism to the present in which painting and sculpture move irrevocably towards self-definition and mutual exclusivity. Many artists did not "guard" for their painting or sculpture ideas about color. The result of these pioneering efforts was the revision of the older axioms regarding what was best for sculpture: color could be applied to sculpture, not to imitate nature, but for expressive, symbolic, decorative, constructive, and optical purposes.

The courtship of light

The brightening of sculpture after 1900 was related to a widespread spirit of optimism and the desire of sculptors to have their work give joy.[87] The ardent courtship of light was not new, but took different manifestations that proceeded from the common withdrawal from the imitation of nature and modeling of nervous surfaces. At the turn of the century the work of Rodin, Rosso, Bourdelle, and Matisse exemplified "picturesque" sculpture, that with its emphasis upon a vigorous range of alternating lights and dark produced decomposition of light. For Rodin, the uneven distribution and reflection of light in nature had to be emulated, for in his view, "Art is the reproduction of life." By contrast with his bronzes, Rodin's stone sculptures played to the light by restricting shadow to delicate half tones. While he spoke of making out-of-door sculpture "free to all the caprices of light," and recognized light's capacity to "separate, disjoin, decompose," he felt the artist could control these tendencies and resist the appearance of the sculpture's disintegration in daylight by the firm and exact modeling of forms, principally their contours. Repeatedly Rodin is called an Impressionist, but unlike painters such as Monet, he did not depict the disintegrating action of light on surfaces. As the light faded in his studio he would test the exactness of his modeling as he saw his statues stripped of details, reduced to large planes, and then their silhouettes, and lastly, the mass alone. When we look at his last great torsos, that of a *Young Girl* and *Prayer*, it is apparent that in these bronzes he had foregone the tragic possibilities of light and shadow dramatized in the

Burghers of Calais, for his own optimistic view of equanimous life.

Medardo Rosso, on the contrary, had no interest in providing his sculpture with exactly or objectively modeled anatomical forms upon which the light could then reflect (Fig. 130). "Volumes are penetrated by the light of the atmosphere and do not exist as volumes or masses."[88] One sees in Rosso's work what is left of material form after light has eaten into it. Wax allowed him to both reflect and hold light in his surfaces, which added to their inconstancy. He also enjoyed the chromatic effects achieved by placing his wax sculptures near paintings whose colors were reflected in his receptive surfaces.

For Matisse, exactitude of form depended both on knowledge of anatomy and his own intuitive esthetic. His audacious departures from descriptive modeling allowed him to be more conscious of the rhythm and intensities of light reflected from the surfaces. In his Back no. 3, as in the 1916–17 painting of *The Bathers*, Matisse shaped light and shadow into zones or chords of his own, rather than nature's contrivance. Light, rather than simulated figural action, imparted movement and dramatic effect to his work. Controlled light and shadow animated the passively posed woman. No matter how strong or capricious the light, Matisse provided for retention of a sense of his structure's firmness.

The movement for the unification of light was led by Maillol and others who searched for new absolutes of form. What was commonly sought were surfaces with little or no irregularity, a leveling out of what Rodin had described as the hole and the lump, so that as much as possible light would be evenly reflected. Sculpture was to acquire before 1918 a new wholeness of radiance. Maillol's sculptures, when first exhibited in 1902, struck many as having achieved a new absolute of form. Their formal fullness defied Rodin's surface hollows. Then and throughout his life, Maillol formed his figures with the intensity and lucidity of Mediterranean sunlight in mind, so that, as in life, his nudes would have a luminous halo about them. The new primitivizing of Derain, Modigliani, Epstein, and Gaudier-Brzeska replaced fidelity to the nuance of flesh with broad smooth planes that became stages for the almost uninterrupted movement of light. Elie Nadelman's high polish of his stone pieces abetted fluency of light refraction. As light is known to us by the surface that reflects it, these stone sculptures encourage our awareness of their material as well as drawing our attention to lumi-

130. Medardo Rosso, *Bust of Yvette Guilbert*, 1895.

nosity itself. According to Geist, by 1910, and perhaps as early as 1905, in a work called *Pride*, Brancusi had introduced unpatinated bronze into modern sculpture as an important formal component. It is possible that Brancusi's new practice caught the comprehending attention of Boccioni. What may have helped Boccioni decide against further use of aggregates of heterogeneous materials in his 1912 or 1913 *Development of a Bottle in Space*, was the thought that bronze uncolored by acid might give his work the look of new metal, untarnished by reference to the patinas of antiquity. Since he did not, in fact, cast any bronzes before his early death, one can only speculate that unpatinated bronze would have conveyed his view of the phenomena of "luminous emanations of our bodies."[89] If the war had not ended his life it is possible that Boccioni might have taken the next step of working from smooth and opaque to polished reflective surfaces.

We are uncertain as to when Archipenko first exercized the option of not patinating his bronze surfaces, as so few of his early works were cast in metal before the war. By his own recollection Archipenko began experimenting in 1914 with such materials as sheet metal and glass, and techniques such as polishing, that gave him a highly reflective surface (Fig. 131). In his own book of 1960, the sculptor observed, "Reflection enriches the effect of the object. It can multiply lines; it can amplify or reduce the effect of forms, color, or line; it can shape according to the positions of the planes or the concave or convex bending of the reflecting metal. Reflections express depth and space. They absorb the entire environment to which they are exposed; they magnify the brilliance of the color. . . . The double ef-

131. Alexander Archipenko, *Head*, 1914.

fect of the real and of the reflective is useful for constructions."[90]

In some of his now lost reliefs of 1914, Archipenko used polished surfaces as mirrors to reflect the colored backs of his constructions posed in front of the curved metal sheets, thereby allowing the beholder to see front and back simultaneously. The mirrored surface thus entered his art

111

132. Alexander Archipenko, *Flat Torso*, 1914.

literally as a motif. *Flat Torso* of 1914 (Fig. 132), in the Philadelphia Museum of Art, may have been one of his first hand-polished sculptures, but we can't be sure if the polishing immediately followed the casting, and if that was in 1914. It was not until after the war that Archipenko worked extensively in highly polished surfaces, and may have redone earlier pieces. With his *Woman Combing Her Hair* (Fig. 133), of 1915, Archipenko introduced concave for convex forms so that under certain lighting conditions the optical effect would be for the shapes to appear in reverse attitude or projection. Picasso had made these inversions in his *Head* of 1909, but the rough textured and patinated surfaces reduced somewhat their optical reversibility. Where for centuries artists had worked to free their figure sculptures from the effects of optical distortions, Picasso and Archipenko made them their collaborator, and the "accidents of light" became a controlled part of craft.

Sidney Geist wrote of Brancusi, "polished metal is the emblem of his modernity." After such works as *Sleeping Muse* (Fig. 134), *Prometheus*, and *Maiastra*, Brancusi could say, "I have eliminated the holes which make shadows."[92] The desire to approach "the real meaning of things" had led him to simplicity and the clarification and purification of his forms. It was not alone his material bronze, that led to the new mirror-like surfaces of 1917 and thereafter until 1933. "High polish is a necessity which relatively absolute forms demand of certain materials. It is not compulsory; indeed it is very harmful to those who do *biftek* sculpture."[93]

A distinction should be made between such early sculptures as *Sleeping Muse* of 1910, that has a moderately polished, unpatinated surface of the face, and *Princess X* (Fig. 135) or

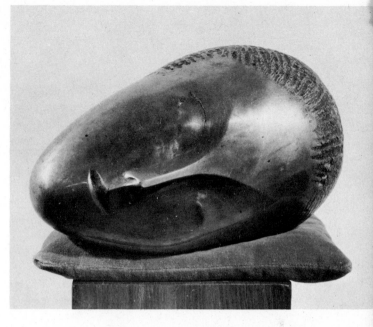

134. Constantin Brancusi, *Sleeping Muse*, 1910.

Torso of a Young Man in bronze of 1916 or 1917 which have highly polished, mirror-like skins. Degrees of polish between these dates may reflect his slow evolution of the device, but they may also manifest Brancusi's sensitivity to the aptness of a certain finish for the motif. Works like the *Sleeping Muses* still have slightly modeled features and textures that he did not want to obliterate through further polishing or greater reflectivity. (Athena Spear noted in the margin of this manuscript that the first *Sleeping Muse's* eyes were originally open, but that polishing made them appear closed.) Brancusi's experience with purifying his marbles such as the 1911 *Prometheus*, may have encouraged explorations of comparable finish for the same theme in a later bronze that comes closer to clear reflectivity. It was certainly the evolution of the purified arching form in stone of *Princess X* that produced the kind of absolute surface that could support the mirror reflectivity of the bronze version.[94]

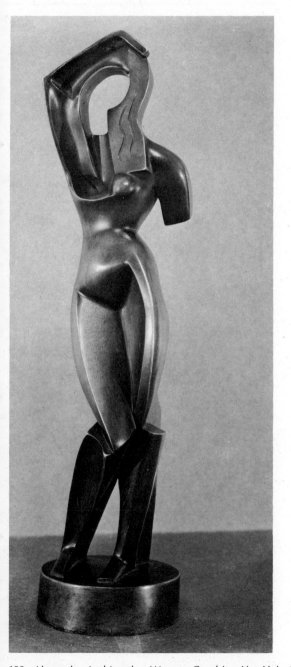

133. Alexander Archipenko, *Woman Combing Her Hair*, 1915.

Archipenko saw polish and reflection as appropriate to new sculptural materials as well as his interest in optics. Brancusi was treating the oldest materials in sculpture in a new way to achieve a poetic purity of form that he associated with the aspirations for truth and beauty of the new century. Both recognized that mirror-like surfaces arrogated to the sculpture its setting, including the viewer, and as with the new permissiveness towards vernacular materials previously noted, art was being transformed in still another way by its environment. In Brancusi we sense greater profundity of thought with respect to the uses of reflection. In *Maiastra* the wedding of light to the bird's form is a becoming thematic attribute, that of the golden bird of Romanian folklore, or as a radiant reference to *Princess X's* withdrawal and quest for inner illumination. The confluence of chance reflection and calculated form or a mundane setting married to an hermitic motif is more ironic in Brancusi's art. It is then one of the paradoxes of early modern sculpture that in the eliminating of shadows to achieve clarity and firmness of surface, sculpture was brought to the antithesis of formal certitude by the cultivation of ambiguity of stability, solidity, shape, and space.

The passing of the pedestal: bringing sculpture down to earth[95]

From Greek and Roman times statues were placed atop pedestals. Before, and even after the First World War, architects were called in to do their design. Such a collaboration was also a reminder that architecture was viewed by academicians as the parent of sculpture. Until Rodin, the use of the pedestal was unquestioned because it doubled the height of the work, permitted the sculpture to be on earth but not touch it, and would hold the audience at a respectful distance. Public sculpture could thus become familiar while remaining venerable. For more than twenty-five hundred years in Western art the pedestal symbolized the statue's superiority, the unmistakable mark of the subject's grandeur and the guarantee of art. For the more modestly sized sculptures that went indoors, there were smaller pedestals or shallow plinths, by which to separate the figure from the floor, mantle, or shelf.

It was axiomatic for the academicians that sculpture be upright with a firm base. The base was part of the sculpture, serving to give structural support and a synoptic stage-like setting that helped demarcate the statue's personal space. Although of the same material as the figure, bases were treated traditionally in an illusionistic manner, to suggest the figure's place on earth or the deck of a ship. In early twentieth century salons, for example, sculptured bases simulated streets, tombs, mountain tops, waves, jungle floors, river banks, clouds, and so forth. The gravity-defying feats of carvers who cantilevered nymphs into space depended upon the cloud-like marble support.

In 1897, Rodin exhibited a bronze version of his life-size *Eve* (Fig. 136) and literally buried its base in the dirt floor of the salon hall. This was another step in his plan to bring sculpture to life. In hiding its bronze platform, Rodin had eliminated the old device for marking off the "circle of solitude," in Rilke's words, that isolated a public sculpture from the crowd. The elimination of the base was an option, not an imperative for

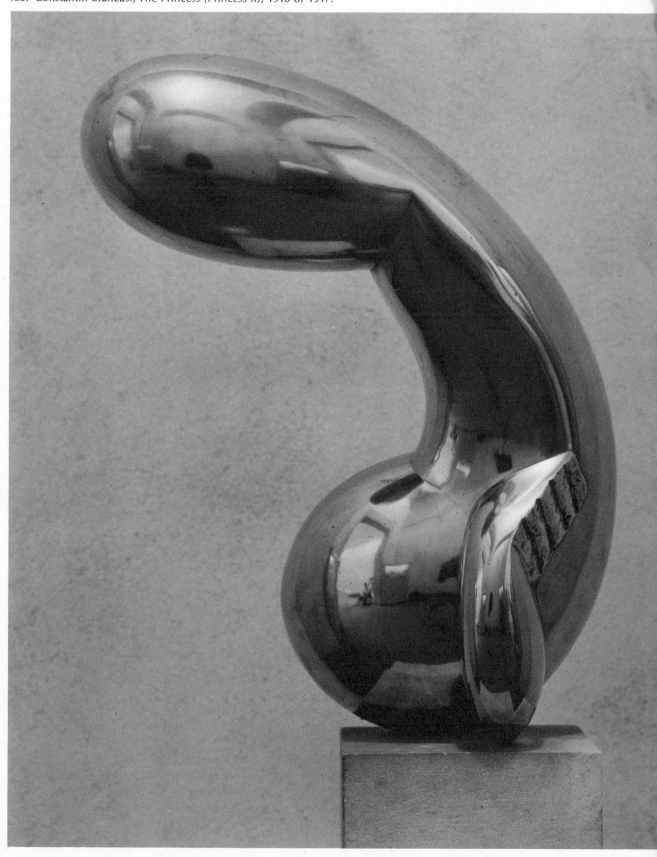

135. Constantin Brancusi, *The Princess (Princess X)*, 1916 or 1917.

136. Auguste Rodin, *Eve*, exhibited in the Salon of 1898 with the base buried in the sand.

Rodin, whose marble figure compositions continued to evoke rocks, caves, the sea, and the very stone itself. His partial figures, such as the *Flying Figure* and *Iris Messenger of the Gods* made in the nineties and originally without bases, were later made to rise in the air from a simple geometrical pedestal and were mounted on an exposed metal armature. In stone sculpture from Greek times the artist was allowed to expose a tenon or brace, to support an extended limb as Rodin had done in the marble version of his monument to *Victor Hugo* that once stood in the courtyard of the Palais Royal. This variant on the tenon was similarly used by Duchamp-Villon to elevate his *Torso of a Young Man* in plaster, and by Boccioni for his *Unique Forms of Continuity in Space* in lieu of feet.[96]

During his lifetime, Rodin's small studies of hands, feet, and series of Can-Can dancers had no bases, but were simply placed on shelves, tables, and mantels. The absence of a base encouraged their being handled, and many of Rodin's late works found their home not in public places, but in the human hand. Lacking a base, his figures were liberated from a fixed orientation, and as they were turned in one's hands, they took on new life.[97] But for his public works, such as the *Burghers of Calais* and *Monument to Balzac*, Rodin's sense of tradition and decorum caused him to continue the base and accede to the use of a pedestal. With the *Burghers* he had hoped to eliminate the pedestal and by using the combined rugged paving-stone-like bases of the figures to posit the group directly on the pavement of the medieval Calais square from which their ancestors had departed. He wanted the living to rub elbows with the dead. Both in characterization of his grieving subjects and by his design, Rodin had taken the sculptural hero off of his pedestal and brought monumental sculpture down to earth. For the *Burghers* he had the historically appropriate setting. There was no such mitigating or inspiring circumstance for the *Balzac*, and its final enlargement and modeling presupposed a pedestal that would have elevated the figure above the crowd and clothed the writer in his own space.

In 1880, Degas had stationed his *Little Dancer of 14 Years* on a base made from the flooring of a practice hall, and his bather (Fig. 137) reclined in an actual tub, that was to be seen from above.[98] Only Barlach and Lehmbruck continued the illusionistic base, but avoided ostentatious settings in favor of simple ground. In his small sculptures, Maillol, as did Matisse, often mounted his bronzes on simple plinths of wood or stone when they were not to be placed directly on a tabletop or sideboard. For Maillol, the simple cubical support inspired thoughts of the

invisible cube or "crude geometry," as he called it, in which he envisaged the sculpture as it evolved.[99] Although similarly against illusionistic bases, Matisse would use a traditional modeled support when the subject called for it, as in the *Serpentine*, made from the photograph of a model leaning on a studio prop.

The fertility of Gaudier-Brzeska's thinking as a sculptor is seen just in his ideas about the sculptural base. Often he used a simple rectangular or circular form of meager proportion in relation to the sculpture's height, probably because of his urgency to obtain the most height for his image out of the small stone blocks he could find or buy with what little money he had.

(His decisions may also have been confirmed by the modest bases of tribal· carvings seen in the British Museum.) At times he opted for a polygonal base that roughly followed the lateral configuration it supported. This led to prismatic pedestals for stone sculptures without bases, and which were flat only underneath, as in the *Embracers* and *Birds Erect* (Fig. 138). Conceivably he felt these diamond-like supports were more dynamic and an encouragement to the viewer to move around the work whose frontality was denied even to its foundation. He several times dispensed entirely with the base in 1913 and 1914 in such works as his small carvings of animals, *Bird Swallowing a Fish*, and *Ornament*.

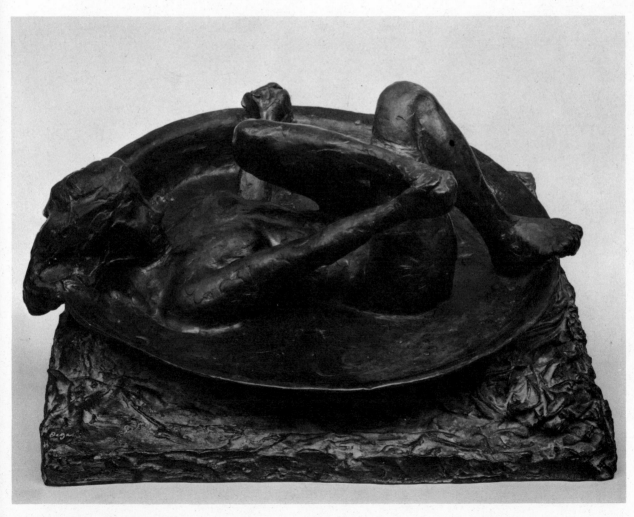

137. Edgar Degas, *The Tub*, c. 1886.

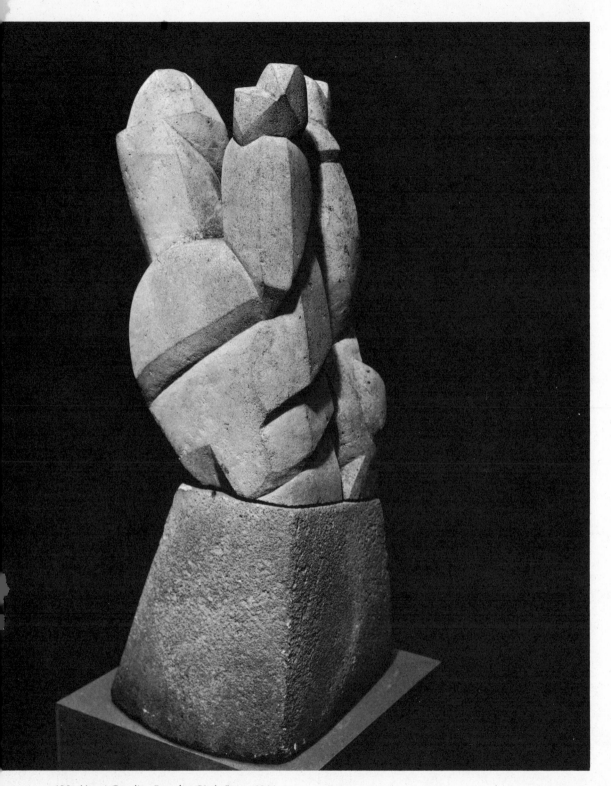

138. Henri Gaudier-Brzeska, *Birds Erect*, 1914.

Whether this omission was due to the artist's desire for greater self-sufficiency of the image, or to induce their handling and more intimate contact with their domestic settings, or both, we don't know.

As sculpture moved away from naturalism, and he became involved with partial figures, for Archipenko the purifying of the base of any illusionistic reference became mandatory. When in 1909 he began to resort to simple geometric bases it was apparent he did not look upon them as passive elements. Such sculptures as *Baby, Seated Figure*, and *Suzanne* all show the figure overlapping the base by seeming to sit on it with legs extended down and outward. Even when seen as distinct from the figure, the bases were never shaped into neutral rectangles, as in Maillol. When he began painting his sculptures, as in the 1913 *Carrousel, Pierrot*, the divisions of color quadrate a polygonal base. In *La Mer, Dans Les Roches* (Now called, *The Madonna of the Rocks*—Fig. 139), of 1911, he made the base seem generative of the form by its continuity with the spiraling figure, thereby predicting, if not influencing, the inte-

grated design of base and sculpture in Boccioni's *Development of a Bottle in Space* and that of Duchamp-Villon's *Horse* of 1914.

Brancusi eliminated a modeled base altogether for his *Prayer* of 1907, and set it on a solid stone support. All versions of the *Kiss* were to be placed on pedestals, and the one in the Montparnasse Cemetery sits directly on the

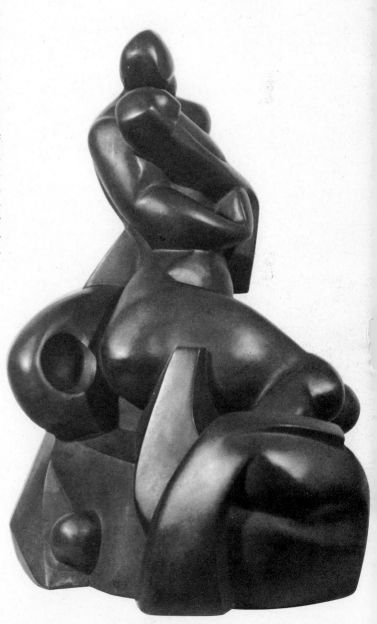

139. Alexander Archipenko, *The Madonna of the Rocks*, 1912.

gravestone. As did Rodin, Brancusi wanted most of his works off of the ground. He revolutionized the design of his pedestals by rejecting borrowings from European architecture. But Edith Balas has recently shown their possible derivation from Rumanian vernacular architecture. Sometimes he would use another sculpture, but more often he carved pedestals that to many seem to be sculptures in themselves, as in *Chimera*. Sidney Geist is adamant in viewing them as decorative objects on the order of picture frames, not classifiable in intent or quality with the sculptures they support.[100] When Brancusi used simple geometrical blocks to support his birds or heads, focus was sharpened on the shaping genius of his mind and hand, and intentionally or not merely reiterated that the basis of his inspiration was in life and not geometry nor formal abstraction.

Nadelman employed the wireframed chairs of his seated wooden figures as the means of their support. In the original version of the *Rock Drill*, Epstein mounted his figure on an actual pneumatic drill whose tripod and bit became the sculpture's base and pedestal. When Marcel Duchamp assembled his bicycle wheel and stool in 1913, the latter may have been a punning reference to a pedestal. Duchamp may have been asking, if a work of three-dimensional art requires and is defined by a pedestal, which is an inanimate object, why not a bicycle wheel on a stool? Traditionally, pedestals were tacit reminders of the immobility of sculpture, and Duchamp's wheel is fittingly pinned to its stationary support. When sculptors such as Rodin and Brancusi had removed bases and pedestals from their sculptures, thereby removing the equivalent of the picture frame, this was a prec-

edent if not an influence on Duchamp's substitution of the unsupported *Bottle Rack* for sculpture itself. Although the influence of the Readymade would not be strongly felt in sculpture until after World War II, it had raised questions about what is art as well as sculpture, whose answers today have led many artists away from sculpture entirely. Even without Duchamp's Readymades, the removal of the pedestal and base served to certify the unpretentious nature of some of the new sculpture. The effect was to democratize and objectify sculpture, and to affirm the artist's will. Sculpture's new life among the world of objects made academic the contemporary critical argument over what was sculpture and what was an *objet d'art* in the Salons.

Ways and means: the fickleness of fidelity to the medium

A premise frequently ascribed to the early period of modern sculpture is that the artist must be true to his materials: he must respect intrinsic qualities of the medium so that the viewer will be aware of the appropriateness of the image to the substance that has given it form. This romantic view was especially popular in Europe and the United States in the 1920s and 1930s as a result of the disenchantment with Rodin's art and his use of assistants, the low repute of modeling in general and the vogue for the hard "honest" labor required of direct carving.[101] Sculptors such as Maillol, Brancusi, and Epstein were invoked as exemplars of a new honesty in craftsmanship. This premise was not an overriding, constantly-adhered-to principle for the artists before 1918, and it

falsely assumed that traditionally oriented artists had no feeling for materials nor respect for labor inasmuch as artists like Rodin often had plaster sculptures transferred into stone by skilled artisans. Actually, Rodin liked to refer to himself as a "worker," and wrote how he suffered from the labor of his art.

Both in theory and practice, academically trained artists had definite ideas about what was and was not appropriate for certain materials in the making of statues.[102] Stone and marble, for example, were thought to be structurally incapable of supporting vigorous figural movement in statues, unlike wood and bronze. Marble was considered ideal for sculptures of the nude because of its fine-grained purity and color that complimented flesh. Granite, which was more coarsely grained and closer to building materials, was judged preferable for out of doors monumental sculpture that would be seen in conjunction with architecture. Attention has already been drawn to academic disdain for covering natural materials with color but tolerance for polychromed materials.

In the conservative view, clay was believed to be ideal and indispensable for the making of rapid sketches. Sculpture issuing from the "feverish thumb" in clay should be transferred not to stone, but bronze. Plaster was the intermediary by which the idea in clay could be preserved, reworked, and even exhibited in the Salon so that the artist might attract a sponsor for casting or carving. This explains why the sculpture Salons were white. Economics, the aim of saving time and an abundant supply of unemployed sculptors and trained artisans, encouraged successful artists such as Rodin, hard put by demands for their work, to have their plaster models carved in stone by such capable artists as Bourdelle and Escoula. Rodin knew how to carve, had done it, and supervised and finished many of his important commissions, but after 1900 the demand for his work in marble was so great that he had to employ a large crew of stonecutters. (Lipchitz referred to Rodin's "factory-like" studio at Meudon as "Rodin Anonyme.") Today those who disparage Rodin's marbles and his sensibility to stone have usually not seen his best works or have been influenced by the many rejected pieces and soiled stones indiscriminately displayed in the Paris Musée Rodin. The "do-it-yourself" mystique or compulsion that was widespread in the 1920s, occurred when most carvers like Henry Moore were too poor to have assistants to do their carving.

"Direct carving" has different implications. That of the artist doing all of the cutting and polishing himself had precedents before Maillol's first self-carved woods in 1892. Jean Dampt's prayerful *St. John the Baptist*, that won him a gold medal in the Salon of 1881, was the result of this kind of personal involvement, and the artist claimed to have invented new tools for cutting stone. But the style of the stone was identical with Dampt's bronze; and the carving was a *tour de force*. Many Salon artists, including Escoula, Rodin's own assistant, and Joseph Bernard, worked directly in stone. Bernard eschewed clay and built his forms in wet plaster on his armatures (Fig. 140). The styles of Maillol and his Spanish counterpart, Manolo, and to some extent Brancusi were formed independently of any one material, and often the same sculptures were transferable to different materials. While Maillol taught himself to carve (he loved to be able to swing hard at stone, but lamented his lack of skill), his figures

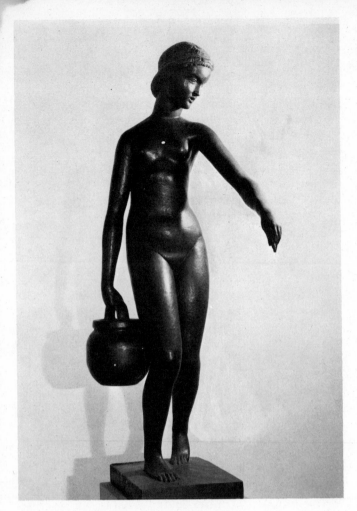

140. Joseph Bernard, *Girl With a Pail*, 1912.

Finally, he did not wish to celebrate the beauty of materials at the expense of form. Barlach's carving was largely inspired by his admiration for his late medieval German heritage, and while he made his facture explicit, he too transposed the same motifs from wood to bronze, or the reverse, without radical stylistic change. Elie Nadelman did not seem to be aware that his views came close to those of the academicians:

There is a plastic life and a "life" of living beings which are completely different from each other. I call plastic life the energy, the will which material itself possesses. A simple stone must already be considered a living body by the artist, since it indeed demonstrates its will by refusing all positions we might wish to afford it unless they are suitable, and it maintains that position which its weight, in accord with its shape, demands. I know this phenomenon is perfectly well recognized in science, but is nevertheless true that in art it is not applied at all.[103]

Neither in pose nor style were Nadelman's bronze and marble nudes different from one another, and he painted the surfaces of some of his wooden and bronze sculptures. As Sidney Geist has seen it, "truth to materials" has been more of a psychological than physical love affair.[104]

The second and more important aspect or connotation of direct carving, exemplified by Epstein, Gaudier-Brzeska, Modigliani, and Brancusi was that the artist should be inspired conceptually by the medium and change his style when he worked in stone. Brancusi is reported to have carved his 1908 *Torso* directly from the model. Influenced by Brancusi, Modigliani is supposed to have felt that there was too much "mud" or modeling in con-

such as *Mediterranean* had been mid-wifed by drawings, clay, plaster and small bronze versions. This was also true of Manolo's 1913 carvings of a seated nude which, however, had surfaces textured by the marks of a claw chisel. Brancusi thought work a biblical curse and used power tools when he could afford them. When he transferred his portraits of *Mademoiselle Pogany* and his *Birds* from one material to another, he was responsive to the qualities of marble and stone, but commented, "Polish is a necessity demanded by forms relatively independent of the material composing them."

temporary sculpture. He eliminated living and clay models, but not drawings, and thought out his sculptures as he carved. The "stonyness" of his carvings sometimes derived from their incompletion due to his impatience with the rigors of carving particularly hard rock (Fig. 141). Jacob Epstein's carvings, inspired as were Modigliani's by the great preclassical and non-Western traditions of carving, cannot be stylistically exchanged with his modeled figures (Fig. 142). Gaudier-Brzeska wrote, "The sculpture I admire is the work of master craftsmen. Every inch of the surface is won at the point of the chisel—every stroke of the hammer is a physical and mental effort. No more arbitrary translation of a design in any material."[105] He willingly gave up his tremendous gifts as a modeler for this new mystique about labor and materials, feeling that his carved forms gained in sharpness and rigidity (Fig. 143). But not all sculptors who were intrigued with this carving tradition felt compelled to observe such fidelity. Tribal sculpture appealed to Derain, Matisse, Brancusi, and Picasso, not primarily for its craftsmanship, but rather its bold, imaginative design and evidence of emotion (Fig. 144). Gauguin's carving style knew different modes and was influenced not only by what he called "barbaric" art, but the most sophisticated ideas about modern painting. Inconsistent as he was, Gauguin, nevertheless, was one of the pioneers of direct carving in both aspects of its meaning.

The main reason why fidelity to the medium was not compelling for most early modern sculptors was that they were clear in their priorities: art was more valued than craft. Artistic vision counted for more than labor: and calling attention to thought was more important than sweat. In 1893,

Hildebrand had observed the beginnings of truth to the medium and wrote: ". . . Some have concluded that the principles of artistic form are dictated simply by the properties of the material used. . . . Sculpture, then, is nothing more to them than the result of applying various methods of carving to different materials. This confusion of the end with the means of art should be discredited once and for all."[106]

Modeling in sculpture is still thought to be as personal as handwriting. The case of Renoir, who because of severe arthritis had to employ a gifted assistant between 1913 and 1917, reminds us that beautiful sculpture could be modeled without being touched by the artist's own hands. Trained by Maillol, Richard Guino developed maquettes from old paintings and drawings supplied by Renoir. Detailed consultation with Renoir on these small models, even to their facture, then led to their enlargement by Guino, who might work from a live model during this process. The results were again submitted to Renoir for final adjustments. With a bamboo baton stuck between his rigid fingers, he corrected profiles and proportions. In France, the authorship of a work of art, as it had been since Raphael and the Renaissance, rested upon the conception and the master artist's guidance, rather than total execution. In 1971, however, the French courts ruled that Guino's contribution to these sculptures was enough to warrant his designation as co-author.

Another ethical principle that Rodin seemed to have violated was his practice of having assistants—such as his chef d'atelier, Lebosse—mechanically enlarge compositions without adjustments in proportions. Matisse, on the other hand, believed in the integral re-

123

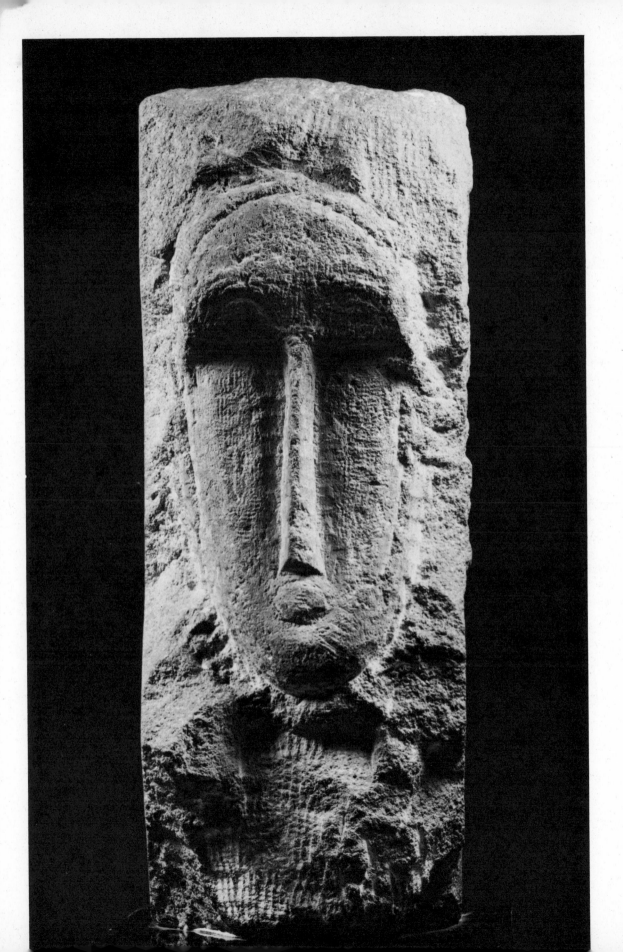

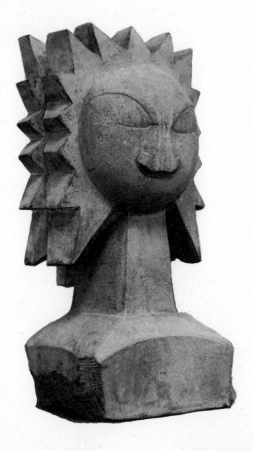

141. (left) Amadeo Modigliani,
Head, c. 1910.

142. (above) Jacob Epstein,
Sunflower, 1910.

143. (right) Henri Gaudier-Brzeska,
*Photo of the Artist carving the
head of Ezra Pound.*

lation of a conception to scale and never practiced enlargement or reduction. The great reliefs of the *Backs* were conceived and executed in their present size.

It was Rodin, however, who first drew attention to the sculpture process by leaving unchased the seams of his moulds imprinted on the plasters and bronzes, or making no effort to erase the marks of clay made by damp cloths, not trying to conceal an armature exposed at the heel of his *Walking Man*. He never disguised the brutal editing with his wire, knife or sword, as when he corrected plaster enlargements made by assistants of works such as *Meditation*. This practice constituted acceptance of "accidents" which were rejected by younger artists (Fig. 145). Exceptions would be Gaudier-Brzeska's first carving, *Head of a Boy*, and Manolo's stone figures, which leave evidences of the claw chisel as texturing device.

Until 1912, there were abundant

144. André Derain, *Crouching Figure*, 1907.

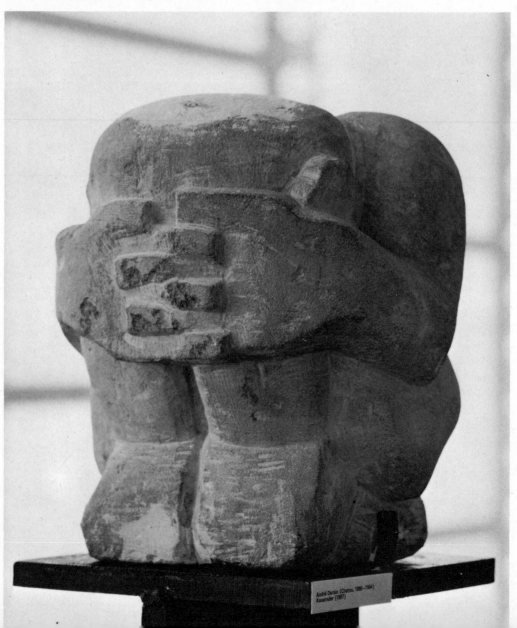

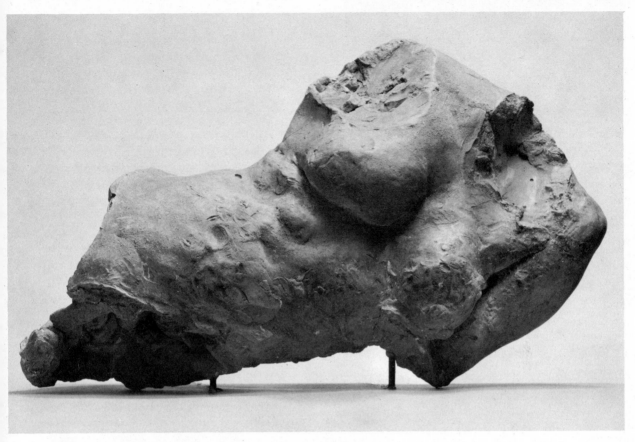

145. Auguste Rodin, *Study of the Torso of a Woman*, date unknown.

materials available to the sculptor which included not only varieties of stone and bronze, but also lead, cast stone or cement, ivory, and precious metals. (Pablo Gargallo had fashioned his masks and a partial figure of a *Faunesse* of 1908 in copper.) The basic methods by which they were shaped were either additive, in the form of modeling, or subtractive, as in carving or fitting sculptures together of different materials. Rodin employed a method of assembling fragments as well as full figures and putting them into new configurations, often without disguising their separate origins. In his *Little French Girl*, Brancusi assembled by stacking together parts from pre-vious sculptures; more rudely connected than Rodin's assembled figures, which gave him new possibilities of scale, texture, and rhythm. It was Archipenko and Boccioni who called for an attack on the "nobility" and exclusivity of marble and bronze, and they urged the use of new, modern materials to give form to twentieth century imagery. Archipenko used glass and sheet metal worked by bending and cutting and not carving. Boccioni's lost *Head plus House plus Light* of 1912 (Fig. 146) was a plaster bust into which had been stuck part of a window, its frame, catch, and glass, and a woman's hairpiece. In his last work, *Horse*, and the now lost pieces of Depero and

146. Umberto Boccioni, *Head plus House plus Light*, 1912.

second this inventory's actual use, but the principle of shrinking the area of nonartistic materials had been established and their manifesto reads like a survey of a Whitney Museum sculpture survey of recent vintage.

The use of ephemeral materials, freely manipulated by these sculptors and by Baranoff-Rossiné, owed to Picasso and Braque's development of collage (Fig. 147). Though lost, we know Braque was making constructions of paper in 1913. When Picasso pasted paper to canvas, the history of art came unglued. The way was open to complete permissiveness of materials and methods. Picasso was a *"bricoleur,"* and his vernacular materials came from what was at hand in his studio and had previously known utilitarian use. Traditional and specific materials were not indispensable to the realization of certain conceptions after 1912. No attempt was made by Picasso to achieve elegance of craftsmanship, as he was concerned with doing what was necessary to execute his ideas. The incentive to incorporate polyglot materials may have come from tribal art such as a Wobe mask in his possession. *Guitar* was made from thin sheet metal, soft enough to be cut with a shears, and the parts were then bent and twisted or knotted into shape. To the means of sculpture Picasso contributed what Meyer Schapiro called in his lectures at Columbia University "transforming manipulation and assemblage." The revolution in the ways and means of sculpture could be expressed: sculpture could be made from any material, including the most ephemeral, and others not traditionally associated with it. Just as important, sculpture could be made not only by modeling and carving, but by actual construction, assembling, or manipulation. These liberating premises led to

Balla and Marinetti's *Self-Portrait*, the most fragile materials such as paper, cloth and cardboard were used, which struck at the "eternalizing" function of sculpture.[107] (His surviving bronze sculptures show Boccioni more conservative in practice than theory.) For their abstract plastic complexes in 1915, Balla and Depero called for "Strands of wire, cotton, wool, silk of every thickness, and colored glass, tissue paper, celluloid, metal netting, every sort of transparent and highly colored material. Fabrics, mirrors, sheets of metal, colored tin foil, every sort of gaudy substance. Mechanical and electrical devices; musical and noise-making elements, chemically luminous liquids of variable colors; springs, levers, tubes, etc."[108] Photographs of the lost constructions do not

147. Pablo Picasso, *Mandolin*, 1914.

the exciting ideas of the Russian Suprematists, who felt affinities with modern engineering, construction, and materials. In the years between 1915 and 1917, Tatlin, Puni, and others, who were in fact musicians and poets, literally exhibited "reliefs" assembled from whatever movable detritus they could find in Moscow, preferably near the exhibition halls. Ideologically and physically, sculpture had been invested with a new environmental continuum. Instead of the environment being transformed by art, we witness the beginnings of the physical forms of art being transformed by the environment.

The revolution in relief sculpture

The pioneers of modern sculpture invigorated the tradition of architectural relief sculpture that dated from antiquity, but they also established the beginnings of a new history. The perpetuation of one of art's oldest forms by sculptors such as Maillol, Renoir, and Duchamp-Villon was eloquent of their desire for continuity with the past and hopes for a continued beneficial alliance between sculpture and architecture. But there were other artists such as Archipenko, Picasso, Arp, and the Russian Suprematists who reformulated the relation of the relief to architecture, challenged its traditional nature, and used it as a bridge to abstraction.

Historically, relief sculpture had been used for purposes of ornament and decoration of furniture or household objects and weapons, and for carved altarpieces during the middle ages. Economic reasons compelled *sociétaires*, such as Dalou and Bartho-

lomé, to make small marketable reliefs for private homes. The relief's most important function from the academic viewpoint was its adornment of architecture. Traditionally, it had been carved or modeled in stone or bronze, and its polychromy was interrupted in the Renaissance. Academicians resisted the revival of painted relief, arguing that it was the moral significance of the subject that gave relief its "color" by dictating the light and dark effect of the whole. The habitual format for the relief, as taught in the art schools, was an enframed rectangular field with a flat rear plane like a Greek metope, hence adaptable for architecture. The depth of the relief was determined by such contingencies as its location and light. Because of the flattening or disintegrating action of direct sunlight, high relief (figures almost in the round) was prescribed for exterior decoration and groups on pediments

148. Adolf von Hildebrand, *Archers and Amazons*, 1887–88.

or external friezes. Demi- or middle-relief could be used for compositions recessed under an overhang of the roof, but were best for indoors. Bas- or low-relief was considered as best for interiors, as its flat surface attracted light. The academic ideal was figural narration or paired figures who were authorized more and strenuous movement denied to free standing statues. Figural composition was to be "architectonic," in that the figural axes were to reiterate those of the building and diagonals would modulate the transition from vertical to horizontal architectural lines. Relief was thus adjudged best that respected the lines and planes of architecture. In high reliefs especially, the crossing over or superposing of limbs in front of one another or of the bodies was considered risky, as projected shadows might be out of scale and lead to ambiguity.

In his influential treatise, Hildebrand advises that the relief sculptor design his composition as if it existed between two flat sheets of glass so that several points of the highest relief touched this imaginary frontal plane.[109] The rear plane could be flat or at least at a consistent depth from the surface. By this means, he argued, the integrity of the wall surface would be preserved, and figures would not appear to be just "stuck on." There must always be clear and unified measurability of the relief's recession. He considered it "inartistic" for parts of the relief to project beyond the frontal plane. One of the issues dividing sculptors at the century's turn was whether the figures should have distinct contours or have them merged with the background. Hildebrand insisted upon the former, as he said that relief sculpture should not imitate actual appearance, but must adopt what he called a rectified "visual" form. He

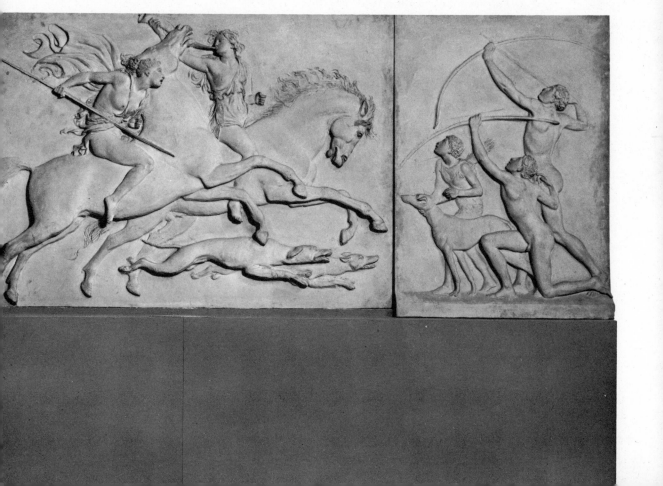

conceded that in bronze there were problems with the dark metal and its sheen and advised more vigorous internal modeling within the distinct figural contours, while still keeping many points lined up with the frontal plane (Fig. 148).

To academicians, the dilemma of contemporary relief sculpture lay in the ultra-picturesque ambitions of many sculptors, the use of exaggerated perspectives that imitated painting and which violated the planes and "gravity" of architecture. From the standpoint of many critics what was wrong with current academic practice, as seen in the 1900 relief decorations of the Grand Palais, was that they represented eclectic sculpture for eclectic architecture. Artists were seen by the critics as being forced into period styles by conservative architecture or being unemployed because the new Paris architecture was not including much work in relief. Independent artists lamented the lack of inspiring architecture. Gaudier-Brzeska, Duchamp-Villon and Modigliani dreamed of doing their own buildings.

Hildebrand's essay was prompted by his dismay over the trends towards "realism" in sculpture, and his model of what was wrong with reliefs, although the name is never mentioned, was Rodin. One of the most ambitious and spectacular relief projects in history is the *Gates of Hell* (Fig. 149), in which Rodin resorted to all forms of projection. Below the free-standing figures of the *Shades* atop the portal is the lintel in which the range is from completely detached figures, such as *The Thinker*, to partially engaged figures. On the sides of the doors Rodin varied his figures from low through middle to high relief, but they are mostly in low elevation from the surface. The panels of the doors, which

his critics such as Bourdelle saw as being "too full of holes," have figures moving not only laterally, but in and out. This last would have earned Hildebrand's "inartistic" rebuke. According to the French academic view, Rodin violated the essential qualities of art because "*l'effet*" (light and dark) took the place of beauty. Such varied movement and perspective foreshortenings upset the architectural verticals, "amusing the eye" by the play of lights and darks at the expense of "ideal verities." Rodin deliberately avoided subdivision and framing of his groups (they overlap the door's margins), as this would have implied a medieval theological view of a zoned universe. Hell was not a place for Rodin; it was in the passions which man carried with him beyond the grave. He differed from Hildebrand by not using a flat rear plane and by seeing figures in depth rather than having them adhere to an imaginary frontal plane. Rodin's plan was to have the reliefs of the *Gates* draw the viewer under and into them and to thereby become a part of the sculptural drama.[110]

Renoir's 1916 relief of the *Judgment of Paris* (Fig. 150), shows the continuity between not only his painting and drawing, from which Guino derived the relief, but also the proximity of the aged artist's tastes to those of illusionistic Salon reliefs. Renoir accepted the conservative view that active movements were appropriate for reliefs, as well as recourse to graduated embeddings of the figures in the setting to achieve a sense of continuous recession in depth. Where he departs from Prix de Rome reliefs annually shown in the Salons, is in the mitigation of detail in order to achieve a greater amplitude of form and larger rhythmic contrasts. He was not trying to impress a

132

149. Auguste Rodin, *The Gates of Hell*, 1880–1917.

150. Pierre-Auguste Renoir, *The Judgment of Paris*, c. 1914.

151. (right) Ernst Barlach, *The Vision*, 1912.

jury by his command of archaeological facts, nor did he trespass an imaginary frontal plane as was the practice of aspirants for the Rome prize who tried to breach the spatial barrier between viewer and actor.

As did Rodin, Barlach used reliefs to enact his visionary imagination, and they allowed him to show the dreamer and the dreamed. Floating mantled figures hover above sleeping forms. His ideal was the late German gothic carved reliefs that had shallow space. Modest in size, some of his reliefs were intended to frame fireplaces in houses, as churches were not available to Barlach, until after 1920. With their indeterminate space, caused by a uniformly gouged surface, his spiritualized art was at home in a private setting (Fig. 151).

The most persistent and passionate

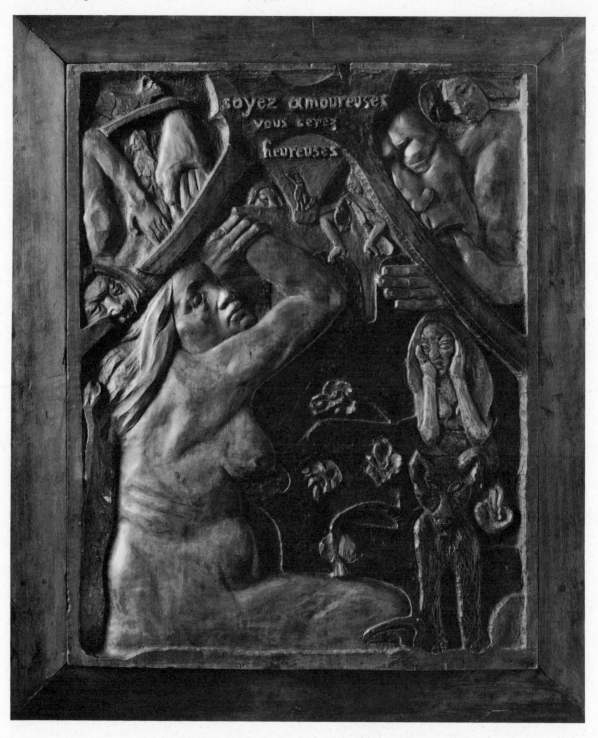

carver of wooden reliefs was Paul Gauguin, who discovered his own talent by playful whittling. His first decorative relief of 1882 was made for a cupboard in his own home.[111] It is interesting that the relief is flatter in conception than his paintings of the time. Self-taught, he gravitated to unclassical models that the academy would not have offered him. Throughout his life he preferred bas-relief, and his paradigms began with Chinese carved decoration, to be replaced by folk art of Brittany, and Egyptian, Indonesian, and tribal art encountered at the Paris World's Fair of 1889 and in the South Pacific. Both their forms and subjects convinced Gauguin of the "error of the Greeks," and formed his personal imperative for making contact with what he felt were "barbaric peoples," and to liberate thereby his creative imagination. Wooden shoes, staffs, cylinders, barrels, boxes, and flat panels became the bearers of his recollections of travels to Martinique, symbolic themes in Brittany, and cryptic autobiographic images and pan-religious sentiments inspired by European and Polynesian culture. To look upon Gauguin's reliefs as surrogate paintings, ancillary to the development of his fertile and influential art, is to ignore their history brilliantly recorded by Christopher Gray. Their number and difficulty of execution and his decision to decorate his last house in the Marquesas only in reliefs and not painting tell us otherwise. In many ways, including those by which he carved, Gauguin went against the grain of traditional relief sculpture. He neither consistently adhered to illusionistic nor flat backgrounds. Color was applied for personal symbolic and decorative purposes. Unlike his paintings, relief sculpture allowed Gauguin an interplay between his surfaces and

light, and he could satisfy a love for figural volume by imparting some nuance or internal modeling to the generally flattened forms of bodies, as in *Soyez Amoureuses* (Fig. 152). The coarse-grained textures and crude outlining of figures that often appear in the reliefs were matters of suppressing natural finesse, which separates Gauguin from European relief and, ironically, from his primitive or "barbaric" models. Although he was inspired by folk and tribal models, the rawness of finish presupposes a highly refined European sensibility. Unlike Bourdelle's self-conscious archaizing or streamlining of early classical Greek reliefs for the Théâtre des Champs Elysées in 1912 (Fig. 153), Gauguin's work came slowly, irrevocably, from personal, lived experience. It was part of a whole vision, no matter its inconsistencies, and was internal to a complete art.

153. Antoine Bourdelle, *Tragedy*, 1912.

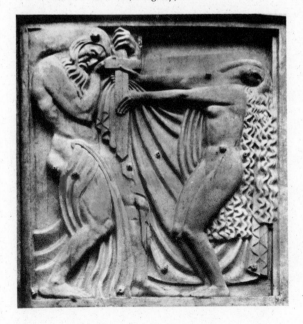

Bourdelle plugged the holes in relief, for which he had criticized Rodin, but he opened a credibility gap with the revolutionaries by affecting an ancient style (similar to a steam-rollered early classical pediment). Ironically, Bourdelle's reliefs were to exert a far greater influence on architectural decoration than did Gauguin's, because of their ready imitability. As Gray has pointed out, seventeen years before Picasso, Gauguin had discovered tribal art, but his discoveries were not as well known in Paris and lacked the timeliness in terms of the comparable susceptibility of other artists to Picasso's transformations of African art.[112]

Maillol's beginnings as an artist were in the Nabis movement, and he was encouraged by Gauguin to be a sculptor. His great relief, *Desire* (Fig. 154), is the antithesis of Gauguin's denial of a framed-stage space, and

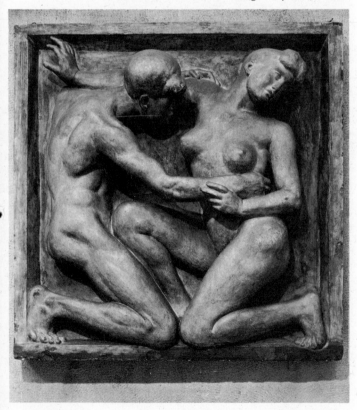

154. Aristide Maillol, *Desire*, 1906–08.

reflects his view of the relief as a special condition for free-standing sculpture.[113] Maillol was consciously redoing classical Greek metopes in form and subject, but with a personal amplitude of figural forms that filled the area and maintained consistent adherence to the frontal and rear planes. *Desire* could have served to illustrate Hildebrand's treatise. So architectonic is the order of the couple that even if the rectangular frame is concealed, their postures infer it. The tactful positioning of the limbs is such that the surfaces receive as much light as possible. Surity of shaping and proportion prevents their disintegration under strong light. Although Maillol's style was formed before his trip to Greece in 1908, if any modern sculptor's relief could be visualized on the Parthenon, this relief would be the one. Elie Nadelman's small bas-reliefs were too stylized, too much in the grip of his thesis on curves to be similarly referable to ancient Greece. They profess his concern for beauty over expressive effects of light and dark and view of decoration as relentless rhyming.

In his 1913 carved relief of a seated nude, one can see the young Spanish sculptor Manolo's unresolved synthesis of a Maillol-like fullness of figural form with a consciousness of an imagined surface plane. The problem was tackled in part by a complicated posture which would show as much of the figure as possible but which still produced foreshortening. He enacted and evoked roundness in his shapes by modeling and curved contours in otherwise flattened areas. Frustration may account for the unfinished areas. Unable to swear total allegiance to

155. Raymond Duchamp-Villon, *The Lovers*, 1913.

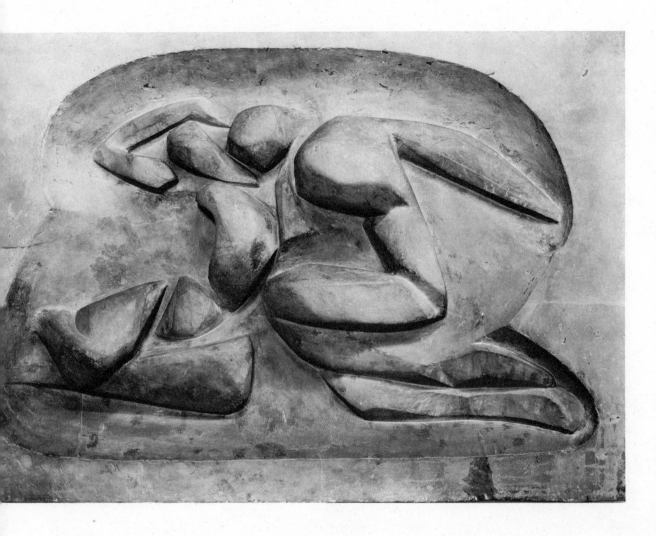

surface design Manolo eventually succumbed to a love for pastoral scenes in relief having perspective.

In age and thought, Maillol and Duchamp-Villon were of different generations, the younger man more intellectual, daring and concerned about redesigning both reliefs and architecture. Duchamp-Villon had modeled the facade of a Cubist House that was shown in the *Salon des Indépendents* of 1912, which demonstrated the reducibility of Cubism to applied motifs usable with period architecture.[114] More important for sculpture was his relief, *The Lovers* (Fig. 155), by which at one stroke he redid Rodin, modernized the Egyptian technique of incised relief, and moved beyond Maillol's personal classicizing to a human form that could only be dated in the early twentieth century and not substituted

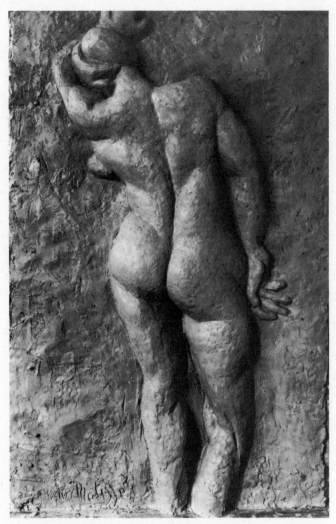

156. Henri Matisse, *The Back*, 1909 clay (lost or reworked into what is now known as *The Back no. 1*).

for an Elgin metope. The figural pose is too close a paraphrase of Rodin's *Eternal Springtime* for coincidence, but Duchamp-Villon divests his forms of all particularizing detail and fleshly sensuality. It was as if the young sculptor were admonishing the older artist to restrict such free-swinging forms to relief and to tighten his design. For Duchamp-Villon, what counted in architectural sculpture was a "rather meager formula: SEEN FROM A DISTANCE THE WORK MUST LIVE AS DECORATION THROUGH THE HARMONY OF VOLUMES, PLANES AND LINES."[115] Accordingly, he redesigned the bodies, preserving their syntax, but imaginatively using intervals for the joints, as in a wooden studio *écorché*, and reshaped the masses of the figure in ways which still preserved recall to their biological nature. He had learned in the studies for this relief that sculpture could be a matter of rhyming, and some abstraction facilitated rhythmic conjugations of the human form. In Maillol's relief, the space precedes the figures. The space in *The Lovers* belongs to the figures, and the concave areas respond to their movement. Optically, the artist won a refreshing ambivalence of the concave and convex as the light changes, and as one stares at the relief it sometimes looks like a negative mold of the sculpture with the volumes of the figures recessed and the untouched frontal surface becoming the back plane. This interest in opticality for reliefs was shared with, and may have been inspired by, the work of Archipenko.

After Rodin's *Gates of Hell*, the most heroic and pioneering relief project was that undertaken by Matisse in 1909, in his life-size study of the back view of a nude model (Fig. 156). There were five versions in all, the last not being completed until 1930.[116] It was

as if he sought to show that modern decorative sculpture could rival what Michelangelo had done for religious art. Michelangelo fascinated Matisse, whose art and viewpoint seem so antithetical to such an attraction. In his studio, Matisse juxtaposed his last plaster version of the *Back* with a cast of Michelangelo's *Bound Slave* in the Louvre, turned with its face to the wall, so that the visitor could share with the artist the comparison of their respective treatments. Matisse was struck with the expressive body movements, which evoked energy in repose, created by Michelangelo, and he paraphrased them in his sculpture without their tragic implications. The choice of a woman's back for his own relief was not unusual for the time, and it afforded a test for his views on expression. It further eliminated the guessing game about the woman's identity or what she symbolized. From a photograph we know that the first full-sized version of the relief was completed and signed by the artist in 1909. The ample proportions and sensuous surface of the model are preserved by acute observation and firm modeling. The figure while not embedded in the wall, is in demi-relief, suggesting that Matisse may have conceived it from the beginning for an interior, where it would receive side lighting and not full, direct illumination all day long out of doors. To academicians, the pose raised a problem as old as Vasari, namely of what to do with the foreshortened feet. Matisse solved it by not showing them but stopping the legs at their juncture with a frame at the base of the relief. Shortly after he completed the first version, Matisse seems to have become dissatisfied with the off-centered positioning of the figure that is an academic hipshot pose, also feeling that

157. Henri Matisse, *The Back no. 1*, 1909.

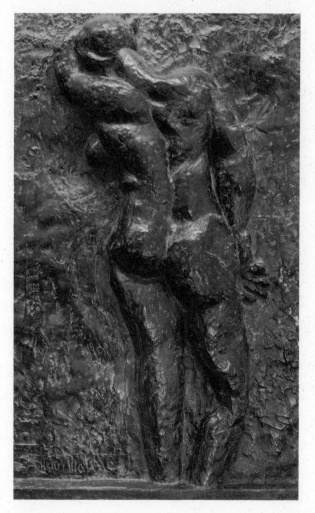

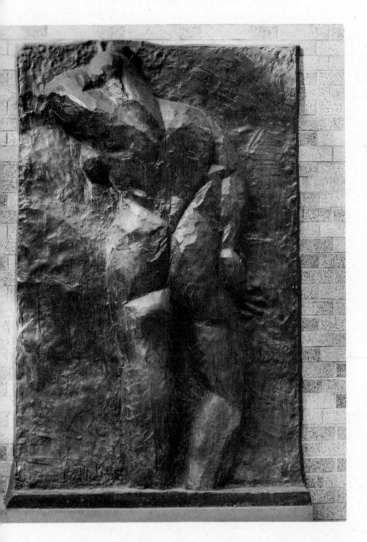

158. Henri Matisse, *The Back no. 2*, c. 1913.

159. (right) Henri Matisse, *The Back no. 3*, 1916–17.

his descriptive modeling was too inexpressive. He probably recut the clay to achieve what is known today as *The Back* no. 1 (Fig. 157). The successive variations were made from plaster casts, and from a photograph in the Le Cateau Matisse museum, we know he worked them with chisels. The reliefs done before 1917 show an increasingly brutal redesigning of the back, similar to what he had done in the *Jeannette* series, as he sought to impart more character and a new formal unity to his subject (Fig. 158). *The Back* no. 3 shows most dramatically how the search for overall quality in the work effects the treatment, number, and logic of the parts. Despite the vigor of the reshaping and fusion of parts and the new verticality that is abstracted from the body and aligned with the axes of the field, the relief still preserves the subject's essential femininity. Impressive as is the synthesis of Matisse's passion and intellect, it was not durable, and it took him many years to conclude the relief (Fig. 159).

The new history of relief

Contrary to the exhaustion theory of how modern art has evolved, whereby new movements are said to replace those that have worn out, the new history of the relief which begins in 1912 resulted from positive incentives and not dissatisfaction with contemporary answers to old questions. Unless we understand the new questions and problems, the "dirty shirt" view of history, whereby artists discard "outworn" habits, wins by default. Evidence of fresh conceptual thinking is found in the pervasiveness of reform: adulteration and vernacularization of materials as opposed to the homo-

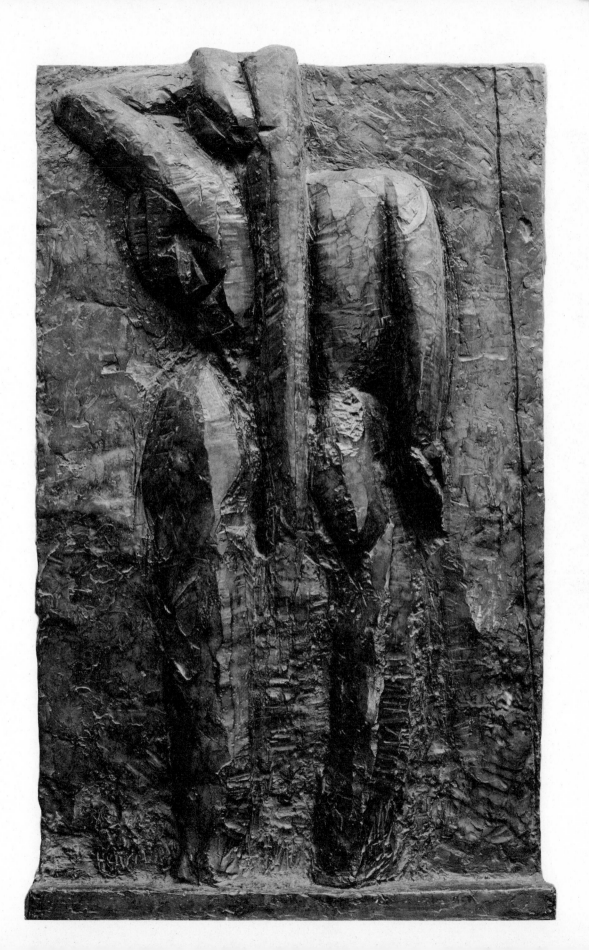

geneity of stone and bronze; the use of varieties of polychromy that are inconsistently descriptive or abstract; the absence of a rectangular frame and sandwich-like planes to which the composition may be referable; the replacement of figural focus by objects, materials, and abstract shapes; and independence from architecture that influences scale, composition, and the means by which the relief is supported. Simplified formalistic views of modern art's history by which painting and sculpture are viewed as irrevocably trending to exclusivity of each other cannot cope with the reliefs made by painters and sculptors who disdained hardening of the categories as art disease. The new concept of relief was the meeting and not the battleground of painting and sculpture. This concept began with Picasso's *Guitar*, Archipenko's "Sculpto-Paintings,"

Tatlin's "painterly" and "contre-reliefs," and Arp's layered biomorphic constructions.

Before considering the achievement of these artists, mention should be made of the earliest modern abstract relief done by the Austrian architect, Josef Hoffmann in 1902 (Fig. 160).[117] Abstraction had its beginnings in late nineteenth century decorative art, and architects such as Adolf Loos, Frank Lloyd Wright, and Hoffmann designed their own decoration which took the direction of rectilinear geometric forms as a reaction against the obsession with organic motifs in Art Nouveau architecture. Viewing themselves as complete artists, they did not surrender decorative assignments to sculptors. In the fourteenth exhibition of the Vienna Secession, Hoffmann exhibited a small framed stucco relief intended to be placed above a doorway. Its variable white cubicular bars, asymmetrically juxtaposed, are startling premonitions of Malevich's studies for sculptured architecture of 1920, and Van Tongerloo's researches into harmonizing geometric volumes after 1917.

Archipenko's new concepts of the relief presupposed new materials and techniques whose synthesis produced what he called "Sculpto-Painting," an invention dated by the artist in 1912. He defined this as "a panel uniting colors and forms having interdepen-

160. Joseph Hoffman, *Relief.*

dencies of relief, concave or perfor-
ated forms, colors and textures. . . .
Forms are intermixed with the patterns
of color and the space between them
in accordance with the particular es-
thetic or spiritual problem."[118] In ad-
dition to compositions that could be
hung on walls, beginning with *Med-
rano* of 1914 (Fig. 161), Archipenko
made self-supporting and potentially
free-standing reliefs. The destroyed
*Oval Mirror Reflecting a Woman Hold-
ing a Small Mirror* of 1917 (Fig. 162)
was patterned after a dressing table
mirror on legs. The 1916 *Woman Be-
fore a Folding Mirror* could have been
free of the wall or situated in a corner.
Archipenko's reliefs refract Cubism in
the punning relationship of art ob-
jects to those of utility, a relation-
ship augmented by the capacity of the
former to be disposed about a room
on flat horizontal surfaces. Henri Lau-
rens made a number of self-supporting
corner-like reliefs from wood and
cardboard in 1916–1918. The angular
conjunction of the back planes solves
the problem of achieving an upright
stance. For Archipenko, Laurens, and
Lipchitz what was "architectonic" was
the lucid, internal coherence of the
compositional parts. When confronted
with the premise that the artist could
reject the logic and order of the natu-
ral and man-made world outside of
art, the response of these artists was to
intervene actively in the work by inte-

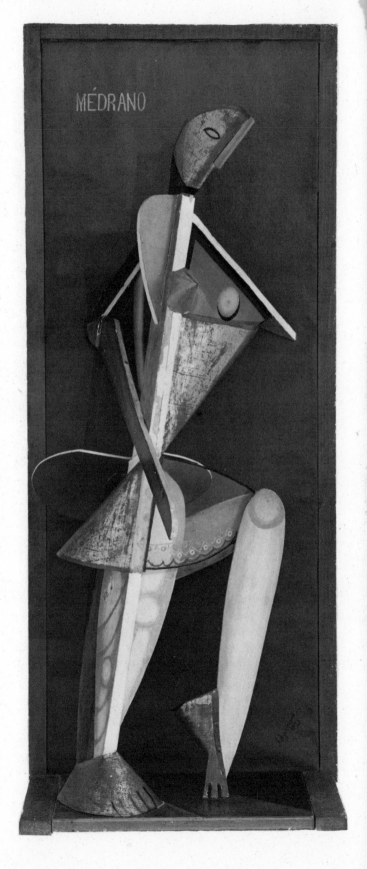

161. Alexander Archipenko, *Medrano*, 1915.

162. Alexander Archipenko, *Oval Mirror Reflecting a Woman Holding a Small Mirror*, 1914 (lost).

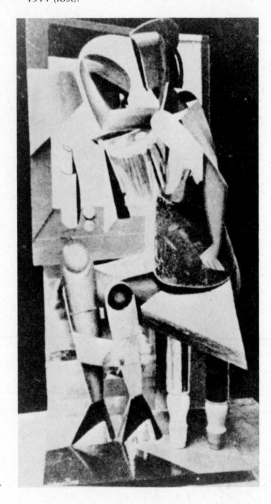

grating and restructuring objects so that the resulting inconsistency of illusionism enforced the aim of visual and intellectual enjoyment (Fig. 163). The problem of light casting shadows out of scale with the motif was eliminated, as with each composition there is to begin with an unsteady sizing of the motifs.

Picasso's Cubist paintings of 1909 had caused him to remark to his Spanish companion, Julio Gonzalez, that by following the directions and values of the painted planes in the composition one could engineer a three-dimensional construction. He came to revolutionize relief sculpture through the possibilities opened in his painting. Old photographs show on the walls of his studio in 1912 and 1913 conjunctions of drawings and reliefs, as Picasso began to build his compositions not into depth, but into the space of the room.[119] In more ways than one, architecture was left behind. Hung from the wall by a nail, his *Guitar*, the Tate *Still Life*, and *Mandolin* of 1914 find their outlines inductively, as their compositions evolve. While many of the planes face us, there is no concerted attempt to have them repeatedly touch an imaginary frontal surface. The modesty of the motifs belies the reliefs' momentous importance for artistic thought. Thematically, Picasso accepted and celebrated the easy and intimate sociability of the Cubists' life in the cafés and studios. The reliefs are mementoes of shared modest pleasures. In form, they claim the artist's right to reform reality, or to counter it with their own. By not forsaking the familiar world of things, Picasso could put forward in his reliefs tangible even if dislocated objects that occupied the same space and reflected the same light as guitars, cups, and saucers.

To Tatlin, who saw Picasso's reliefs in the spring of 1913, the heterogeneity and tangibility of their materials assembled without regard for strict resemblance were the means by which to move from painting to sculptural abstraction.[120] The most gifted of the Russian artists who worked with relief before 1918, Tatlin established what others were quick to second, the new abstract relief as the carrier of hopes for a new society. The arbitrary and imaginative Cubist constructions dramatized the possibilities for a po-

tent new order by which the artists could symbolically counter the hierarchical social structure of the Czarist regime. Their assault on traditional categories of art was like an attack on the class system. Tatlin's reliefs signified new personal freedom of action and imagination discouraged by Russian art academies if not pre-Revolutionary society. These reliefs made young Rus-

sian artists continue to feel that they had made contact with the modern world outside of Russia and that they could surpass the Paris avant garde movements which still seemed tied to persons, places and things. The Cubist premise of improvisation in construction led to results in Russia by 1915 that made French avant garde art seem like homages to care and craft. Jealous

163. Henri Laurens, *Woman With a Mantilla*, 1918.

of imitation, the Russian artists assembled their reliefs on walls and windows of the exhibition hall at the last minute. Ivan Puni used half of his own dining room table to make his relief, *Sculpture Verte* of 1915 (Fig. 164). Larionov tied ribbons and nails to an electric wall fan which was turned on when the show opened.[121] Tatlin developed his own truth-to-the-material ethic, believing that the nature of his materials constituted the ideas he should respect as the relief was being formed. Revolution translated into new materials, new techniques, and rational construction. This divorce from the associative properties and potential of materials was comparable to the contemporary concern of Russian poets and musicians with pure sounds whose syntax was unique to the composition. In 1915, Tatlin began his "contre-reliefs" (Fig. 165), by which through the use of wires his compositions were stretched between two walls near a corner. He showed that relief sculpture could be suspended in space. The tensile property of wire introduced Tatlin and sculpture to new means by which to get sculpture off the ground and wall, to be gravity resistant, and thereby more fully involved with space. Not surprisingly, in retrospect, this reformulation of relief

164. (left) Ivan Puni,
 Sculpture Verte, c. 1915.

165. (right) Vladimir Tatlin,
 Counter-Relief, 1915
 (reconstructed 1966–70).

166. Jean Arp, *Plant Hammer.*

and his concern with making art more relevant to the social revolution caused Tatlin to think in terms of combining painting, sculpture, and architecture further fusing the arts, which he was to try in his monument for the Third Communist Internationale of 1919. Tatlin exemplifies a certain type of modern artist who, unlike Picasso, does not believe that art can ever turn back. The possibilities opened to Tatlin by the contre-relief could not content him with making compositions to adorn architecture. Prophetic of later developments, Tatlin had started on a path in sculpture which led to its own obliteration as a distinct entity.

The common objectives of producing something entirely new, a form of abstraction to express the times and their feeling about them, explain the revolutionary but divergent characteristics of Tatlin's and Arp's reliefs. Those of Jean Arp owe their singular character to his response to the First World War and a conviction that art had betrayed civilization by seeking favoritism from the classes that benefited from human destruction. To the artist, exiled in Zurich, this meant not abandoning art, but restoring its civilizing function. Encouraged by his future wife, Sophie Taüber, and the Dadaists, Arp removed himself from esthetics and craft-consciousness, as he did not want either to get in the way of immediate and direct production of art. He rejected his academic training, to be faithful to nature in favor of being "natural" as a creator. Man was no longer the measure of nature, but he felt both man and nature to be unmeasurable and reconcilable in new irrational ways. Above all, the poetic had to supplant the prosaic. Reliefs titled *Plant Hammer* (Fig. 166) and *Madame Torso In a Wavy Hat* brought a gentle humor to sculpture without

masking profundity of insight. Where the Russians championed disorder as a disruptive social force, Arp used random ordering to evoke art's affinities with natural phenomena and laws whose understanding healed man's sense of alienation from the world. The Spartan, even puritanical, insistence of Tatlin on the literalness of his materials contrasts with Arp's open-ended metaphors, compounded of fragments of bodies, stones and plants.

The problem confronting Arp in 1915 was to make art as if it had never been made before, while being "natural" as an artist. It was during World War I, as a result of the efforts of Arp and the Dadaists, that originality became a conscious and concerted objective, in contrast to individuality, which had been the aim in Western art since the Middle Ages. The painted relief as well as collage resolved his dilemma of alternatives to painting and sculpture. Working with wood, a material he did not feel was freighted with tradition, and using a saw because it did not demand or disclose manual virtuosity, Arp developed from his automatist drawings "free forms" that were meditations on man and nature. Small scale was appropriate to Arp, as he sought to be sure of his ground when exploring new territory. Arp may have benefited from Picasso's constructions in the stratifying of his reliefs and in the absence of a solid rectangular back plane and frame, but his evocative organic shapes, their casual and non-gridlike dispersal, and his use of space in perforated shapes were authentic alternatives to both traditional art and Cubism. These reliefs were a startling alternative to the function of traditional sculpture that had been to shock the preoccupied bourgeois by contact with "great ideas." Matisse had countered this ideal by

providing for the esthetic delight of the "mental worker," in the form of the equivalent of armchair relaxation. Arp wanted his reliefs to teach a sympathetic person to "dream with his eyes open." As for those who clung to the rule of reason, Arp once described his reliefs as "monstrous home furnishings . . . to show the bourgeois the unreality of his world."[122]

Post scriptum

Proportionately modern painting did not suffer the loss in World War I of as many and comparably gifted men as Henri Gaudier-Brzeska, Umberto Boccioni, Raymond Duchamp-Villon, and Wilhelm Lehmbruck. By 1918, Gauguin, Rodin, and Degas were dead as well. Rosso had stopped making sculpture shortly after 1900, as did Modigliani after 1914. Derain had made his most important contribution, and the most influential work of Epstein and Nadelman falls within this period. Tatlin had only a few more exciting years of making sculpture before he turned to other projects. Maillol joyfully continued to remake essentially the same sculpture until his death in 1944. Barlach, as had Maillol, found his style but discovered more to say as he became the pride of Weimar Germany and then a target of the Nazis. Matisse was to do fewer but still important sculptures while resisting the temptation to fall into a set style. Brancusi's art must be viewed as a continuous evolution, and his work between the two world wars ranks with the best modern sculpture. Arp, Van Tongerloo and Gabo were just at the beginning of their distinguished careers in 1918, as were Lipchitz and Laurens, who made important transformations of Cubism in the twenties and thirties. Picasso was to go on and make over four hundred more sculptures, which despite their frequent brilliance and richness rarely surpass in influence his work between 1912 and 1915.

Summary

According to Picasso, "There has to be a rule even if it's a bad one because the evidence of art's power is in breaking down the barriers."[123] The number, age, and strength of the barriers they breached certifies the heroic forcefulness of early modern sculptors. As Picasso also pointed out, it was essential that artists recognize the existence of a problem and not try to distract us by stylistic sleights of hand. He, Brancusi, Arp, Archipenko, Lipchitz, and Boccioni, to name a few, saw clearly that sculpture's problems derived from the demands of ulterior service, erudition, and the misuse of sculpture's own past. The innovative artist had to forego playing the traditional roles of institutional spokesman, Salon savant, souvenir maker, sycophant, and entertainer. He learned to speak for himself. Salon sculpture had become captive to finesse and virtuosity. Too many artists confidently counted upon miracles of the hand rather than achievements of the mind. The intellectual freedom won by early modern sculptors was the right to greater choice and pursuit of other purposes. Conceptual independence meant that without esthetic or craft inhibitions sculpture could be freed from resemblance to older paradigmatic sculpture or nature itself and opened to inquiry, invention, and in Arp's words, "other order."

The early twentieth century revolutionaries sought to restore to sculpture power, profundity, and poetry. Artists asked themselves how they could make sculpture that looked as if it belonged to the new century, accommodating changing concepts of reality and still meeting the need to reach a universal audience. For many this meant the search for the simple in form and spiritual in content. Several innovative artists unsuccessfully sought an art that was the equivalent of academic sculpture in capturing the allegiance of society that would look to it for tangible symbols of its hopes. The public did not come to support the life attitudes and personal values of these artists, because of lack of exposure, the intervention of the war, and the conflict between new formal languages and the public's conservative values regarding rhetoric and beauty.

Only Rodin, Duchamp-Villon, Bar-

lach, and Boccioni came to terms with life's mobility, and for them modernity meant motion. For the others, sculpture could be given a meaningful presence, paradoxically, only by its immobilization, like someone standing still in a moving crowd. Although sculpture could be seen everywhere in Europe, the avant garde believed in a new visibility, one in which the viewer did not see through the work to literary references, philosophical abstractions, or historical events. They sought to arrest the eye and focus the thoughts of the sympathetic beholder by a more indivisible form and meaning, or increased self-referral, or stoniness and silence, or surprise and, ironically, growing physical transparency that made more tangible light and space. The primacy of monuments and monolithic sculpture had been challenged, but the credibility gap between the academicians and the public had been supplanted only by a void of unintelligibility, suspicion, or disbelief between the man on the street and the rebels. In terms of international public acceptance, no modern sculptor has ever matched Bartholdi's *Statue of Liberty*.

While the Academy respected individuality, the new sculptors wanted more: self-expression and creation rather than the imitation of art and nature. They wanted originality and the right to redefine sculpture from their own experience or rediscover what it had been at its origins, before classical antiquity and apart from Western society. Some were led, thereby, to examine the art of tribal cultures, which they viewed as a natural group expression, uncontaminated by the naturalism and idealism of European civilization and formed by imagination and feeling. Tribal art presented paradoxes to men bent on originality, and interest in it was symptomatic rather than causal of change in early modern sculpture. Lipchitz and others shook hands with African art, and modern taste was now friendly to world sculpture.[124] Erratic and scant as it often was, private rather than public sponsorship and the willingness of many artists to endure grinding poverty abetted these reflections on sculpture's past and potential. Disinterest in becoming part of the national educational system and public relations arm of the government encouraged such stylistic *tours de force* as Derain's stone figures. A sculptor such as Brancusi need no longer celebrate truths found by others in styles formed before him. The burden of pursuing absolute Platonic perfection had been removed for Picasso by the discovery of alternatives to the "museum beauty" of classical Greece and Renaissance Italy. Found in ethnographic museums, these alternatives meant that form could be aggressive and not presuppose noble motives. The early modern sculptors had found outlets for private feelings and personal reflections on culture that were not at the service of institutional guardians of orthodox belief. The experience of mystery and wonder, exaltation and spirituality in general were sought outside of the church.

The complex legacy of the first generation of modern sculptors included revitalizing the nude as well as dethroning the figure by sculptural enfranchisement of objects and abstraction. A new literalism coexisted with innovatory metaphorical means for expressing private experiences. There was a broadening of the basis of inspiration to comprise world sculpture and the self, while recourse to the written word was rejected. A heightened sensibility to the inspirational potential of materials developed concurrently with

a new indifference to media and making. At no time did the medium become the message. The polarizing of the poetic and the prosaic was companion to the removing of sculpture from its pedestal along with the connotations of preciousness and separation from life. Sculpture was henceforth to try conclusions with the world of industrially made objects. The new permissive premises contributed to later triumphs and crises in sculpture, for sculpture had been made potentially easier, accessible to those untutored in craft and imitative skills, those with no loyalty to the profession, and for whom sculpture was not only simple to make, but to give up and do without. What has proved to be a dangerous legacy has been the criterion of relevance to one's time in terms of materials and techniques. Before 1918 there had begun with considerable impetus the contraction of what was not sculpture in theme, form, and materials, and those who were not sculptors.

Like modern painting, early modern sculpture was based on audacious concepts of esthetic wholeness that meant autonomy from traditional models of how the artist should work, what his sculpture should look like, and how the viewer should experience it. To Maillol this translated into unity rather than the unit. For Matisse, Brancusi, Picasso, and others each sculpture had its own spirit or personality, unique intellectual and esthetic qualities that must be respected and sustained throughout the entire work no matter the cost. The price demanded by the liberation of esthetic intuitions often included suspension of explanatory details or dispensability of parts of the body and even alteration of their sequence, disregard of customary proportions, impeachment of familiar boundaries, application of expressive

and nondescriptive color, and penetration of the sculpture's mass by space and drastic alliances with light to create form. Justification for all these violations depended solely upon the internal logic and character of the sculpture itself. The understanding, appreciation, and judgment of a sculpture rested upon comparison with preceding works by the same artist, rather than knowledge of anatomy, the rectified aplomb, and historical exemplars in the Louvre. The achievements of new forms of artistic cohesion and expression of personal experience meant a new unity in terms of the artist's more intimate relationship to his work. He assumed the responsibility of either reforming nature or literally inventing the vocabulary and grammar of his sculptural language. In terms of that to which the sculpture referred, there was a divergence of views between those like Tatlin seeking a new wholeness by making the work's meaning concentric, narrowing to self-referral, and those like Rosso and Boccioni, who wanted radiocentricity to accomplish a new continuum with the environment.

Before the several revolutions summarized in this essay, sculpture was thusly describable: Staged on a pedestal and wall as the beautiful or expressive mime of nature, sculpture's surfaces of the hollow and lump were carved in stone or modeled and bronze cast in the eternal service of whoever paid for it. (Pierre Gasq exemplified this view in his personification of sculpture in 1900.) Before 1918, every one of these conditions had become optional or avoidable, and a second history of sculpture had begun. Picasso's *Guitar* (Fig. 75), Brancusi's *The Kiss* (Fig. 32), Boccioni's *Development of a Bottle in Space* (Fig. 76), Van Tongerloo's *Construction in a Sphere*

(Fig. 106), Gabo's heads in celluloid (Fig. 118) and the Cubist sculptures of Lipchitz and Laurens (Figs. 35, 77), Tatlin's "contre-reliefs" (Fig. 165), and Arp's *Plant Hammer* (Fig. 166), as outstanding examples, were inconceivable before 1900 and required new definitions of sculpture. For these works tangibility, meaning their physical three-dimensional character, was all that remained of the traditional definition of sculptures as the selective and palpable imitation of nature. The art of Rodin, Rosso, Degas, Gauguin, Maillol, Lehmbruck, Barlach, Matisse, Nadelman, Derain, Modigliani, Epstein, Gaudier-Brzeska, Duchamp-Villon, and much of Archipenko and Brancusi could still support a liberal definition of sculpture as the interpretation of nature by modeling and carving. In 1910, Gaudier-Brzeska had said emphatically, "Sculpture is the art of expressing the beauty of ideas in the most palpable form." Because of its second history, sculpture had to be broadly redefined to accommodate its new options of self-support: the invention of shapes and their order; the making of abstraction and interpretation of objects as well as the figure and nature according to personal ideals of beauty and self-expression; new surfaces—detachable from mass—that were flat or curved, thick or thin, allowing light and space to be integral to the design, and realized in any material no matter how ephemeral by assemblage and construction. More than at any previous time in history, by 1918, sculpture was available to the buyer and public on the artist's terms (Figs. 167, 168).

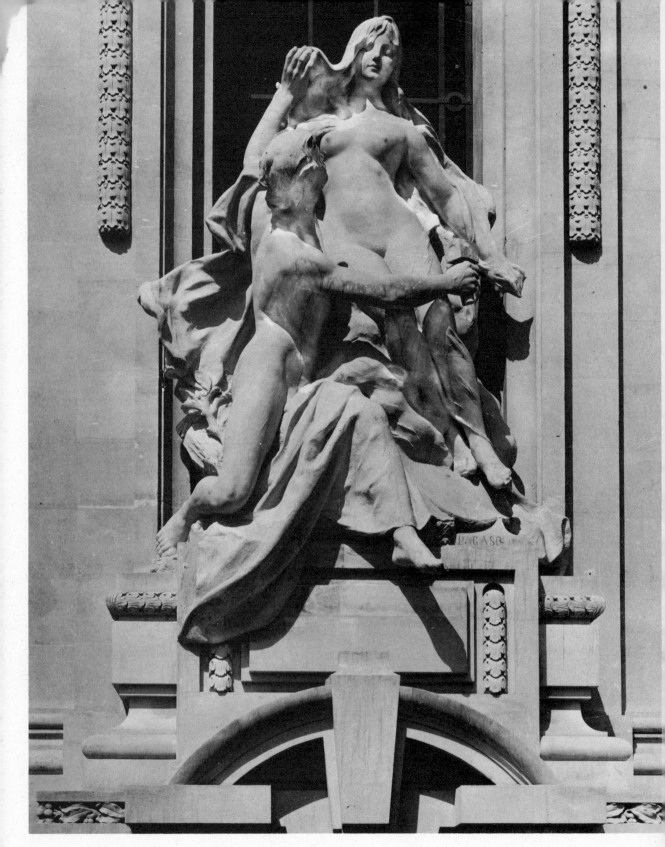

167. Pierre Gasq, *Sculpture*, c. 1900.

Notes

1. Charles Blanc, *Grammaire des Arts du Dessin: Architecture, Sculpture, Peinture* revised edition, 1880. Laurens. A basic work for understanding the École des Beaux-Arts view of sculpture. For an excellent summation of the purposes and patronage of sculpture see Ruth Mirolli's *Nineteenth Century French Sculpture: Monuments for the Middle Class*, Catalogue of an exhibition at the J. B. Speed Museum, Louisville, 1971.

2. Léonce Bénédite, "La Sculpture" Part 1 *La Revue de l'Art*, 1899, 410ff.

3. Many of the prize winning Salon sculptures in plaster are today housed by the Museums of the City of Paris in the Dépôt des Marbres, in Auteuil.

4. Gustav Babin, "La Sculpture," *La Revue de l'Art*, 1901 (1) p. 420.

5. Blanc, p. 386.

6. Kenneth Clark, *The Nude: A Study in Ideal Form*, Pantheon, 1956, p. 358.

7. Judith Cladel, *Maillol: Sa Vie-Son Oeuvre, Ses Idées*, Grasset, 1937, p. 132. Important for the many quotations from the artist.

8. Albert Elsen, *The Sculpture of Henri Matisse*, Abrams, 1972, p. 48ff.

9. Lincoln Kirstein, *Elie Nadelman*, Eakins Press, 1973. Mr. Kirstein was kind enough to allow me to read his important book in galley.

10. The best discussion of primitivism and modern sculpture is the chapter of that title in Robert Goldwater's *Primitivism and Modern Art*, revised edition, Vintage, 1966. See also Lucy Lippard's "Heroic Years From Humble Treasures: Notes on African and Modern Art," in her collection of essays, *Changing*, Dutton, 1971.

11. Quotations in this paragraph come from Boccioni's writing published in Umbro Apollonio's indispensable *Futurist Manifestos*, in the Documents of Twentieth Century Art series by Viking, 1973, p. 176.

12. H. S. Ede, *A Life of Gaudier-Brzeska*, London 1931, p. 147–148. The letter to Dr. Uhlemayr is dated November 28, 1912. The U.S. edition of this book is titled *Savage Messiah*.

13. Françoise Gilot and Carlton Lake, *Life With Picasso*, Signet, 1964, p. 248.

14. Sidney Geist, *Brancusi, A Study of the Sculpture*, Grossman, 1968, p. 45 and 159. In my opinion this is the finest study made on a modern sculptor, matched only by its sequel in Geist's

catalogue for the Brancusi exhibition at the Guggenheim Museum in 1969.

15. Richard Buckle, *Jacob Epstein, Sculptor*, World, 1963, "The Strand Sculptures" and Jacob Epstein, *An Auobtiography*, Vista, 1955, "Strand Statues: A Thirty Years War: 1908."

16. See Leo Steinberg's "Michelangelo's Florentine Pieta: The Missing Leg," Art Bulletin, Dec. 1968.

17. This information was given to me by Sidney Geist.

18. Margot Barr. *Medardo Rosso*, Museum of Modern Art, 1963, p. 76. An indispensable and meticulously researched study.

19. Carl D. Carls, *Barlach*, Praeger, 1969, p. 9. The best book on Barlach in English, with valuable quotations from the artist.

20. Mr. Kirstein writes about this sculpture as a portrait in his new book.

21. Philipp Fehl, *The Classical Monument*, NYU, 1972, "The Canon." A basic study of a major subject in the history of sculpture. For a larger survey of the subject in this section, see the chapter, "The Figure in Sculpture" in my *Purposes of Art*, Third Edition, Holt, Rinehart and Winston, 1972.

22. Paul Gsell, "Chez Rodin," in *L'Art et les Artistes*, January 1907. A very important interview in which Rodin speaks about not only the meaning of the *Balzac*, but also his interpretation of the *Burghers of Calais*. This material is not reproduced in Gsell's famous conversations with the artist, *L'Art*. For a detailed treatment of this great project, see my catalogue, *Rodin and Balzac*, coauthored with S. McGough and S. Wander, published by Cantor, Fitzgerald of Beverly Hills, California, 1973.

23. Reinhold Heller, *The Art of Wilhelm Lehmbruck*, National Gallery of Art, 1972, p. 27. Mr. Heller's essay is the best study on Lehmbruck in English and makes important contributions to our understanding of this artist.

24. George Heard Hamilton and William Agee, *Raymond Duchamp-Villon*, Walker, 1967, p. 112. A very important book in text, illustrations, and source material. Unless specified, all quotes from the artist derive from this book.

25. Marianne W. Martin, *Futurist Art and Theory, 1909–1915*, Clarendon Press, 1968, p. 172. An indispensable study.

26. James Johnson Sweeney, *Jacques Villon, Raymond Duchamp-Villon and Marcel Duchamp*, S. R. Guggenheim Museum, 1957, (See the artist's letter to Walter Pach, 1/16/13.)

27. Philip R. Adams, *Antoine Bourdelle*, Slatkin Gallery, 1961, p. 72.

28. Epstein, p. 51.

29. Ibid., pp. 56–57.

30. Ibid., pp. 56–57.

31. Hamilton and Agee, p. 112.

32. Geist, p. 52.

33. Barr, p. 13 and 71.

34. Heller, p. 28.

35. Geist, p. 29.

36. Barr, pp. 58–59.

37. Barr, p. 51.

38. Gilot, p. 69.

39. Gertrude Stein, "Elie Nadelman," *Larus*, vol. 1, No. 4, July, 1927.

40. This is from a "Statement of Principles" by Nadelman that is in Kirstein's new book.

41. Blanc, p. 14.

42. Ezra Pound, *Gaudier-Brzeska, A Memoir*, The Marvell Press, 1960, p. 49.

43. Alfred Werner, *Modigliani The Sculptor*, Peter Owen, 1965, p. XVIII.

44. Jacques Lipchitz with H. H. Arnason, *My Life in Sculpture*, Viking, 1972, p. 162. A wonderful source book on the life and ideas of a major sculptor.

45. Herbert Read and Leslie Martin, *Naum Gabo*, Harvard University Press, 1957, p. 162.

46. William R. Rubin, *Picasso in the Collection of the Museum of Modern Art*, Museum of Modern Art, 1972, p. 74.

An outstanding contribution to Picasso scholarship.

47. Apollonio, pp. 176–177.
48. Geist, *Brancusi: A Study of the Sculpture*, p. 65.
49. K. G. Pontus Hultén and Troels Andersen, *Vladimir Tatlin*, (Catalogue of an Exhibition) Moderna Museet, 1968. A group of fine essays and illustrations of Tatlin's work.
50. John E. Bowlt, S. Frederick Starr, Leonard Hutton-Hutschneker, *The Russian Avant-Garde, 1908–1922*, (Catalogue of an exhibition at the Hutton Gallery) 1971–72. A brilliant exhibition and important catalogue. See also Hilton Kramer, "Old Times, New Times," *The New York Times*, January 30, 1972.
51. Marianne W. Martin, 201. See also, Umbro Apollonio's *Futurist Manifestos* in the Documents of Twentieth Century Art series by Viking, 1973, pp. 197–198.
52. Georges Van Tongerloo, *Paintings, Sculptures, Reflections*, Wittenborn, Schultze, 1948, p. 9.
53. Carola Geidion-Welcker, *Jean Arp*, Abrams, 1957, p. XIV.
54. I have published a book on this subject, *The Partial Figure in Modern Sculpture: From Rodin to 1969*, The Baltimore Museum of Art, 1969. See the introduction for the historical background of the partial figure, and the first chapter for a more detailed account of Rodin's use of it.
55. Judith Cladel, *Rodin*, L'Homme et L'Oeuvre, Van Oest, 1908, pp. 97–98. One of Miss Cladel's early books on Rodin which established her credentials as his finest biographer.
56. Albert Elsen, *The Sculpture of Henri Matisse*, Abrams, 1972, p. 34.
57. Gilot, p. 254.
58. Ede.
59. Pound, p. 28.
60. Apollonio, p. 180.
61. Alfred Barr, *Matisse, His Art and Public*, Museum of Modern Art, 1951, p. 123.
62. Marguette Bouvier, *Aristide Maillol*, Editions Marquerat, n.d., pl. 34.
63. In his new book, Lincoln Kirstein presents and defends Nadelman's views on Picasso's indebtedness to him.
64. Van Tongerloo, p. 20.
65. Andrew C. Ritchie, *Sculpture of the 20th Century*, Museum of Modern Art, n.d. p. 40.
66. Blanc, p. 393.
67. Raymond Escholier, *Matisse, Ce Vivant*, Fayard, 1956, p. 163–164.
68. For reproductions of these drawings see Hamilton and Agee, esp. pp. 51, 52, 59, 79, 82.
69. M. Potter and others, *Four Americans in Paris*, (Catalogue of an exhibition of the Stein Collections) Museum of Modern Art, 1970; see especially Picasso's *Three Women* of 1908 in the Hermitage Museum, plate 46.
70. Cladel, p. 82, for Maillol's thoughts on this subject with which he was sympathetic.
71. Lipchitz and Arnason, p. 29.
72. Joshua C. Taylor, *Futurism*, Museum of Modern Art, 1961; see pages 129–132 for Boccioni's "Technical Manifesto of Futurism, 1912."
73. Alexander Archipenko and Fifty Art Historians, *Archipenko*, Tekhne, 1960, pp. 56–58.
74. Archipenko, pp. 57–58.
75. Taylor. (All Boccioni references are from his "Technical Manifesto.")
76. Marianne W. Martin, plate 218.
77. Gilot, p. 209.
78. Guillaume Apollinaire, *Chroniques d'Art, 1903–1918*, Gallimard, 1960, p. 333.
79. Lipchitz and Arnason, p. 29.
80. Lipchitz and Arnason, p. 37.
81. Blanc, pp. 432–433.
82. *Rodin on Art*, (introductory essay by R. Howard, translation from Paul Gsell's conversations with Rodin) Horizon, 1971, p. 61.

83. Cristopher Gray, *The Sculpture and Ceramics of Paul Gauguin*, Johns Hopkins, 1963, plates 51, 77, 91. A major study.
84. Archipenko, p. 45.
85. *Henri Laurens, Exposition de la donation aux Musées Nationaux 1967*, n.p. Grand Palais, Paris.
86. Adolf Hildebrand, *The Problem of Form in Sculpture*, Stechert, 1907, p. 78.
87. Athena Tacha Spear, "Sculptured Light" in *Art International*, Christmas 1967, has a very fine essay on this subject with good observations about this period.
88. Margot Barr, p. 9.
89. Apollonio, p. 89.
90. Archipenko, *Fifty Creative Years*, p. 59.
91. Geist, *Brancusi: A Study of the Sculpture*, p. 160.
92. Geist, p. 157.
93. Geist, *Brancusi*, Grossman, p. 154.
94. I am grateful to Sidney Geist for his painstaking explanation of the problems caused by uncertain dating of tracing the evolution of the Brancusian mirrored surface. I regret not having availed myself of his counsel on this problem before the publication of the first version of this essay in 1973. Both he and I had been misled by working from photographs, particularly one of the *Maiastra* in Edward Steichen's garden which made the sculpture seem more polished than it in fact was. On July 22, 1973, Geist wrote to me, "I am convinced the *Maiastra* 1911 was not so polished in spite of the photograph in my catalogue. . . . The piece could have been wet, the sun could have been on it, and it's fuzzy anyway. I have another good clear shot, taken in the same garden, and it surely doesn't look polished." On August 12th, Geist wrote, "As for the polish story, the 1917 date I aver is for reflective, mirror polish. . . . The case of Prometheus is puzzling because the Guggenheim catalogue was in error. . . . [There was an errata sheet published which I did not receive] The polished Hirshhorn example has no date; the gilded one is inscribed 1911. . . . The MOMA *Newborn*, polished, is dated 1915 on the basis of the marble of that year. . . . But in going over everything for the umpteenth time, I see Brancusi dated it 1920 in 1926, and there's no reason to think him wrong here. . . . Same with the *First Cry*, from the destroyed *First Step* of 1913 or 1914. We all thought 1915 for the polished one, but Brancusi said 1917 and there is no evidence for an earlier date. (The gilded one may of course be earlier.) You ask is the Sleeping Muse of 1910 his first unpatinated or partially unpatinated bronze. I think *Pride*, 1905 (Colin), and the second version of Torment, 1907 (Richard Davis) are unpatinated. Some of the 1910 *Sleeping Muses* were made shiny, but not reflective because the surfaces waver and can't support the absoluteness of mirror polish. . . . And the surfaces waver because (as I think) the original marble was not carved with a bronze in mind, the bronze having been perhaps an afterthought. The bronze of *Sleeping Muse* is after all Brancusi's first bronze from a carving. The *Muse*, 1912 (Lindt) only went into bronze—and reflective bronze—in 1917, and then at the request of Quinn. I'm sure that working on the bronze version (and he absolutized the form) impelled Brancusi to carve the second *Sleeping Muse* the same year, this time with a reflective bronze in mind. But early that year, (as far as we can tell, and shown in March [?] 1917 in New York) he'd made the reflective bronze *Princess X*, whose marble would seem to be the first piece that was carved with the ultimate polish in mind. (He may have carved—or started—a Maiastra earlier with polish in mind, but it broke.)" I share this lengthy quotation with the reader so that he or she may appreciate the problems involved with researching Brancusi, and Sidney Geist's thoroughness.
95. Jack Burnham, "Sculpture's Vanishing Base," in his *Beyond Modern Sculpture*, Braziller, 1968, is an important study of this subject.

96. The original plaster version of the Du-champ-Villon supported by tenons is reproduced in Walter Pach's *Raymond Duchamp-Villion. Sculpture 1876–1918*. Povolozky, 1924. The Museum of Modern Art's version of the Boccioni sculpture has the legs resting on bronze blocks.

97. Leo Steinberg, *Other Criteria*, Oxford, 1972. See his essay on Rodin, revised from its original version of 1963 and published as a catalogue by the Charles Slatkin Galleries.

98. There is still doubt as to whether or not Degas wanted his *Bather in a Tub* to be placed directly on the floor or raised on a low pedestal. There is also a question as to whether or not the raveled sheet beneath the tub was part of the original version.

99. Cladel, p. 149.

100. Geist, p. 169. See Athena Spear's excellent monograph, *Brancusi's Birds*, NYU Press, 1969, on Brancusi's distrust of salon pedestals. She also argues against Geist, pointing out that Brancusi sold a carved pedestal to the collector John Quinn as a sculpture. The most detailed and interesting case for considering Brancusi's carved pedestals as sculptures is made by Edith Balas in her 1973 dissertation for the University of Pittsburgh, "The Sculpture of Brancusi in the Light of His Rumanian Heritage."

101. Robert Goldwater's "Truth to What?" in the *Arts Yearbook* of 1965 is a marvelous analysis of the "Truth to the medium" phenomenon.

102. On the properties of materials from a conservative viewpoint see Blanc, pp. 351ff and Hildebrand, Chapter 7.

103. This is from Nadelman's "Statement of Principles" in Kirstein's book.

104. Geist, p. 158.

105. Pound, p. 31.

106. Hildebrand, pp. 91–92.

107. For Balla and Depero, see Martin, plates 217–218, and for Marinetti's "Self Portrait" see Taylor, p. 110. Taylor also reproduces Balla's *Boccioni's Fist*, p. 117.

108. Apollonio, p. 198.

109. Hildebrand, 86–92.

110. In my Rodin's *Gates of Hell*, Univ. of Minnesota Press, 1960, pp. 92ff. I discuss how the relief invites the viewer into the portal.

111. Gray reproduces this earliest relief on pp. 114–115.

112. Gray, p. 79.

113. Cladel, p. 80.

114. For reproductions and discussion of the Cubist House see Hamilton and Agee, pp. 64–69.

115. Hamilton and Agee, p. 114.

116. Elsen, *The Sculpture of Henri Matisse*, for a fuller discussion of the "Backs," pp. 182ff.

117. I have seen only a reproduction of this work in Werner Hoffmann's *Turning Points in Twentieth Century Art*, Braziller, n.d., plate 18.

118. Archipenko, pp. 40–41.

119. Jaime Sabartes, *Picasso, Documents Iconographiques*, Cailler, 1954, pl. 191.

120. For photos of the Tatlin reliefs now destroyed see the Hultén and Andersen Catalogue.

121. Hutton, see esp. the section on Chronology.

122. Arp, *On My Way*, p. 49.

123. Gilot, p. 187.

124. Lipchitz and Arnason, p. 20.

List of illustrations

1. A turn of the century sculpture Salon in the new Grand Palais. Photo Roger-Viollet.

2. Charles-Jean Cléophas Desvergnes, *Statue of the Arts and Photography*, made for the section on the Chemical Arts of the 1900 Paris Exposition.

3. Charles Roufosse, *The First Shiver*, marble, Petit Palais. Photo Roger-Viollet.

4. Leonetto Cappiello, *Yvette Guilbert*, 1899, painted plaster. Musée Carnavalet, Paris. Photo Bulloz.

5. Albert Bartholomé, *Tomb of Mme. Bartholomé*, Bouillaut (Oise). Photo Roger-Viollet.

6. Emmanuel Frémiet, *"I'm Forever Blowing Bubbles,"* 1899, bronze, Tiffany glass light fixture. (Photographed in the house of Sarah Bernhardt) Galerie du Luxembourg, Paris. Photo Roger-Viollet.

7. Constantin Meunier, *The Reaper*, Tate Gallery.

8. Léon J. Deschamps, *Harvest time*, n.d. The Metropolitan Museum of Art. Gift of Mrs. Stanford D. Foot, 1945, in memory of her sister, Louise E. von Bernuth.

9. Roger Bloche, *Cold*, bronze. Formerly in the Musée du Luxembourg, Paris. Photo Roger-Viollet.

10. Emmanuel Frémiet, *Orang-outang Strangling a Savage from Borneo*, 1895, marble, Musée National d'Histoire Naturelle, Paris. Photo Roger-Viollet.

11. Henri L. Bouchard, *Monument to the Aeronaut Victims of the Dirigible "Republique,"* 1911, granite. Photo from *L'Art et Décoration*, 1911.

12. Henri Gaudier-Brzeska, *Stags*, 1914, veined alabaster, 13¾" H. Courtesy Art Institute of Chicago. Gift of Samuel Lustgarten.

13. Jules-Aimé Dalou, *Nude Woman*, 1899, marble. The Metropolitan Museum of Art. Gift of Mr. and Mrs. Frank Altschul, 1952.

14. Jean Léon Gérôme, *Corinthe*, exhibited in the Salon de Mai, 1904. Green marble column with a gilded Corinthian capital, chryselephantine ornamentation with gilded bronze and various stones (opals, turquoise, etc.) and tinted marble. Figure: 11" x 11" x 18" column and capital: 56¾" H.

15. Auguste Rodin, *Prayer*, plaster. Exhibited in the 1910 Salon, Musée Rodin, Paris. Photo Archives Photographiques.

16. Aristide Maillol, *Mediterranée*, 1905, plaster (as exhibited in the 1905 Salon) 41" H. Photo Bulloz.

17. Pierre-Auguste Renoir, *Venus Victorius*, 1915–16, 71" H. x 43" W. The Tate Gallery.

18. Wilhelm Lehmbruck, *Fallen Youth*, 1915–16, synthetic stone, c. 28½" H. x 94" W. The Lehmbruck Family.

19. Edgar Degas, *Developpé en avant*, 1909, bronze, 22⅝" H. The Museum of Modern Art. Bequest of Mrs. H. O. Havemeyer, The H. O. Havemeyer Collection.

20. Henri Matisse, *Standing Nude With Arms Raised Over Her Head*, 1906, 10½" H. Private Collection.

21. Elie Nadelman, *Standing Female Nude*, c. 1905–09, bronze, 26" H. Joseph H. Hirshhorn Museum and Sculpture Garden Foundation.

22. Herbert Ward, *The Sculpture of Idols*, before 1911–12, bronze. Smithsonian Institution. Ward, a Franco-American artist, had a strong anthropological interest and used his conservative training to give an exact likeness to the carver at a time when the pioneers were more interested in the art made by African artists. This sculpture is a kind of tribute to the "anonymous" African carver who Sidney Geist felt should be represented in this book.

23. Jacob Epstein, *Venus With Doves*,

marble, 96" H. Yale University. Photo courtesy Courtauld Institute of Art.

24. Paul Gauguin, *Figure of a Standing Woman*, 1890s, grey limestone. Collection Walter Chrysler, Jr., New York.

25. André Derain, *Standing Nude*, 1906, stone, 38" H. x 12¼" W. Collection Madame Alice Derain, Paris.

26. Henri Gaudier-Brzeska, *Red Stone Dancer*, 1913, red Mansfield Stone, polished and waxed, 17" H. The Tate Gallery.

27. Pablo Picasso, *Figure*, 1907, wood, 32¼" H. Estate of the Artist. The Cliché des Musées Nationaux.

28. Constantin Brancusi, *Figure (Little French Girl)*, 1918 (?), oak 49" H. The Solomon R. Guggenheim Museum. Gift, Katherine S. Dreier Estate.

29. Jacob Epstein, *Doves*, 1914–15. marble, 19¼" H. x 29" W. Billy Rose Collection.

30. Auguste Rodin, *Iris, Messenger of the Gods*, 1891–92, bronze, 16½" H. Musée Rodin. According to Captain Anthony Ludovici, Rodin's secretary in 1906, he had to cover this sculpture whenever the artist received visitors from England. Posed for by a can-can dancer from Montmartre, sculptures such as this contributed to his reputation as being obsessed with sex.

31. Aristide Maillol, *Night*, 1902, bronze, 7" H. Private Collection.

32. Constantin Brancusi, *The Kiss*, 1910, stone, 35¼" H. Montparnasse Cemetary, Paris. Photo The Solomon R. Guggenheim Museum.

33. Ernst Barlach, *Russian Beggarwoman*, 1907, boettcher stone, 11½" H. Joseph H. Hirshhorn Museum and Sculpture Garden.

34. Medardo Rosso, *Impression of an Omnibus*, wax on plaster, 20" H. The Minneapolis Institute of Arts. The original of 1883–84 was destroyed in 1897: Rosso attempted to duplicate it in later years. (He had some poor pictures of it.)

35. Jacques Lipchitz, *Sailor With Guitar*, 1914, bronze, 30" H. Albright Knox Gallery. Photo Archives Photographiques.

36. Henri Laurens, *The Clown*, 1914 (?), painted wood, 23" H. Moderna Museet Stockholm. Photo Archives Photographiques.

37. Auguste Rodin, *Monument to Balzac*, 1898. Paris.

38. Wilhelm Lehmbruck, *Rising Youth*, 1913, cast stone, 7'8" H. Collection, The Museum of Modern Art. Gift of Mrs. John D. Rockefeller.

39. George Minne, *The Little Relic Bearer*, c. 1897, marble version in Musée Royal d'Arte à Bruxelles. Photo copyright A.C.L.

40. Elie Nadelman, *Man in the Open Air*, 1915, bronze, 54½" H. at base, 11¾" x 21½" H. Collection, The Museum of Modern Art, New York. Gift of William S. Paley.

41. Auguste Rodin, *The Walking Man*, 1877, exhibited 1900, (enlarged 1905 and shown in the 1907 Salon) bronze, 21¼" H. National Gallery of Art, Washington, D.C. Gift of Mr. John W. Simpson.

42. Ernst Barlach, *The Stroller*, 1912, wood. Collection Herbert Kurz, Wolframs-Eschenbach. Photo Alfred Ehrhardt.

43. Raymond Duchamp-Villon, *Torso of a Young Man (The Athlete)*, 1910, bronze 21¼" H. The Leland Stanford Junior Museum. Gift of the Committee for Art at Stanford.

44. Umberto Boccioni, *Unique Forms of Continuity in Space*, 1913, bronze, 43⅞" x 34⅞" x 15¾". Collection, The Museum of Modern Art, New York. Acquired through the Lillie P. Bliss Bequest.

45. Antoine Bourdelle, *Dying Centaur*, 1914, bronze (medium size definitive study). The Bourdelle Museum, Paris.

Photo Archives Photographiques.

46. Jacob Epstein, *The Rock Drill*, 1913, original version in plaster and with a pneumatic drill.

47. Jacob Epstein, *The Rock Drill*, 1913 (?), revised version, bronze, 28″ H. The National Gallery of Canada, Ottawa.

48. Raymond Duchamp-Villon, *The Horse*, 1914, plaster, c. 16″ H. Photo Archives Photographiques.

49. Constantin Brancusi, *Prodigal Son*, 1915, oak, 17½″ H. Philadelphia Museum of Art. Louise and Walter Arensberg Collection.

50. Constantin Brancusi, *Chimera*, 1918, oak, 59¾″ H. Philadelphia Museum of Art. Louise and Walter Arensberg Collection.

51. Paul Gauguin, *Self-Portrait, Oviri (The Savage)*, c. 1893, bronze. A. S. Teltsch, Esq.

52. Oscar Kokoschka, *Self-portrait as a Warrior*, 1907–08, painted clay. 16″ H. Museum of Fine Arts, Boston. J. H. and E. H. Payne Fund.

53. Medardo Rosso, *Conversation in a Garden*, 1893, wax over plaster, 17″ H. Collection Dr. Gianni Mattioli, Milan. Photo Gabinetto Fotografico Nazionale.

54. Pablo Picasso, *Mask of a Picador (with a Broken Nose)*, 1903, bronze. Baltimore Museum of Art. Cone Collection.

55. Henri Gaudier-Brzeska, *The Fool (Self-Portrait)*, 1912 (?), plaster stained ochre. Victoria and Albert Museum, London.

56. Jacob Epstein, *Self-Portrait with Visor*, 1912, over life-size, bronze. Schinman Collection, Bernard Dannenberg Gallery).

57. Auguste Rodin, *Portrait of Baudelaire*, 1892, bronze, 8″ H., Joseph H. Hirshhorn Museum and Sculpture Garden.

58. Wilhelm Lehmbruck, *Portrait of Fritz von Unruh*, 1917, 26 15/16″ x 8 13/16″

x 9 7/16″ (including integral base), grey stone. The Lehmbruck Family.

59. Medardo Rosso, *Ecce Puer*, 1906, wax, 16½″ H. Joseph H. Hirshhorn Museum and Sculpture Garden.

60. Henri Matisse, *Jeannette V*, 1913, bronze, 22⅞″ H. Joseph H. Hirshhorn Foundation.

61. Raymond Duchamp-Villon, *Head of Baudelaire*, 1913, bronze, 15¾″ H. Collection, The Museum of Modern Art, New York. Alexander M. Bing Bequest.

62. Pablo Picasso, *Woman's Head (Fernande Olivier)*, 1909, bronze, 16¼″ H. Collection, The Museum of Modern Art, New York.

63. Umberto Boccioni, *Portrait of the Artist's Mother, Antigraziosa*. Photo Gabinetto Fotografico Nazionale.

64. Elie Nadelman, *Abstract Head*, 1909 (?). Whereabouts unknown.

65. Constantin Brancusi, *Mademoiselle Pogany*, 1913, bronze, 17¼″ H. Collection, The Museum of Modern Art, New York. Acquired through the Lillie P. Bliss Bequest.

66. Henri Gaudier-Brzeska, *Hieratic Head of Ezra Pound*, 1914, stone. Estate of Ezra Pound.

67. Amadeo Modigliani, *Head*, 1911–13 (?), stone, 24¾″ H. Tate Gallery.

68. Jacob Epstein, *Mother and Child*, 1913, marble, 17¼″ H. x 17″ W. Collection, The Museum of Modern Art, New York. Gift of A. Conger Goodyear.

69. Constantin Brancusi, *Sleeping Muse*, 1910, bronze, 6¾″ H. The Metropolitan Museum of Art. The Alfred Stieglitz Collection, 1949.

70. Alexander Archipenko, *Head*, 1913. Photo Courtesy Mrs. Frances Archipenko Gray, New York City.

71. Emil Filla, *Man's Head*, 1913–14, bronze, 15⅜″ H. Photo Narodni Galerie, Prague.

72. Joseph Csaky, *Head of a Man*, 1914,

stone, 15" H. Galerie Claude Bernard, Paris. Photo DeCastro.

73. Jacques Lipchitz, *Head,* 1915, bronze. Tate Gallery.

74. Naum Gabo, *Head No. 2,* 1916, sheet iron covered with yellow ochre-colored paint. Collection of the artist.

75. Pablo Picasso, *Guitar,* 1911–12, sheet metal and wire, 30⅓" H. Collection, The Museum of Modern Art. Gift of the Artist.

76. Umberto Boccioni, *Development of a Bottle in Space,* 1912, silvered bronze, 23¾" H. Collection, The Museum of Modern Art, New York. Aristide Maillol Foundation.

77. Henri Laurens, *Bottle of Beaune,* 1918, wood, 26.13" H. Galerie Louise Leiris.

78. Constantin Brancusi, *Cup,* 1917, wood, 6¼" Diam. Musée d'Art Moderne, Paris.

79. Alberto Magnelli, *Still Life,* 1914. Photo Studio Yves Hervochon.

80. Marcel Duchamp, *Bicycle Wheel,* 1951, third version, after lost original of 1913. Assemblage, overall 50½" H. Collection, The Museum of Modern Art, New York. The Sidney and Harriet Janis Collection.

81. Vladimir Tatlin, *Relief,* 1914.

82. Vladimir Baranoff-Rossiné, *Symphony no. 1,* 1913, polychrome wood construction with crushed egg shells, 64" H. Collection, The Museum of Modern Art, New York. Katia Granoff Fund.

83. Alexander Rodchenko, *Construction,* 1917. Whereabouts unknown. Photo Alfred Barr Archive.

84. Kasimir Meduniezky, *Abstract Construction no. 557,* 1919, Yale University Art Gallery. Gift of Collection Societé Anonyme.

85. Henri Gaudier-Brzeska, *Ornament,* 1913 (?), carved bronze. The Tate Gallery.

86. Max Weber, *Air-Light-Shadow,* 1915, polychrome plaster, 28⅞" H. Collection, The Museum of Modern Art.

Blanchette Rockefeller Fund, 1959.

87. Fortunato Depero and Giacomo Balla, colored *"Noise-Motion,"* 1914–15 (destroyed), plastic complex of equivalents in motion. Photo reproduced from Jane Rye, *Futurism* (Dutton, 1972).

88. Constantin Brancusi, *Endless Column,* 1918, oak, 80" H. The Solomon R. Guggenheim Collection. Photo courtesy Mrs. William Sisler, Palm Beach, Florida.

89. Picasso in his studio, 1908–09. Photo Gelett Burgess ("The Wild Men of Paris," *Architectural Record,* May 1910).

90. Lehmbruck in his studio, Zurich, 1918. Photo R. Heller (*The Art of Wilhelm Lehmbruck,* National Gallery of Art, 1972, p. 34).

91. Bourdelle in his studio next to the enlarged version of *The Archer,* c. 1914.

92. Derain in his studio, 1908–09. Whereabouts unknown of the sculpture held by the artist and head in lower right hand corner. Photo Gelett Burgess ("The Wild Men of Paris," *Architectural Record,* May 1910).

93. Archipenko. Photo Courtesy Mrs. Frances Archipenko Gray.

94. Auguste Rodin, *Torso of a Young Girl,* 1909, bronze, 32½" H. Joseph H. Hirshhorn Museum and Sculpture Garden.

95. Auguste Rodin, *Cast of the Artist's Hand Holding a Small Torso of a Woman,* 1917, plaster. The Rodin Museum, Philadelphia.

96. Constantin Brancusi, *Torso,* 1908, marble, 9½" H. Art Museum of Craiova. Photo Courtauld Institute of Art, London.

97. Aristide Maillol, *Torso of Freedom in Chains,* 1906, bronze, 47½" H. Courtesy of the Art Institute of Chicago.

98. Alexander Archipenko, *Seated Black Torso,* 1909, bronze, 15" H. Perls Gal-

lery, New York City.

99. Georges Van Tongerloo, *Spherical Construction*, 1917, painted wood, 3½″ H. Philadelphia Museum of Art. A. E. Gallatin Collection.

100. Naum Gabo, *Torso*, 1917, sheet iron treated with sand.

101. Jacques Lipchitz, *Half Length Standing Figure*, 1916, marble. The Solomon R. Guggenheim Museum.

102. Henri Matisse, *The Serf*, 1900–1903, bronze, 37⅜″ H. The Baltimore Museum of Art. The Cone Collection.

103. Constantin Brancusi, *Prometheus*, 1911, marble, 7″ L. Philadelphia Museum of Art, Louise and Walter Arensberg Collection.

104. Constantin Brancusi, *The New Born*, 1915, marble 8⅛″ L. Philadelphia Museum of Art. Louise and Walter Arensberg Collection.

105. Elie Nadelman, *Head of a Young Man (Self-Portrait)*, 1907 (whereabouts unknown).

106. Georges Van Tongerloo, *Construction in a Sphere*, 1917, yellow painted mahogany, 2¾″ D.

107. Henri Matisse, *The Serpentine*, bronze, 1909, 22¼″ H. Private Collection.

108. Wilhelm Lehmbruck, *Kneeling Woman*, 1911, cast stone, 69½″ H. Collection, The Museum of Modern Art, New York. Abby Aldrich Rockefeller Fund.

109. Constantin Brancusi, *Sculpture for the Blind*, 1924, marble. Philadelphia Museum of Art. Louise and Walter Arensberg Collection.

110. Auguste Rodin, *The Crouching Woman*, 1892, bronze, 21″ H. Musée Rodin, Paris.

111. Henri Matisse, detail of *The Serf*, 1900–03, bronze, 37⅜″ H. The Baltimore Museum of Art. The Cone Collection.

112. Ernst Barlach, *Man Drawing a Sword*, 1911, wood, 30″ H. Barlach Haus, Hamburg. Photo H. P. Cordes Atelier.

113. Raymond Duchamp-Villon, *Seated Woman*, 1914, bronze, 25¾″ H. Yale University Art Museum.

114. Constantin Brancusi, *Prayer*, 1907, bronze, 43⅞″ H. Muzeul de Arta, R. S. R. Bucharest. Photo Courtauld Institute of Art.

115. Constantin Brancusi, *Torso of a Young Man*, 1916 (?), polished bronze, 19″ H. Cleveland Museum of Art.

116. Georges Van Tongerloo, *Construction Within a Sphere*, 1917, silvered plaster, 7″ H. Collection, The Museum of Modern Art, New York.

117. Jacques Lipchitz, *Half Length Figure*, 1916, bronze. Private Collection. Photo Courtauld Institute of Art.

118. Naum Gabo, *Head of a Woman*, c. 1917–20, construction in metal and celluloid, 24″ H. Collection, The Museum of Modern Art, New York.

119. Alexander Archipenko, *The Boxers (Struggle)*, 1914, painted plaster, 23¾″ H. The Solomon R. Guggenheim Museum.

120. Alexander Archipenko, *Walking Woman*, 1912, bronze, 26½″ H. Perls Galleries. The Joan and Lester Avenet Collection.

121. Pablo Picasso, *Absinthe Glass*, 1914, sand covered bronze, 8½″ H. Collection of the artist. Photo Courtauld Institute of Art.

122. Max Weber, *Spiral Rhythm*, 1915 (enlarged at a later date) bronze. Hale R. Allen, New York. Photo O. E. Nelson.

123. Jacques Lipchitz, *Man With a Guitar*, 1916, stone, 38¼″ H. Collection, The Museum of Modern Art, New York. Mrs. Simon Guggenheim Fund.

124. Louis-Ernest Barrias, *Nature Unveiling Herself to Science*, c. 1898, polychromed marble, marble, bronze. Photo Roger-Viollet.

125. Ernst Ludwig Kirchner, *Standing Painted Figure*, 1908–12, painted wood. Gemeente Musea, Amsterdam.

126. Alexander Archipenko, *Carrousel*

Pierrot, 1913, painted plaster, 23⅝"
H. The Solomon R. Guggenheim Museum.

127. Pablo Picasso, *Absinthe Glass*, 1914, painted bronze with silver spoon, 8½" H. Collection, The Museum of Modern Art, New York. Gift of Mrs. Bertram Smith.

128. Henri Laurens, *Head*, 1915–18, painted wood, 20" H. Collection, The Museum of Modern Art, New York. Van Gogh Purchase Fund.

129. Jean Arp, *Forest*, 1916–17, painted wood, c. 13" H. Private Collection.

130. Medardo Rosso, *Bust of Yvette Guilbert*, 1895, wax. Galleria d'Arte Moderna, Rome. Photo Gabinetto Fotografico Nazionale.

131. Alexander Archipenko, *Head*, 1914. Photo courtesy Mrs. Frances Archipenko Gray.

132. Alexander Archipenko, *Flat Torso*, 1914, Philadelphia Museum of Art. Photo courtesy Mrs. Frances Archipenko Gray.

133. Alexander Archipenko, *Woman Combing Her Hair*, 1915, 13¾" H. Collection, The Museum of Modern Art, New York. Acquired through the Lillie P. Bliss Bequest.

134. Constantin Brancusi, *Sleeping Muse*, 1910, bronze, 10⅝" L. Musée d'Art Moderne, Paris.

135. Constantin Brancusi, *The Princess (Princess X)*, 1916 or 1917, polished bronze, 23" H. Philadelphia Museum of Art. Louise and Walter Arensberg Collection.

136. Auguste Rodin, *Eve*, exhibited in the Salon of 1898 with the base buried in the sand.

137. Edgar Degas, *The Tub*, c. 1886, bronze, 9¾" H. The Metropolitan Museum of Art. Bequest of Mrs. H. O. Havemeyer, 1929. The H. O. Havemeyer Collection.

138. Henri Gaudier-Brzeska, *Birds Erect*, 1914, stone, 26⅝" H. Collection, The

Museum of Modern Art, New York. Gift of Mr. and Mrs. W. Murray Crane.

139. Alexander Archipenko, *The Madonna of the Rocks*, 1912, bronze. The National Museum of Wales, Cardiff. Photo Courtesy Mrs. Frances Archipenko Gray.

140. Joseph Bernard, *Girl With a Pail*, 1912, bronze, 73" H. Musée d'Art Moderne, Paris. Photo Archives Photographiques.

141. Amadeo Modigliani, *Head*, c. 1910, stone, 19¾" H. Joseph H. Hirshhorn Museum and Sculpture Garden.

142. Jacob Epstein, *Sunflower*, 1910, San Stefano stone, 23" H. Collection Anthony d'Offay Esq., London. Photo Courtauld Institute of Art.

143. Henri Gaudier-Brzeska, *Photo of the Artist carving the head of Ezra Pound.*

144. André Derain, *Crouching Figure*, 1907, stone. The Museum of Twentieth Century Art, Vienna.

145. Auguste Rodin, *Study of the Torso of a Woman*, date unknown, terra cotta. The Metropolitan Museum of Art. Gift of the sculptor, 1912.

146. Umberto Boccioni, *Head plus House plus Light*, 1912, various materials, destroyed.

147. Pablo Picasso, *Mandolin*, 1914, construction in wood and painted, 23⅝" H. Estate of the Artist. Photo Courtauld Institute of Art.

148. Adolf von Hildebrand, *Archers and Amazons*, 1887–88, cement cast (1954) from plaster model for triptych. Wallraf-Richartz Museum, Cologne.

149. Auguste Rodin, *The Gates of Hell*, 1880–1917, bronze, 216" H. x 144" W. x 33" D. Musée Rodin, Paris.

150. Pierre-Auguste Renoir, *The Judgment of Paris*, c. 1914, bronze, 29¼" H. The Cleveland Museum of Art. Purchase from the J. H. Wade Fund.

151. Ernst Barlach, *The Vision*, 1912, top 16" x 23"; bottom 32" x 40." Neue Nationalgalerie, West Berlin.

152. Paul Gauguin, *Be In Love and You Will Be Happy*, 1888. Courtesy, Museum of Fine Arts, Boston. Arthur Tracy Cabot Fund.

153. Emil Bourdelle, *Tragedy*, 1912. Study for the decoration of the Théâtre des Champs Elysées, Musée Bourdelle, Paris.

154. Aristide Maillol, *Desire*, 1906–08. Tinted plaster relief, 46⅞″ x 45″. Collection, The Museum of Modern Art, New York. Gift of the artist.

155. Raymond Duchamp-Villon, *The Lovers*, 1913, original plaster relief, 27½″ x 46″ x 6½″. Collection, The Museum of Modern Art, New York.

156. Henri Matisse, *The Back*, 1909, clay (lost or reworked into what is now known as *The Back no. 1)*. Whereabouts unknown. Photo Druet.

157. Henri Matisse, *The Back no. 1*, 1909. Bronze, 74⅜″ x 44½″ x 6½″. Collection, The Museum of Modern Art, New York. Mrs. Simon Guggenheim Fund.

158. Henri Matisse, *The Back no. 2*, c. 1913, bronze, 74¼″ x 47⅝″ x 6″. Collection, The Museum of Modern Art, New York. Mrs. Simon Guggenheim Fund.

159. Henri Matisse, *The Back no. 3*, 1916–17, bronze, 74½″ x 44″ x 6″. Collection, The Museum of Modern Art, New York. The Simon Guggenheim Fund.

160. Josef Hoffman, *Relief*. Bildarchiv, Osterreichische Nationalbibliothek, Vienna.

Index